LYNDA BENGLIS

LYNDA BENGLIS

LYNDA

BENGLIS
DUAL NATURES

SUSAN KRANE

HIGH MUSEUM OF ART
ATLANTA, GEORGIA

Lynda Benglis: Dual Natures
was funded by the Lannan
Foundation and the National
Endowment for the Arts,
a federal agency, with
additional support from
the Members Guild of the
High Museum of Art.

Lynda Benglis: Dual Natures
was organized by the High
Museum of Art and presented
at the following venues:

High Museum of Art
Atlanta, Georgia
29 January - 31 March 1991

Contemporary Arts Center
in conjunction with the
New Orleans Museum of Art
New Orleans, Louisiana
1 June - 4 August 1991

San Jose Museum of Art
San Jose, California
15 September - 1 December 1991

CONTENTS

LENDERS TO THE EXHIBITION

Sue and Steven Antebi
A. J. Aronow, New York
Mr. and Mrs. M. A. Benglis, Lake Charles, Louisiana
Paula Cooper Gallery, New York
Barbara and George Erb, Birmingham, Michigan
Mr. and Mrs. Donnelley Erdman, Aspen, Colorado
Sondra and Charles Gilman, Jr., Collection
Mr. and Mrs. Graham Gund
Helen Herrick and Milton Brutten, Philadelphia
Anne and William J. Hokin
Margo Leavin Gallery, Los Angeles
Sally Sirkin Lewis and Bernard Lewis, Beverly Hills, California
Jeanne Randall Malkin, Chicago
Gerd Metzdorff, Vancouver, Canada
Iris and Allen Mink, Los Angeles
The Modern Art Museum of Fort Worth
The Museum of Modern Art, New York
New Orleans Museum of Art
Camille and Paul Oliver-Hoffmann
Philadelphia Museum of Art
Phillip G. Schrager
Tilden-Foley Gallery, New Orleans
Richard Tuttle
Walker Art Center, Minneapolis
Frederick Weisman Company
and three private collections

FOREWORD

By its very nature, the art of our times challenges us to consider a work on its own merits, without the critical validation accorded to art that has withstood the test of time. It is, therefore, in the arena of contemporary art that museums do their most pioneering work, an obligation that we welcome with confidence.

At the High Museum, contemporary art has long enjoyed a comfortable presence. Two recent series, *Art at the Edge* and *Southern Expressions*, have brought the talents of emerging artists to a wider public, through these exhibitions and their accompanying catalogues. Susan Krane, curator of twentieth-century art since 1987, has been the driving force in these efforts.

Ms. Krane's exploration of Lynda Benglis's work, particularly her analysis in this catalogue, is a penetrating evaluation of one of the most original sculptors of our time. Since the 1960s, Benglis has consistently sustained a high level of creative output, which has, in turn, received continuing critical interest. For all the exposure her work has received—in exhibitions and in art periodicals—this is the first major museum retrospective of Lynda Benglis's work. It is, therefore, with deep satisfaction that we present the work of this innovative artist, whom I have greatly enjoyed getting to know during the course of this project and whose work we are particularly proud to have in our collection.

Gudmund Vigtel
Director
High Museum of Art

ACKNOWLEDGMENTS

Lynda Benglis's work has been widely known and discussed since the early 1970s; her art, however, has only on rare occasions been surveyed historically, and never in any comprehensive fashion. After selecting a number of her later works for a group exhibition at the Albright-Knox Art Gallery in 1987, I became interested in assembling a retrospective of Benglis's art, which with increasing frequency was being raised as a point of reference in discussions and during my studio visits with emerging artists. Few of these artists and colleagues, however, had actually seen more than a handful of Benglis's earlier works in person. Given the recent resurgence of interest in sculpture, and in issues that parallel those raised by the groundbreaking work of the late 1960s and early 1970s, a critical review of Benglis's achievements seems long overdue. It is our hope that this retrospective (initiated several years ago) will continue the reevaluation of her art prompted by the important contextual exhibition *The New Sculpture 1965-75,* organized by the Whitney Museum of American Art in the spring of 1990.

This exhibition has been made possible by the cooperation and interest of many people who have generously given of their time and efforts. The support, input and encouragement of Paula Cooper in New York and Margo Leavin in Los Angeles (Benglis's longtime representatives) have been crucial since the inception of the exhibition. We relied on the gracious and conscientious assistance of Julie Graham (who has shepherded every aspect of this project), Sarah Block, Fraser Hudson, Gabriella Ranelli, Natasha Sigmund and Cas Stachelberg at Paula Cooper Gallery and Douglas Baxter (formerly of the gallery); as well as Wendy Brandow, Kathryn Kanjo, Lynn Sharpless and Ellen South at Margo Leavin Gallery and Doug Roberts (formerly of the gallery), all of whom helped with the unending details of organization and kindly answered our constant stream of requests. We are also indebted to Fredericka Hunter and her staff at Texas Gallery in Houston; Tim Foley and his staff at Tilden-Foley Gallery in New Orleans; Rebecca Donelson; Diana Fuller; Susanne Hilberry and Sandra Schemske of Susanne Hilberry Gallery in Bloomfield Hills, Michigan; Linda Farris of Linda Farris Gallery in Seattle; and the staffs of Dart Gallery and of Richard Gray Gallery, both in Chicago, for their willing responses to our many inquiries.

We are especially grateful to the lenders to the exhibition, who have parted with their works for the duration of this show. This historical review of Benglis's career would not have been possible without their generosity and willingness to share their collections with a broader audience. I also thank the many individuals and corporations who interrupted their busy schedules to allow me to view works in their collections.

Countless colleagues and individuals at corporations, galleries, museums, libraries and publications offices assisted our research. I thank them for their invaluable help, for opening their facilities to us and for the fruitful exchange of ideas that often ensued in the process. Our sincere thanks go to: Richard Armstrong, curator, Whitney Museum of American Art; Jay Barrows, curator for Best Products; Sally Beddow, The MIT Museum; Emery Clark; Rosemary Congero, assistant to Paul Anka; Alfred H. Daniels; Ann Daley, curator, Captiva

Corporation; Terry Fassburg, vice president of public affairs, Frito-Lay, Inc.; James L. Fisher, curator of prints/assistant to the director, exhibitions, The Modern Art Museum of Fort Worth; Bets Friday; Maggie Gillham, former curatorial assistant at the High Museum of Art, now curator, Art Museum of South Texas; Raymond Goetz; Michael Goldberg; Ron Gorchov; David Heath; Margaret Honda; Dale Hoyt, archivist, The Kitchen; Klaus Kertess; Landfall Press; Janie C. Lee Galleries; Tom Lines and Edgar Lugo, SlideMakers; Gerd Metzdorff; Bob Metzger of Center Gallery, Bucknell University; Robert Morris; Michael Nash, Long Beach Museum of Art; Annalee Newman; Randy Rosen; Keith Sonnier and his assistant Carolyn James; Richard Tuttle; Dorothy and Herbert Vogel; Britta Le Va and Joe Zucker.

We particularly thank Kari Horowicz, librarian, and Janice Lurie, assistant librarian, at the Albright-Knox Art Gallery; William B. Walker, chief librarian, Thomas J. Watson Library, The Metropolitan Museum of Art; Hikmet Doğu, associate librarian, reference, and Eumie Mimm, assistant librarian, reference-periodicals, The Museum of Modern Art; and James Lim, librarian, San Francisco Public Library, for their extraordinary help in answering our relentless questions regarding verification of facts and names. The efforts of Eric Marano and Eric Schefter of American Montage, Inc., Eileen Clancy, video distributor, The Kitchen, and Mindy Faber, associate director, Video Data Bank, were crucial to the research and presentation of Benglis's video works and to the production of the videotape that accompanies this exhibition. I am also grateful to Douglas G. Schultz, director, Albright-Knox Art Gallery, for permission to excerpt several passages from my text, "Lynda Benglis" in *Structure to Resemblance* (Buffalo, New York: Albright-Knox Art Gallery, 1987) for the essay in this catalogue, and to Nene Humphrey and Rocío Rodriguez for their helpful comments on preliminary versions of my texts.

The educational videotape that accompanies this exhibition was produced with Marcy Brafman of Caesar Video Graphics in New York, and edited by Susan Elmiger. It was a pleasure to work with them over the course of the project, to which they brought great imagination and a fresh vision. I am grateful to Molly McCoy (who generously donated her time to narrate the tape), and to Ted Rubenstein for reviewing the script. I also thank Jack Brogan for welcoming camera crews into his studio to shoot footage of the fabrication of Benglis's works, for answering my numerous technical questions and for his insights on Benglis's working process.

My special thanks go to Georgette Morphis Hasiotis, editor of this catalogue, for her enthusiasm for Benglis's art, for her painstaking attention to detail and for keeping everyone's spirits up during the arduous task of preparing the manuscript for publication. I am glad to have had the opportunity to work with her once again. I am grateful to designer Jim Zambounis for his sensitive and elegant design and for his cheerful accommodation of our tight schedule. My thanks also go to Kelly Morris, editor at the High Museum, and Margaret Miller, associate editor, who oversaw the production of this catalogue with their usual great care and concern for design as well as for the context of the art.

Our colleagues at the participating institutions have made the tour of this exhibition possible. We thank Annette Dimeo Carlozzi, director, and Lew Thomas, visual arts curator, at the Contemporary Arts Center in New Orleans; John Bullard, director, and William Fagaly, assistant director, New Orleans Museum of Art; I. Michael Danoff, director, and Colleen Vojvodich, curator, at the San Jose Museum of Art, for their commitment to Benglis's art and for their ready assistance during the organization of this show. We are pleased that

this retrospective of Benglis's art will travel to her home state and to California, environments that have been so pivotal for her.

Throughout the organization of this exhibition, Lynda Benglis has generously cooperated with our numerous requests and intrusions. She willingly submitted to numerous interviews, opened her studio and home to us, and patiently responded as we dredged up often mundane details of the near past. I thank her for the great pleasure of working with her on all aspects of this project and for sharing her insights and remembrances so freely. It is with respect and admiration for her personal achievements and independence that we present this exhibition. In addition, I am grateful to Karen Benglis, the artist's sister and studio assistant, who aided us with archival research, photography and numerous other organizational matters.

This project was truly a team effort, and I am indebted to the entire staff of the High Museum for their participation. Gudmund Vigtel, director, encouraged the undertaking of this exhibition when I came to the High Museum in 1987, and I thank him for his continual support. Carrie Przybilla, assistant curator of twentieth-century art, contributed the thorough video synopses and the chronology to this catalogue, assisted with all aspects of research and organization, and supervised the many interns who worked at various times on the exhibition. Joy Wasson, curatorial assistant for twentieth-century art, helped assemble information for this catalogue (including the public collections lists) and conscientiously and unerringly coordinated many diverse organizational tasks. I am especially grateful to Carrie and Joy for their good humor, dedication and comraderie during the many long hours we worked on this project, and to Catherine Kennedy, curatorial assistant for the 20th Century Art Society, for cheerfully pitching in whenever needed. Shella De Shong, first a volunteer and then our temporary research assistant, prepared the exhibition history and bibliography with great attention for detail and endless patience with our numerous questions. Summer interns Annabeth Headrick, Scott Gerson, Chassie Post and John F. Wieland, Jr., provided assistance well beyond the call of their positions and brought us needed comic relief. It was a pleasure to work with Ellen Dugan, chief curator of education, on the production of the videotape made in conjunction with this exhibition. I thank the following staff members for their specific efforts on this project: Anna Bloomfield, assistant to the curator for research; Jody Cohen, associate registrar; Sue Deer, director of communication and marketing; Linda Dubler, curator of film and video; Francis Frances, registrar; Leah Greenberg, development associate, grants; Marjorie Harvey, manager of exhibitions; Maureen Marks, merchandise manager; Jack Miller, librarian; Joy Patty, curator, adult programs, education; Nancy Roberts, chief art handler, and art handlers Mickey Clark, Evan Forfar, Mike Jensen, Jim Waters and Steve Woods; Betty Sanders, development associate, corporate support; Jane Scroggs, marketing coordinator, membership; Suzanne Stedman, manager of special events and group sales; Naomi Vine, associate director, programs and curatorial affairs; Amanda Woods, assistant editor; and Midge Yearley, public relations associate.

We are particularly grateful to Bonnie Clearwater, former executive director, art programs, and Lisa Lyons, current director, art programs, of the Lannan Foundation for their generous early support of this exhibition, without which it could not have been undertaken. We also deeply thank the National Endowment for the Arts, whose subsequent funding allowed the presentation of this exhibition and whose patronage of contemporary art exhibitions has contributed so greatly to the vitality and the diversity of the arts in this country.

S.K.

INTRODUCTION

Lynda Benglis's art has always stood in oblique opposition to mainstream concerns. Although her work is firmly rooted in the issues of its times, Benglis has rebounded off the popular critical path, preferring a position of contradiction that refuses easy historical typecasting. Her interests are eclectic and often unexpected; she has liberally encompassed influences as diverse as the work of Barnett Newman and Andy Warhol. When she moved to New York in 1964, she landed in the midst of a particularly explosive art scene, at a particularly political time. She was immediately confronted by divergent yet equally pivotal artistic forces—the brashness of pop art, the reigning Greenbergian critical court, the inspiring, heroic personalities of abstract expressionism and the advent of a heady minimalist aesthetics that brought a radical new focus to sculpture. Her work emerged in forthright response to this crossroads of possibilities and was fueled by the rebellious social changes of the period, by the burgeoning women's movement and by her predilection for independence and provocation.

Benglis rejected the rigor, anonymity and intellectual control characteristic of minimal and conceptual art, and her early works countered the remoteness of the static, minimalist objects that held sway in the mid-1960s. Although well-versed in philosophy (which she had studied as an undergraduate) and interested in current aesthetic theory, Benglis worked empirically; the cool, deductive procedures and exclusive theoretical stance so typical of the period were alien to her experimental nature. Her art—with its often ambiguous organic imagery—was anomalous, enigmatic in appearance and awkwardly expressionistic, even compared to the work of other so-called post-minimalists and process artists who similarly were working away from the minimalist corner (such as Eva Hesse, Richard Tuttle, Bruce Nauman, Barry Le Va and Alan Saret). Benglis eschewed emotional strictures, rationalist strategies and a priori systems. Instead she pursued the idiom of abstraction and the possibilities of illusion from the viewpoint of a female working in a distinctly muscular and traditionally male medium—and as a former painter. At a time driven by a penchant for fabrication and geometry, Benglis remained firmly committed to making images, albeit by the most untraditional means. In the process, she helped to invigorate the vocabulary of sculpture by incorporating elements of decoration and lyricism, as well as anthropomorphic, feminist and naturalistic references—aspects that some twenty years later have proven of primary importance for a younger generation of sculptors.

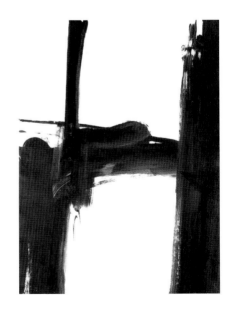

Fig. 1: Franz Kline, *Black and White No. 2*, 1960, oil on canvas, 79½ x 60¾ inches, Archer M. Huntington Art Gallery, The University of Texas at Austin, lent by Mari and James Michener.

Whereas her minimalist colleagues adamantly rejected the subjectivity and often aggrandized emotionalism of abstract expressionism,[1] Benglis felt a strong affinity for such individualistic and gestural work, which she had first become familiar with as a student, after seeing Franz Kline's work at The Isaac Delgado Museum of Art in New Orleans in 1960 (fig. 1). As a young painter, Benglis held that "Painting very figuratively and expressionistically *was* the solution."[2] Like many artists of her generation (many of whom were also trained as painters),[3] she was attracted to the gestural abstract painting that had been largely out of favor in the late 1950s and early 1960s.[4] Benglis carried

the tactility, dynamics and materiality she responded to in the work of Jackson Pollock and Kline as well as the theatricality she admired in Mark Rothko's work into the medium of sculpture: she freed the abstract gesture and suspended it in a dramatic expanse of space. Benglis simultaneously looked to the later stained canvases of Morris Louis and Helen Frankenthaler, with their liquescent images. As she explained:

> [My work] had to do with the relationship between different kinds of materials, and imbuing those materials and images with certain kinds of feelings. Whereas the minimalists were quite proud of the fact they could go out and order their materials, and conceive of the work totally in advance, I thought of myself even then as being related to the expressionists, and although some of my friends were minimal artists, I wanted to go as far away from that as I could.[5]

Benglis clearly believed in the validity of, and the need for, touch and authorship. Abstract expressionism served as a kind of patrimony that gave permission to assert emotionalism and spontaneity, and to be passionately involved with one's materials. It was an authority to which she was clearly bound and indebted, yet whose virility and profundity she instinctively rebelled against. Benglis positioned herself in relation to this looming and distinctly male modernist tradition, and soon coopted it. Her early poured polyurethane environmental installations of 1970-71 were adventurous, aggressive exploitations of process, materials and sweeping expressionist gesture. Their plastic, often gaudy-colored surfaces and overblown scale were a parody through which Benglis engaged in a vital yet witty dialogue with the heroic painterly heritage of abstract expressionism. With these excessive, colossal simulations of the revered autographic gesture, she caricatured the sanctity of abstract expressionism and undermined its tragic, ponderous side, while simultaneously capitalizing on its raw physical and emotive power.

Benglis's relationship to this heritage was complex and hardly unilateral. She was motivated by a desire to express—through expansive, sculptural equivalents—the phenomena and forces of nature, and indeed sought a virtual "chemical" involvement with her materials.[6] Her intentions, as such, were closely tied to the romantic side of abstract expressionism and reflect similar fundamental affiliations with nature, landscape and the sublime. Benglis was equally influenced, however, by her contemporaries' investigations of perception and of spatial experience. Her interests remained primarily perceptual and emotional rather than spiritual in orientation; she strove to convey a heightened sense of the moment—of temporality rather than timelessness.

For Benglis, the self she wished to express through abstraction was not linked to the collective, universal unconscious, or subsumed into metaphysical experience, as was the case for the previous generation of artists: it was rather a socialized self, seen in relation to the artist's public as well as inner being. The heroic personae of the artists of the abstract expressionist generation who were her mentors, in fact, affected Benglis as much as did their work. Benglis met Barnett Newman in 1964, and their discussions and his personage were of enduring importance to her: "*He* was grand. So the work in a way I thought of as grand. . . . "[7] Expressionism, for her, always encompassed a keen sense of the artist as actor. Artistic identity, as mirrored through her art, thus became a composite reflection, defined in large measure by extrinsic cultural and media factors, and seen from the perspective of a period of major transition, when there was a great deal of self-consciousness attached to being both female and an artist.[8]

Regardless of the perhaps typically post-modern complications inherent in her position, Benglis nonetheless inherited from her painterly allegiances a funda-

mental belief in the traditional romantic role of the artist—a characteristic that undercuts the intellectual orientation of even the most visceral and organic work of the period. This poetic, expressionistic position was idiosyncratic, as were her dedication to pursuing formal issues and her emphasis on the unadulterated, primal pleasures of visual experience. Thomas Hess summarized her consciously updated romanticism:

> Benglis's concern with making soft things hard while preserving their insouciant memories of softness may or may not have something to do with feminism, phallicism, and other politico-sensualities. She is more concerned, I think, with the Romantic concept of the artist as a force of Nature. Nature can change states—freeze water, melt rocks; Benglis, too, can congeal or liquefy matter—and in the process make sculpture as calculated, precise and refined as icicles.[9]

Benglis's art is most often grouped critically with process art of the late 1960s and early 1970s, and is similarly affiliated with an emphasis on materials, methods and sculpture as "displayed act" rather than as defined object.[10] Although the eccentricity of Benglis's materials and of her techniques seemed overwhelming at the time, elevating process to the stature of subject matter was never her main objective. The "object quality" of her work was often overlooked, as were her strong ties to the attitude of pop art. The "freedom of pop artists" was exemplary for her and contributed to her catholic range of subject matter and her often perverse use of materials. Benglis's plastic, "superreal surfaces"[11] and cosmetic colors have a cheap, synthetic look and a vulgarity aligned with pop art's sense of irony and transgression. Her affinity for the democratic and renegade nature of pop, however, translated into a personalized process and imagery dramatically unlike the deadpan, corporate visions of the pop artists. Although she eschewed pop's specific iconography, Benglis similarly elevated aspects of low art and vernacular culture into the otherwise rarified realm of modernism, into which everyday life had rarely intruded.

Benglis has consistently been fascinated by issues of cultural context and by visual displacement: she has assimilated elements of decoration and kitsch with her more conventional formal interests in surface, light, volume and planarity. In doing so, she violated the decorum of the mainstream avant-garde, which looked askance at such coquettish interest in raucous color, glitziness and the fashions of commonplace objects. Benglis's gargantuan plastic waves and her slick, lipstick-colored wax paintings, for example, were in part about inherent contradictions and irreverent references. "Each piece," she explained, "is a series of ironies. It's organic looking, but it's plastic. The plastic itself is repulsive, but the form isn't."[12] Benglis shared pop artists' desire to disturb canonical modernism, to connect art more directly and lightheartedly to human experience. There is often an undercurrent of playful, fetching humor in her art which, along with her emphasis on sensory pleasure, offered a release from the self-seriousness and puritanical aloofness of minimalism and of much other "anti-formalist" sculpture.

Over the past twenty-odd years, Benglis has worked with a wide variety of difficult media—polyurethane, latex, wax, glass, metals, gold leaf, chrome, welded steel, neon and video—and pushed them to new ends. Her flamboyant methods of pouring, knotting and pleating sculptural forms have become the stylistic signatures of her art. Her work, however, remains rooted in her experience as a painter. She considers herself primarily concerned with pictorial issues,[13] which she has reinterpreted in more immediate three-dimensional form. Most of her work is meant to be viewed in relief, in relation to the floor or the wall, with which she establishes a very theatrical (and mockingly formalist) figure/ground relationship: her objects consistently read as images

staged in an expanded field. Benglis often compounded her exploration of illusion and metaphor with further suggestions of narrative context, invoking painterly conventions widely disparaged at the time.

Benglis thus firmly rejected the critical classification of her work as "process" art and the limitations implied therein. "I am not involved with just process," she declared in 1969. "I am involved in all the associations with material."[14] A decade later, she separated herself more adamantly:

> I was making an image; I wasn't involved with a process that could be labeled "process" one, two, three. I wasn't involved with "process" at all. Nor alluding to it. You have to remember that many of the artists who were involved with "process" were involved with an enclosed deductive system of logic. I've always been involved with the idea of induction in logic, an open-ended system, not a closed system. In other words, I think the so-called "process artists" had definite steps and that the process and the work were one. The process could not be clearly read in any of the works that I've done. The process always was hidden. The process was transformed by the image. I have always been interested in imagery.[15]

Regardless of the pictorial premises of her art and her atypical insistence on content, the parallels between Benglis's work and that of her peers are revealing. Process art and minimalism, however different, shared an interest in spatial experience, in focusing the viewer's physiological response and perception and often in the participatory, mental reconfiguration of the act of creation. Sculpture of this diverse and experimental period ranged from shamanistic to industrial in appearance, from wildly organic forms to austere geometric objects. The human body, however, was often the measure of much of this work. The viewer's visceral response to form and material (for which the critic Lucy Lippard aptly borrowed the psychological term "body ego"[16]) was the underlying content of much contemporaneous non-representational art. For example, Robert Morris (with whom Benglis later collaborated) expressed his need to relate abstract work to the human body not through figurative allusion (by which he thought the medium of sculpture had been "terminally diseased"[17]) but rather through scale, placement, modes of perception and the method by which the object was generated. His practices are reflected in works such as *Untitled*, 1969 (fig. 2), a felt piece with a distinctly skin-like surface and a powerful sense of the pull of gravity.

Benglis's means of evaluating and exploring form has always been primarily experiential and kinesthetic: her work is based on the body and an accumulated knowledge that is derived sensorily rather than deliberated intellectually. Although she was generally attuned to her colleagues' interest in Gestalt psychological theory, her work grew from an intuited desire to explore and to evoke bodily responses, postures and primal physical sensations. Morris's critical writings, of which Benglis was very much aware,[18] clarify the similarly intrinsic figurative reference points of contemporaneous sculpture:

> I feel a lot of information is somehow kinesthetic and it acts not imagistically, but more in terms of possibilities. I think that is what is different between a sculpture and a building. You don't feel that a building has anything to do with your body except in terms of scale, but an object has a lot to do with it because it was made by a body. Or it has something to do with the possibilites of a body operating on things directly. I'm very much involved with that relationship toward things that has to do with the body's response, that set of relationships toward mass and weight as well as scale.[19]

Fig. 2: Robert Morris, *Untitled*, 1969, felt, 125 x 72 x 55 inches, collection of High Museum of Art, Atlanta, purchase with funds from Edith G. and Philip A. Rhodes.

Fig. 3: Bruce Nauman, *Untitled*, 1965, fiberglass, 83 x 8 x 83 inches, collection of Gerald S. Elliott, Chicago.

Morris posited that we "see" and know space and form primarily through the vehicle of our bodies; Benglis's art is, moreover, accountable to the body at the stage of inception as well as that of perception. The width and height of her first wax paintings of 1966-67 approximated those of her body, and she

thought of the holes in them both as formal devices to break the picture plane and as suggestive orifices.[20] Her wax lozenges of the early 1970s are "arm's length"; the width of the tubing of her subsequent series of knots corresponds roughly to that of her arm; her gold torsos approximate human scale. These hidden modules, organic in origin, were means through which to generate and to legitimize the abstract image.[21] A similar use of bodily dimensions to orient form is reflected in Bruce Nauman's objects of the mid-1960s, with which Benglis's early works have strong parallels. As critic April Kingsley noted, "Nauman's involvement with his own body—with its lanky tubularity—provides much of the content of his work."[22] His cast fiberglass pieces, for example, were based on the positions (leaning, standing, bending, squatting, sitting, etc.) he held during a performance piece at the University of California at Davis in 1965 (fig. 3).[23] Related impetuses generated neon pieces based on templates of his body and works such as *Collection of Various Flexible Materials Separated by Layers of Grease with Holes the Size of My Waist and Wrists*, 1966 (fig. 4). In these works, as in numerous others of the period, specific references to the body gave a rationale to abstract form, and imparted a certain pretense of accessibility.

From her first wax paintings to her recent billowing metalized reliefs, Benglis's work has been perpetually tied to the body—to its forms, animation, sensory responses and biological nature. The body—how it perceives and is perceived—is her constant reference point. Her use of the body is never consciously phenomenological in origin (as was Nauman's, for example), yet is generally related to concurrent widespread interest in Maurice Merleau-Ponty's theories of behavior, and particularly to his tenet that "Man *is*, in fact, his body, despite the essential ambiguity of its being at once lived from the inside and observed from the outside."[24] As Merleau-Ponty associated perceptions of "visual and tactual sensations" with "the internal experience of desires, emotions and feelings,"[25] so, too, has Benglis seen the physical properties of her work as carriers for such intimate expressions.

It is critical to Benglis's art that the body consistently referred to and experienced through is female. The female body could not stand in mutely as a conceptual prop or serve as an objective artistic tool, as it could for many of her male colleagues. When excised from its expected place as a passive subject (in the hands of male artists), the female body was automatically politicized and sexualized, and subtly taboo in a still sexist territory. Benglis's dual sense of the body's internal, felt being and its external observation and objectification by (presumedly male) others—the cognizance of being seen that permeates her art—was colored by her acute awareness of social facades, assumed gender roles and body language. As a southern woman, then recently graduated from an elite women's college to the primarily male art scene of New York (via the Yale-Norfolk Summer School), she was perhaps inordinately aware of these dichotomies and increasingly inclined to manipulate them.

Given the anthropomorphic orientation of much process art, and the rise of performance art and the women's movement (with its early emphasis on "liberating" sexuality), these loaded issues were naturally confronted by women artists at the time. Benglis's work (like that of Eva Hesse) was thus "marginalized" from that of her male colleagues.[26] Her works have a surreal sensuality and suggestive connotations: their materials and forms are often vaguely eroticized. In her sculpture, Benglis addressed issues of sexuality through physicality. In her videotapes and print advertisements, such content is made explicit and is approached more conceptually. As Peter Schjeldahl wrote:

> Benglis' seems to me an "erotic" art, an art in touch with the roots of
> various sexualized sensation, emotion and fantasy. Her works invite rec-

Fig. 4: Bruce Nauman, *Collection of Various Flexible Materials Separated by Layers of Grease with Holes the Size of My Waist and Wrists*, 1966, aluminum foil, plastic sheet, foam rubber, felt and grease, 1½ x 90 x 18 inches, collection of Harry and Linda Macklowe.

ognition, whether in the mind or at the fingertips or in the gut, or sensual feelings that might be mild and pleasant or wrenching and grotesque, but are in any case humanly true. After all, disgust no less than desire is an erotic emotion. . . .[27]

Eroticized abstraction was hardly exclusively female territory. Both Benglis and Hesse, regardless of the great differences in their art, note the strong influence of Claes Oldenburg, in particular the tactility of his early work, his ability to turn "material and subject matter inside out"[28] (which intrigued Benglis), and the undercurrent of sexuality in his work. Hesse summarized his content: "As eroticism, his work is abstract. The stimuli arise from pure sensation rather than direct association with objects depicted."[29] In doing so, Hesse aptly characterized the sensory effects of much art involved with materials and process.[30] Yet the erotic edge of work by women such as Hesse and Benglis was often distinguished by its psychological closeness and by the unexpected (perhaps distinctly female) sense of intimacy and vulnerability at times communicated by these objects.

Explorations of issues of sexuality and gender, although integral, were not initially the motivating factors of Benglis's work, as they indeed have been for a subsequent generation of women artists. Her imagery, rather, evolved intuitively as she explored process, materials and abstract, naturalistic imagery from a female vantage point. Benglis proceeded from internal imperatives, rather than from cohesive theory, as had the women's movement in its early stages: the issue of gender, as it influenced her content and imagery, was implicit. She consciously was driven by traditional, formal decision-making, and a desire to explore painterly surface and abstraction from a highly personal and material point of departure. Louise Bourgeois's comments explicate such an internalized attitude:

> I am not particularly aware, or interested in, the erotic in my work. . . . Since I am exclusively concerned, at least consciously, with formal perfection, I allow myself to follow blindly the images that suggest themselves to me. There is no conflict whatsoever between these two levels.[31]

Benglis similarly declared, "Content grows out of form. Having an iconographic content can give me a form—say feminism, say Pop."[32]

Benglis thus saw herself as an artist working within and in answer to the traditions of modernism, not out of pointed political response. Although compelled by the pressing questions raised by Linda Nochlin's pivotal article "Why Have There Been No Great Women Artists?"(1971) and one of eight women artists invited by *ARTnews* to reply,[33] Benglis, in fact, reacted with "frustration and anger" to the self-conscious encampment of the feminist movement[34] and rejected its communal nature. Regardless, her potent use of alternate materials, decorative elements and domestic, typically "female" color is related to the validation of such issues through the women's movement, which was instrumental in the resurgence of personal subject matter and psychological content in art of the early 1970s. Unlike many of her contemporaries, however, she did not delve into the universal psychological nature of femaleness, but instead focused primarily on its externalized manifestations. Benglis did not want to be segregated as a "woman artist." She preferred to situate herself independently, and purposefully competed within the context of the male art world, against which she identified and measured herself (as did many women of her generation).[35]

Consequently, the subject of sexuality as presented in Benglis's sculptures, videotapes and advertisements over the years has frequently troubled critics. On one hand, Benglis seemed to play wantonly with a stylized self-objectifica-

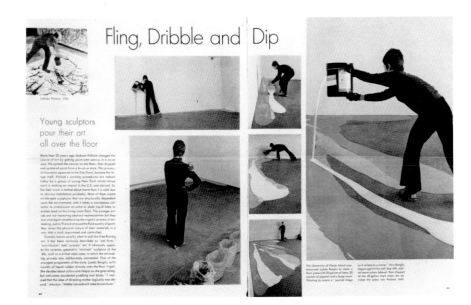

tion contrived to provoke and undermine the dominant male art world, often by speaking through their terms and images. In other works, she challenged hardline feminist politics of the time[36] and toyed with the images of a retrogressive (and politically incorrect) prom-queen variety of femininity. Benglis reveled in the ambiguity of the era and refused specific location. Her intentions and her politics were often hard to decipher: was she ultimately assuming a role of complicity or criticality? Benglis pursued her own brand of feminist inquiry—one that underhandedly addressed issues of power, desire and femininity—in ways that often conflicted with the accepted practices and dogma of the women's movement at the time.

Benglis was one of a handful of women artists recognized by the art press, and was acutely aware of being singled out as such. As an emerging artist, she received a rather stunning amount of critical attention over a very short period of time. She produced six major environmental installations around the country between February and November of 1971. Her work was included in no fewer than fifteen one-artist shows and over fifty group shows from 1969 to 1974. At the start of all this activity, she was prominently featured (along with Richard Serra, Eva Hesse and Richard Van Buren) in *Life* magazine in February of 1970. The article, "Fling, Dribble and Dip" by David Bourdon, was illustrated with dramatic photographs of the artists in the throes of creation. Benglis was pictured pouring a latex floor piece: in the layout, images of her were juxtaposed with one of Hans Namuth's famous 1950 photos of Pollock in action—no small comparison for an artist not yet thirty years old (fig. 5).[37] In 1974, she received another jolt of publicity in a cover article in the *New York Times Magazine*, "The Art of Survival (and Vice Versa)."[38] Confronted with this intense exposure and the ensuing notoriety, Benglis reacted to such media attention by playing with it.

Increasingly conscious of the arbitrariness and distortions of the media's focus, Benglis began to "think about who the artist was in relationship to the object/ work."[39] Public personae became a subject of her work, as she explored role-playing and the notion of inhabiting media formats: in the process, Benglis addressed the sexual self-consciousness of the time and the now prescient feminist topic of masquerade. She did so most visibly in her announcements and series of advertisements for her exhibitions, but also in everyday life. She recounts, for example, that she cropped her hair, dyed it orange and dressed

Fig. 5: Opening layout of "Fling, Dribble and Dip" by David Bourdon in *Life*, 27 February 1970. Photos by Henry Grosinsky. Reprinted with permission of *Life* magazine, © Time Warner Inc.

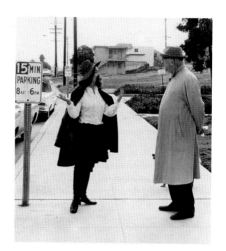

up theatrically throughout the early 1970s—being "punk" before there was punk.[40] Her alterations of her identity must be seen both in light of her continuing dialogue with a primarily male coterie, and in relation to the widespread practice of such role-playing in concurrent works and performances by artists such as Eleanor Antin, Hannah Wilke, Dottie Attie, Martha Rosler and numerous others (fig. 6). For Benglis, personal facade became exchangeable. She manipulated female identity and investigated it as an acculturation, in part determined through and dressed up for the eyes of others—seen constantly through the mirror of an audience. In this sense, Benglis's practices foreshadow those of theoretically oriented feminist artists of the 1980s interested in subverting the dominant male "gaze" by which women historically have been pictured. With her mocking, cathartic forays into this realm, Benglis also brought the macho, mythological cult of artistic personality down to earth and out to the street.

Benglis's art has embodied many contradictions and, because of its variety and openness, has posed difficulties for critical interpretation. She has explored the suspect arena of decoration and has insisted on the role of embellishment and pleasure in art, a focus that has been largely marginalized, regardless of the short-lived "pattern and decoration" movement. Benglis has always been fascinated by the edge between attraction and repulsion, between high art and kitsch, between vulgarity and beauty (the latter of which is a concept alien to modernism in general and rarely invoked in discussions of contemporary art). She has traveled into unfashionable and anti-intellectual aesthetic territory. As a result, Benglis's art at times has been dismissed as ornamental—widely considered an inferior and decadent pleasure. As Pincus-Witten noted, her "spangle and sparkle, the powdered metallic dusts are a kind of infantile and magical coloration that violates 'adult' notions of taste and artistic decorum."[41] Yet Benglis mined the tawdry visual effects of commercial culture with the urge to "question what vulgarity is. Taste is context."[42] Her exploration of such questions and her interest in material and cultural artifice then had a critical price to pay. In retrospect, however, Benglis's concerns now appear to parallel current aesthetic interest in probing notions of display and consumerism as well as hybridization.

In 1966, Dan Flavin prophesied:

> I believe that art is shedding its vaunted mystery for a common sense of keenly realized decoration. Symbolizing is dwindling—becoming slight. We are pressing downward toward no art—a mutual sense of psychologically indifferent decoration—a neutral pleasure of seeing known to everyone.[43]

Benglis's art has proven otherwise. She has asserted the importance of this "pleasure of seeing," yet has compounded it with the vitality of expressionism and invested it with a psychological edge by assimilating cultural issues into abstract art. Benglis has thus flown freely between cultural and historical reference points: she has persistently refused an intellectualized cohesiveness or singularity, and her art has alternated between the romantic and the ironic. At times, she has responded to a primal sense of nature, at times to the perplexities of contemporary culture. Her art is at once reactive and proactive. As she asserted her sensibility within the heroic male playing field of modernist abstraction, Benglis has leavened and brought new meaning to that territory.

Fig. 6: Scene from Eleanor Antin's performance *The King of Solana Beach*, 1972.

1. Barbara Rose, "ABC Art," *Art in America* (New York) 53, no. 5 (October 1965): 61. Benglis reacted to the austerity of the work discussed in Rose's seminal article and in conversation repeatedly cites her sense of the limitations of such "ABC Art." She rejected "thinking that [you could] set up a couple of propositions and a 'therefore' and then it became art." See author's interview with the artist, 30 October 1989, East Hampton, New York, transcript in HMA files.

2. Quoted in interview with Ned Rifkin in Lynn Gumpert, Ned Rifkin, and Marcia Tucker, *Early Work* (New York: The New Museum, 1982), 7.

3. Such as Nauman and Hesse. See Lucy Lippard, "Eccentric Abstraction," *Art International* (Lugano, Switzerland) 10, no. 9 (November 1966): 28.

4. For an overview of the period, see Robert Pincus-Witten, "The Seventies," in *A View of a Decade* (Chicago: Museum of Contemporary Art, 1977), 20.

5. Quoted in interview with Robert James Coad in *Between Painting and Sculpture: A Study of the Work and Working Process of Lynda Benglis, Elizabeth Murray, Judy Pfaff and Gary Stephan* (Ann Arbor, Michigan: UMI Dissertation Information Service, 1988), 243 (copyright 1983).

6. Rifkin: 8.

7. Author's interview with the artist, 26 October 1989, New York, transcript in HMA files.

8. Benglis recalls, for example, being told by her teacher Jack Tworkov at Yale that being a woman artist was "just too difficult—there [are] too many obstacles." See Calvin Tomkins, "Righting the Balance," in *Making Their Mark: Women Artists Move into the Mainstream, 1970-85* (New York: Abbeville Press, 1989), 46.

9. Thomas Hess, "Review," *New York Magazine* (New York) 8, no. 49 (8 December 1975): 114.

10. James Monte, "Anti-Illusion: Procedures/Materials," in *Anti-Illusion: Procedures/Materials* (New York: Whitney Museum of American Art, 1969), 7. The Whitney exhibition was the primary summary of such process-oriented work, following the initial introduction of "anti-formalist" art by Lucy Lippard in *Eccentric Abstraction* at Fischbach Gallery in September 1966. Her ideas are summarized in the article "Eccentric Abstraction," *Art International* (Lugano, Switzerland) 10, no. 9 (November 1966): 28, 34-40. Benglis's work appears in the catalogue of the Whitney show; it was to have been included in the exhibition, but was withdrawn when it could not be shown as Benglis wished. See Richard Armstrong, "Between Geometry and Gesture," in *The New Sculpture 1965-75* (New York: Whitney Museum of American Art, 1990), 12-18, for an analysis of process art and a summary of the pivotal exhibitions and developments of the period.

11. Artist's voice-over in the videotape *Lynda Benglis Paints with Foam (Totem)* by Ann McIntosh and Don Schaefer (Cambridge, Massachusetts: Video/One Production, 1971), black and white, 27 minutes, sound.

12. Quoted in Douglas Davis, "The Invisible Woman Is Visible," *Newsweek* (New York) 78, no. 20 (15 November 1971): 130-31.

13. Jeremy Gilbert-Rolfe, "Reviews: Lynda Benglis," *Artforum* (New York) 12, no. 6 (March 1974): 69.

14. Artist's statement in *Art in Process IV* (New York: Finch College Museum of Art, 1969), n.p.

15. "Interview: Linda [*sic*] Benglis," *Ocular* (Denver) 4, no. 2 (Summer 1979): 36, 40.

16. Lippard, "Eccentric Abstraction," 34.

17. Robert Morris, "Notes on Sculpture, Part IV: Beyond Objects," *Artforum* (New York) 7, no. 8 (April 1969): 51.

18. Long before Benglis knew Morris, she made her first poured polyurethane corner piece, *Untitled (King of Flot)*, 1969, "for" Morris, in reference to the critical ideas he espoused in articles such as "Anti Form," *Artforum* (New York) 6, no. 8 (April 1968): 33-35, and "Notes on Sculpture, Part IV: Beyond Objects," *Artforum* (New York) 7, no. 8 (April 1969): 50-54, which was published around the same time this piece was made. "I always called it *Untitled* because of its sort of secret title, and then in parentheses it was 'King of Flot'—[in reference to] flop art." This piece was later cast in lead and titled *Quartered Meteor*, 1975. Author's interview with artist, 30 October 1989.

19. Quoted in E. C. Goossen, "The Artist Speaks: Robert Morris," *Art in America* (New York) 58, no. 3 (May-June 1970): 105.

20. Rifkin, 10.

21. Author's interview with the artist, 30 October 1989.

22. [April Kingsley], "Reviews," *ARTnews* (New York) 72, no. 5 (May 1973): 89.

23. Jane Livingston, "Bruce Nauman" in Livingston and Marcia Tucker, *Bruce Nauman: Work from 1965-1972* (New York: Los Angeles County Museum of Art and Praeger Publishers, Inc., 1973), 11.

24. Marcia Tucker, "PheNAUMANology," *Artforum* (New York) 9, no. 4 (December 1970): 38. See also Maurice Merleau-Ponty, *The Structure of Behavior*, Alden L. Fisher, trans. (Boston: Beacon Press, 1963).

25. Merleau-Ponty, *The Structure of Behavior*, 156.

26. Marcia Tucker, "Women Artists Today: Revolution or Regression?," in *Making Their Mark: Women Artists Move into the Mainstream, 1970-85* (New York: Abbeville Press, 1989), 197.

27. Peter Schjeldahl, "Lynda Benglis: Body and Soul," in *Lynda Benglis: 1968-1978* (Tampa: University of South Florida, 1980), 4.

28. Quoted in Robert Pincus-Witten, "Lynda Benglis: The Frozen Gesture," *Artforum* (New York) 13, no. 3 (November 1974): 55. Although she did not know her well, Hesse was an important example for Benglis (she was introduced to Hesse and her work through Sol LeWitt). Benglis was moved by the materiality of Hesse's work and recalls asking Hesse her thoughts on feminism and on being a woman artist (which Hesse dismissed). Hesse, on the other hand, was disturbed by Benglis's flagrant use of color. Author's interview with the artist, 29 October 1989, East Hampton, New York, transcript in HMA files. Hesse's attitude about decorative elements was emphatic:

 > I don't want to even use this word [decorative] because I don't want it to be used in any interview of mine, connected with my work. To me that word, and the way I use and feel about it, is the only art sin. I can't stand gushy movies, pretty pictures and pretty sculptures, decorations on walls, pretty colors, red, yellow, blue, nice parallel lines make me sick. . . .

 Quoted in Cindy Nemser, "An Interview with Eva Hesse," *Artforum* (New York) 8, no. 9 (May 1970): 63.

29. Robert Pincus-Witten, "Eva Hesse: Post-Minimalism into Sublime," *Artforum* (New York) 10, no. 3 (November 1971): 39. Hesse here repeats Lucy R. Lippard's assertion in "Eros Presumptive," *The Hudson Review* (New York) 20, no. 1 (Spring 1967): 95. See also Nemser, "An Interview with Eva Hesse," 59.

30. See Lippard, "Eros Presumptive," *The Hudson Review*: 91-99.

31. Quoted in Deborah Wye, "Louise Bourgeois: One and Others," in *Louise Bourgeois* (New York: The Museum of Modern Art, 1982), 27.

32. Robert Pincus-Witten, "Lynda Benglis: The Frozen Gesture," *Artforum*: 57.

33. First printed in *Woman in Sexist Society: Studies in Power and Powerlessness*, ed. Vivian Gornick and Barbara Moran (New York: Basic Books, 1971), 480-510. Nochlin's article was widely known from its reprint in *ARTnews* (New York) 69, no. 9 (January 1971): 22-29, 67ff. In the same issue, Benglis responded with "Social Conditions Can Change," in "Eight Artists Reply: Why Have There Been No Great Women Artists?," 43.

34. Rifkin, 9.

35. In the late 1960s, while married to the painter Gordon Hart and just beginning her own career, Benglis was exasperated at being identified first as an artist's mate rather than as a serious artist in her own right. See Rifkin, 9: "It was assumed the man was the artist and I wasn't." She entered the male-dominated realm of sculpture with a self-styled aggressiveness that contrasted with and complicated the overt delicacy of much of her work.

36. For an overview of the period, see Alice Echols, "The Taming of the Id: Feminist Sexual Politics, 1968-83," in *Pleasure and Danger: Exploring Female Sexuality*, ed. Carole S. Vance, (Boston: Routledge & Kegan Paul, 1984), 50-72.

37. [David Bourdon], "Fling, Dribble and Dip," *Life* (New York) 68, no. 7, (27 February 1970): 62-63.

38. Vivien Raynor, "The Art of Survival (And Vice Versa)," *The New York Times Magazine*, 17 February 1974, sec 4: cover, 8-9, 50, 52-55.

39. Rifkin, 14.

40. Author's interview with the artist, 30 October 1989. See also Jane Livingston, "East Meets West . . . again . . . and again," in *Shift: LA/NY* (Newport Beach, California: Newport Harbor Art Museum, 1982), 16.

41. Pincus-Witten, "Lynda Benglis: The Frozen Gesture," *Artforum*: 59.

42. Ibid., 55.

43. Dan Flavin, "some remarks . . . excerpts from a spleenish journal," *Artforum* (New York) 5, no. 4 (December 1966): 27.

LYNDA BENGLIS: THEATRES OF NATURE

Lynda Benglis's small walk-up studio on The Bowery, where she has worked since 1977, now functions primarily as her staging ground. A few of her earlier works are hung casually on the wall, along with occasional pieces by longtime colleagues: African masks and sculptures and curious statuettes clutter the mantel. Lying around the room in various nascent, knotted stages are the pleated lengths of fine wire mesh that will become armatures for her current works. The studio is a point of reference and a place of preparation, where ideas are harbored and allowed to germinate; Benglis typically proceeds from an embryonic image held in the mind's eye and deliberated over the course of many months. No matter how difficult her materials and industrial techniques, she never works from preliminary drawings or plans. She has always been an empiricist. Her art takes shape and life essentially through the process of laboring with materials, which at this point occurs largely on location at fabricators, small factories and workshops, principally in California, Louisiana and India and wherever new opportunities arise.

For Benglis, image, process and material are inextricably linked. "I like to work in a way that the image flows out of some information about the material itself," she declares.[1] "There is a tension in the forms as the materials are pushed to their limits."[2] This tension and the dynamic intensity that she invests in the act of making have infused her art with a potent theatricality. Despite the diversity of Benglis's interests over the course of the past twenty-five years, this immediacy and astute unification of form and content have remained the constants of her art.

Benglis began as a painter, in search of radical new means of creating metaphorical and psychological statements that had the drama and simplicity she so admired in the work of Franz Kline, Jackson Pollock (fig. 7) and other

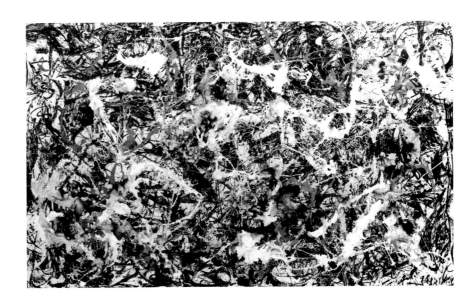

Fig. 7: Jackson Pollock, *Convergence*, 1952, oil on canvas, 93½ x 155 inches, collection of Albright-Knox Art Gallery, Buffalo, New York, gift of Seymour H. Knox, 1956.

abstract expressionists. By the time she left The Brooklyn Museum Art School, however, she had become dissatisfied with the "scale of the paint" and the "insistence" of the canvas support: "It was non-functional, ugly and kind of bizarre. . . . I began to really dislike canvas. . . . the thickness, the weave and the clumsiness of it."[3] After a brief and disillusioned respite from painting in 1965-66, she initiated a series of wax paintings on masonite (cat. 1, p. 65), proceeding from her desire to make the paint and the image coincident— and to thus rid her work of any semblance of the illusionistic field. Benglis indirectly addressed Greenbergian formal concepts in these works and established a querulous, and inherently revisionist, relationship to traditional pictorial concerns.

At the same time, Benglis strove to become more physically involved with the organic matter of her artistic medium. She began to make her own paint, using melted purified beeswax and various powdered pigments, and to experiment with the limits of its physical properties. Many of her first wax paintings have smooth, uniform surfaces, and are either neutral colors or bright lipstick hues (cats. 2 and 3, pp. 66, 67). Their dimensions approximate the proportions of Benglis's body and the translucence of their thinly glazed surfaces has a distinctly skin-like quality, elements that together foretell Benglis's interest in anthropomorphic references and subtle, highly effecting surface sensuality. Although she is characteristically first motivated by such formal issues, she always invests them with a psychological dimension. These works embody a perturbing tension of concealment: she considered the wax surface "as a skin, a mummified version of painting, as something buried with a dimension that isn't quite perceived upon first glance."[4]

Benglis subsequently exaggerated this quality in her lozenge paintings of 1968, as she built up craggy, topographical accumulations of pigmented wax on supports that measured about her arm's length. She worked over the object on the floor, à la Pollock. Using a brush the same width as the rounded panel, Benglis applied the wax in strokes made upward and downward from a center-line; as the wax dripped over the edges, it completely overwhelmed its support and formed an aggressive surface contradictory to the usual picture plane. The resultant free-floating image looked like two opposing and excessively thick brushstrokes, hovering in space. These wax paintings, with eerie petrified surfaces worthy of Madame Tussaud's, strangely memorialize the autographic brushstrokes of the abstract expressionists, with whom Benglis was strongly affiliated in her thinking. *Untitled* (from the "Pinto" series), 1971 (cat. 7, p. 71), for example, is a clear reference to the bold black and white canvases of Franz Kline, through which she was first introduced to gestural abstraction.[5]

Benglis continued to make these wax pieces intermittently throughout the early 1970s, and they came to have an increasingly imploded sense of energy and symbolism, "like bombshells" or "cocoons."[6] Their texture, color and lip-like imagery are abstractly eroticized: through them, Benglis strongly asserted a female focus and sense of identity fully in step with the burgeoning women's movement. Of their provocative imagery she later declared, "The wax paintings were . . . nutshell paintings dealing with male/female symbols, the split and the coming together. They are both oral and genital. But I don't want to get Freudian; they're also Jungian, Ying-Yang."[7]

Despite the charged, metaphorical twist Benglis brought to these images, they were actually inspired by a little-known blue multiple by Barnett Newman, *Untitled*, 1966 (fig. 8).[8] The paint was applied to the back of Plexiglas, so that the blue is seen through the transparent support and looks strangely encased, as does the color in Benglis's wax paintings. Benglis found the radically slick

Fig. 8: Barnett Newman, *Untitled*, 1966, edition of 125, acrylic on plexiglass, 49 x 5 inches, collection of Annalee Newman, New York.

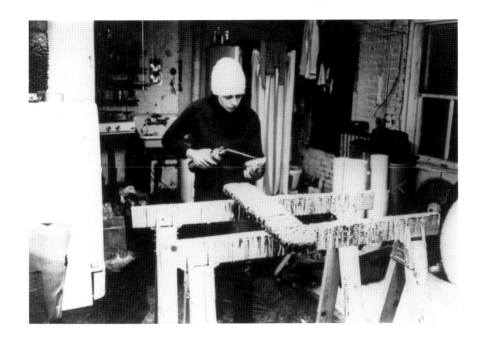

surface and extreme narrowness of Newman's work compelling, like a "kind of Christmas package with a 'zip' down the center."[9] It interested her as a model for the kind of painterly object/image she desired, one that exploited the notion of painterly support without sacrificing nuances of surface and color.

Benglis was especially interested in the iconographic quality of Newman's piece—in its special ability to command a ritualistic presence, which she felt contemporary art had forsaken. She thus strove to create "icons of painting"[10] and to regain a sense of theater absent from the puritan minimalist objects that proliferated in the late 1960s. For the terminology she chose to describe her emblematic sculptures, Benglis was obliged to Dan Flavin, whom she had heard lecture at The Brooklyn Museum Art School in late 1964,[11] and possibly also to her Greek background. In his talk, Flavin discussed his use of the word "icon" in terms of the mystique and aura of his work:

> I used the word "icon" as descriptive, not of a strictly religious object, but of one that is based on a hierarchical relationship of electric light over, under, against and with a square-fronted structure full of paint "light."[12]

Benglis soon exploded the imagery of her iconic wax "bombshells." After a brief experimentation with firing and thus marbleizing their surfaces (fig. 9), she tried, with little success, to let them literally overflow by splashing molten wax directly onto the floor.[13] Benglis then began to pour pigmented latex—a natural rubber—in huge free-form overlapping pools. She was motivated to use the material after she saw Eva Hesse's *Untitled* (model for *Schema*), 1967 (fig. 10) at Sol LeWitt's and responded strongly to the skin-like quality of its molded latex. She explained her intent:

> The two brush-stroke wax paintings and a few fired wax paintings represent the beginning of my involvement with pigmented material and the end of my working on a specific format.

> With the firing of the wax paintings I realized that the idea of directing matter logically was absurd. Matter could and would take, finally, its own form.

> This is the reason I felt it necessary to make in pigmented latex several large paintings that were boundless in form and continuous in imagery.[14]

Fig. 9: Benglis working on a wax painting in her Baxter Street studio, ca. 1972.

Fig. 10: Eva Hesse, *Untitled* (model for *Schema*), 1967, latex, 9½ x 9½ inches, The LeWitt Collection, courtesy of the Wadsworth Atheneum, Hartford, Connecticut.

Benglis's expansive poured latex paintings spread like biomorphic mats on the floor—almost as if they had slid off the canvas. She humorously referred to these objects as "fallen paintings," and later so titled a work of 1968 (cat. 4, p. 68). As much as these works were indebted to the intuitive procedures and intimate involvement with materials characteristic of abstract expressionism and some color field painting, they were also ironic, punning revisions of the formalist figure-ground problem. Benglis took the issue to an absurdist, ultra-logical end: here the paint was literally the figure, and the ground was the actual ground. Simultaneously, she was interested in establishing a wry, pop conflation, in "organic form and synthetic material and in synthetic form and organic material."[15]

One of the earliest of these works, *Odalisque (Hey, Hey Frankenthaler)*, 1969, was done shortly after Benglis saw the retrospective of Helen Frankenthaler's work at the Whitney Museum that winter.[16] It is both a parody of and an homage to Frankenthaler's stained canvases (fig. 11), with their flowing passages of thinly poured paint, through which Benglis continued her own reformatory probing of gestural abstraction. Its title, however, is telling; here Benglis refers to the suggestively reclining, and obviously available, exotic female nude—a traditional subject of European academic painting. Considered in relation to the work of Frankenthaler (one of a few recognized women artists, yet one who has eschewed feminist issues), Benglis's cosmetically colored, lolling latex "odalisque" seems a blatant proposition of femininity and female sensuality, made within the predominantly male arena of modernism. The florid coloration of these works, their tactility and their pervasive biological references are rooted in Benglis's growing interest in sensorial perception—in how we experience the world through the body, and how those experiences are gender-specific:

> I think that there are very different body experiences, for females in particular, and I'm sort of working in this area. I think that males and females are really different . . . because biologically they are different, right? . . . The sex differentiation is an important visual differentiation.[17]

Benglis was interested in extending and amplifying the expressionist tradition in her own terms, while also making reference to the procedures of Pollock and Morris Louis in particular: she, too, worked horizontally over her paintings, allowing herself to be immersed in the field of her image and consumed by the process of coaxing her medium. Like her progenitors, she strove to convey an immediate sense of "nature"—of material organicism and of a specific moment in time:

> I chose natural rubber latex because I wanted a very physical painting that could be viewed and felt. I feel that materials like natural latex have their own time, their own spirit and their own life. I find that in working with such a material of nature, I and the material interact, become sort of one.[18]

The making of these works was no small feat: it involved swinging heavy cans of latex while manipulating the speed and amount of the pours, the viscosity and the pigments to achieve the desired configurations (figs. 12-14). These works (which took about a month to cure) manifest Benglis's consistent interest in fluidity and in using materials that change state yet retain an intuited sense of their original liquidity. Benglis's day-glo works often had a vertiginous effect, as one looked down on the swirling amoebic forms and interwoven skeins of color trapped within their extreme flatness. These kinesthetic effects were a component of her content. In *Bullitt*, 1969 (fig. 15, made of bright orange semi-flexible foam), for example, Benglis wanted to simulate the pit-of-the-stomach, anti-gravity sensation created by the wild roller-coaster car chase in the opening sequence in the movie of the same title.[19]

Fig. 11: Helen Frankenthaler, *Tutti-Frutti*, 1966, acrylic on canvas, 116 x 69¼ inches, collection of Albright-Knox Art Gallery, Buffalo, New York, gift of Seymour H. Knox, 1976.

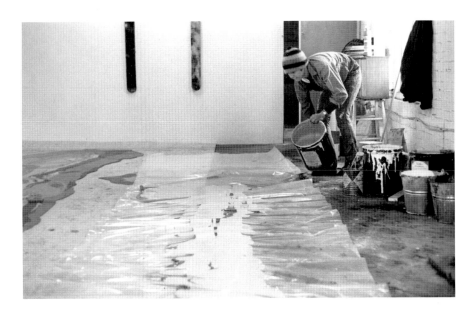

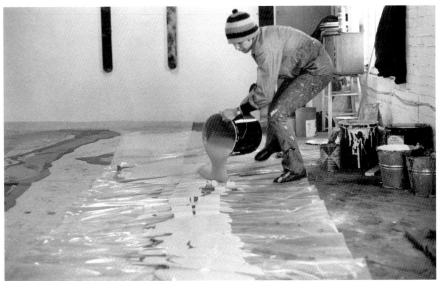

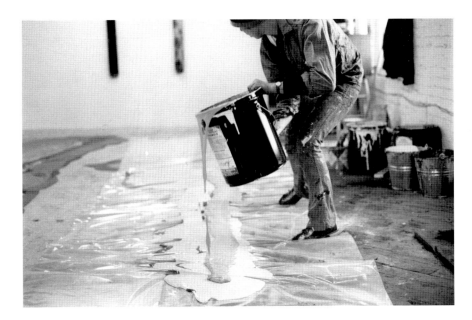

Figs. 12-14: Benglis pouring pigmented latex work in her Baxter Street studio, ca. 1969.

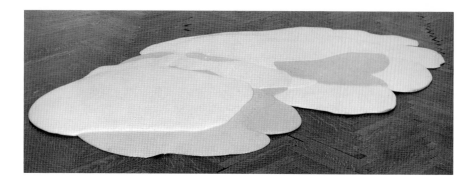

Benglis's imagery has always developed out of her experimentation with various materials, her pursuit of specific sensory effects and of formal issues. Intent on creating a "painterly image that was pure paint matter,"[20] with a greater sense of physicality than latex allowed, she began to explore the possibilities of polyurethane foam. Benglis's first foam works, such as *For Carl Andre*, 1970 (cat. 5, p. 69), were oriented toward the floor or corner; it appeared as if her latex pours had swelled over into a strangely volatile, volcanic eruption. She was interested in subtle physical tensions, for example, the way the buoyant image seemed to hover just over the floor. The scale of these first polyurethane works was roughly human, although they often evoked larger naturalistic formations—huge boulders, oceanic waves and the like.

For Carl Andre is particularly revealing of Benglis's conglomerate interests and of her ability to transpose aesthetic concepts. Regardless of the great disparity between their work, she greatly admired Andre, whom she knew from his visits to Bykert Gallery. "His work presented the material, presented the image; it was one and the same," and Benglis sought "to approach organic form in a very direct way, in the way that he approaches geometric form."[21] In order to do this, Benglis explored the inherent qualities of her materials extensively, and then worked from the illusions the materials themselves presented to her:

> I found, in approaching organic form, that it was quite necessary to know about the change of the matter and the timing and the flow of the material. I felt I wanted to define for myself the organic phenomena; what nature itself would suggest to me in the sculpture. I wanted it to be very primal, suggestive but not too specific; very iconographic but also very open.[22]

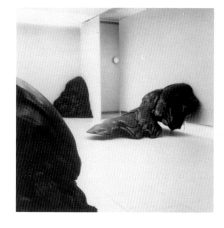

Fig. 15: Lynda Benglis, *Bullitt*, 1969, semi-flexible polyurethane foam, 4½ x 94 x 63 inches (destroyed).

Fig. 16: Lynda Benglis, *Brunhilde*, 1970, polyurethane foam, 36 x 66 x 106 inches, installation at Galerie Müller, Cologne, West Germany, 26 June-23 July 1970.

She first experimented with her unusual and difficult material on small pieces (initially working with a semi-flexible polyurethane). In discussing *For Carl Andre*, Benglis explained the specifics of her technique with this atypical medium:

> To create the materials used to make the piece, I first mix the pigment—in this case black and white—with the resin, and then I mix the catalyst in. Once the catalyst and resin are combined it causes a chain reaction which causes the foaming. I can vary the thickness with water. I add water depending on the pour I want. . . . The water is a "Blowing Agent" which causes the material to foam up more. . . . The length of time I take to pour it makes a difference—in other words sometimes I let it foam up and then pour it later, and sometimes I pour it before it has a chance to foam up at all.[23]

Through this exacting manipulation of the polyurethane, Benglis explored elasticity and the pulling of the "skin"; she exploited the palpable, slow rise of the pours and the volumetric sweep of her gesture.[24] In doing so, she echoed the abstract expressionsts' desire to work with the "essence" of the paint medium, to relate in an alchemic, "spiritual way with the material."[25]

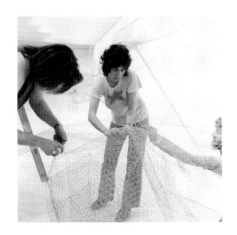

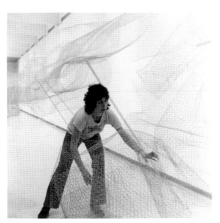

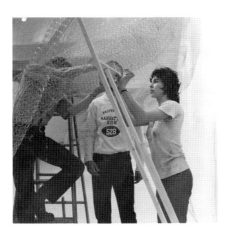

Pollock's work was also strongly in her mind, particularly after she had heard about the organic, painted papier-mâché sculpture he made shortly before his death. Benglis was trying to continue in the direction of Pollock's sculptural digressions and to create, through a similarly "non-logical, contained activity,"[26] images that were suggestive of things known, yet not descriptive. Her seething, voluminous poured creations were "paintings to be walked around. . . .I think they're hybrids—somewhere between painting and sculpture."[27]

For Benglis, the affiliation of mind and body during the creative process and her struggle with the materials of her art-making were key to the imagery of these expressionistic works. She likened the psychology of her process to her earlier trials with the viscosity of oil paint:

> . . . when I was literally wrestling with the plastic [sheeting] and polyurethane in the "Wing" installations, . . . the sensation of being immersed in the image and the material was exactly like what I had felt about paint as a student. It was like wrestling with your sheets as you come out of a dream state, being overwhelmed by the unmanageability of a material.[28]

Benglis soon levitated these spumous, strangely congealed piles of polyurethane foam, and pushed her material and her imagery into a new range. While working on the installation of *Brunhilde* at Galerie Müller in Cologne in June 1970 (fig. 16), she began to use her stir sticks to prop up contorted sheets of chicken wire, which when covered with plastic became airborne armatures for her polyurethane pours. In the series of expansive installations that followed during a brief and intense period in 1971,[29] Benglis aggressively explored this eccentric technique to create strangely animistic, hulking wing-like projections that cantilevered rambunctiously off gallery walls.

The production of these ambitious, gargantuan forms grew ever more elaborate and necessitated the orchestration of crews of assistants. Often made in public, they assumed a peripheral performance element. Benglis's large-scale installations took between one and two weeks to make, yet all were temporary; they were done for specific exhibitions and were usually destroyed after the brief course of the show.[30] Benglis would carefully prepare for these installations, organizing her materials, procedures and "psyche."[31] On site, she first constructed the armatures for the component "wings" (figs. 17-19), often springing them off of several walls of the room. Working from scaffolding and using the ventilators necessitated by the toxicity of the material, she then poured the polyurethane in successive layers over these plastic slides (fig. 20). Benglis carefully choreographed the flows of polyurethane, which appeared to

Figs. 17-19: Benglis preparing armatures for *Adhesive Products* at Walker Art Center, Minneapolis, May 1971.

Fig. 20: *Totem*, in progress, at Hayden Gallery, Massachusetts Institute of Technology, Cambridge, November 1971.

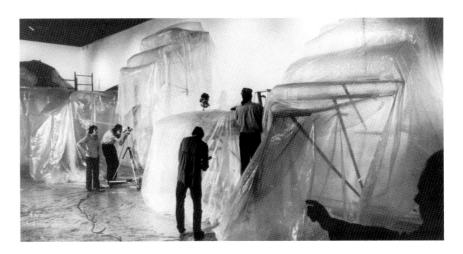

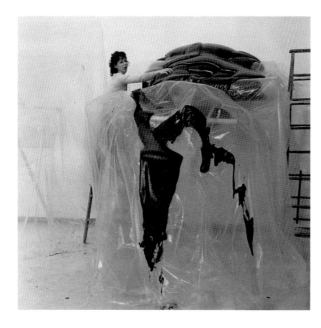
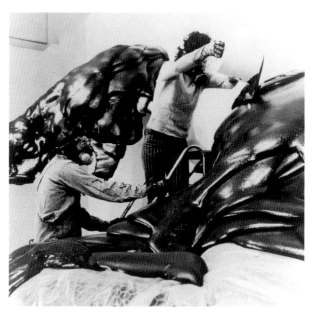
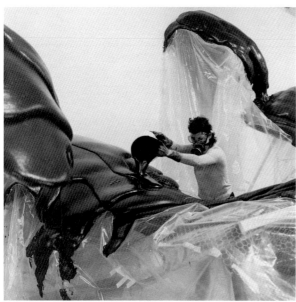
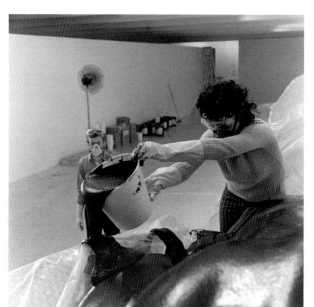
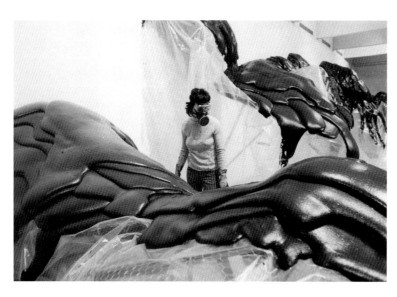

erupt mysteriously from the wall like some sort of renegade natural elements (figs. 21-25). She became quite expert at this cumbersome process, and was able to compose sweeping drawings in space, each with a distinct tempo and connotation. Upon completion, the foam was allowed to set for several days before the understructures were finally removed.

The character of these installations varied greatly. In *Phantom*, done at Kansas State University in February 1971 (fig. 26), and *For Darkness: Situation and Circumstance*, created at the Milwaukee Art Center in June (figs. 27, 28), she mixed phosphorescent pigments into the polyurethane; the works were meant to be seen both in regular gallery light and in the dark, in which they appeared dramatically like glowing minerals or stalagmite forms.[32] *For and Against* (also called *For Klaus*)[33] (fig. 29), done at Vassar College in April, and *Adhesive Products* (fig. 30), at the Walker Art Center in May (titled for the Bronx firm that makes the foam,)[34] were shiny, pitch black, and assumed a distinctly ominous feel that has been related to the rebellious political anger of the Vietnam period.[35] Five of the seven components of *Pinto* (fig. 31), at Paula Cooper Gallery in September, were combinations of white, gray and black, which made the viewer increasingly aware of the individual pours rather than the overall volume of the forms. Here, Benglis simulated shadows and mimicked the gradations of pictorial shading through her stylized "gray scale," thus also heightening and manipulating the sense of contour. In the last of these major environmental pieces, *Totem* (fig. 32), made at MIT in November, Benglis incorporated day-glo colors and outrageously gaudy but matte hues (inspired by a new line of automobile paint); through shrill combinations of reds, orange and pink, she explored the contrasting spatial effects of these pigments.

Benglis's installations were amazing physical tours de force and compelling manifestations of eccentric technique, for which she received wide critical acclaim. She dubbed them (and, later, all of her works) "frozen gestures," and thus underscored both their expressive, animated quality and the fact that they were embodiments of changing states of matter, e.g., liquid to solid. Not least, Benglis's "frozen gestures" referred to the revered moment of the abstract expressionist gesture, herein captured and imagined in an exaggerated, god-like scale.

Benglis's huge environmental gestures energized the ambient space and had strong kinesthetic effects: one virtually felt the choreographed movements of their making and the obdurate flow of the viscid material. Their sense of immediacy was, however, surrealistically petrified. The works were oddly suspended in the present tense—like a prior reality, seen once removed. They seemed to evoke geological time, and were indeed often described in prehistoric terms by critics, who saw them variously as "macabre,"[36] "cavernlike,"[37] or "the claws of an ancient behemoth or the drooping foliage of some malevolent, prehistoric swamp plant."[38] As their component parts reached out horizontally, often as much as fifteen feet from the wall, these installations appeared strangely sci-fi, like hallucinations with a slight Hollywood twist. Their plastic surfaces assumed an artificial, pop Oldenburgian look that enhanced the theatricality and melodrama of the forms. Although they were highly metaphorical and reminiscent of a range of naturalistic images, these works remained nonetheless adamantly physical. They were objects as much as illusions—fictions that occupied and commanded non-fictive, physical space.

Benglis pursued a complex of interests in these installations, as she inflated Franz Kline-like gestures and exaggerated the vocabulary and scale of abstract expressionism in her monumental three-dimensional forms. Concomitantly,

Figs. 21-25: *Adhesive Products*, in progress, at Walker Art Center, Minneapolis, May 1971.

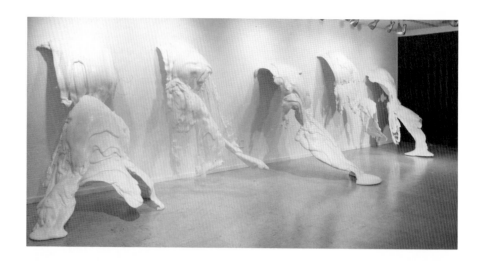

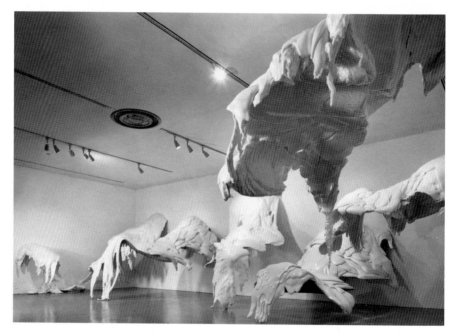

Fig. 26: Lynda Benglis, *Phantom*, 1971, polyurethane foam with phosphorescent pigments, 8½ x 35 x 8 feet, installation at Kansas State University, Manhattan, 4 February-13 March 1971.

Fig. 27: Lynda Benglis, *For Darkness; Situation and Circumstance*, 1971, polyurethane foam with phosphorescent pigments, 10½ x 34 x 8 feet, installation at Milwaukee Art Center, 19 June-8 August 1971.

Fig. 28: Lynda Benglis, *For Darkness; Situation and Circumstance*, 1971, as it appeared cyclically, with gallery lights off.

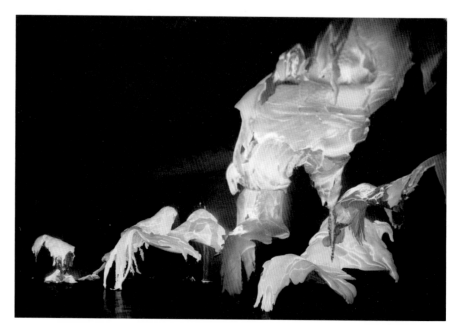

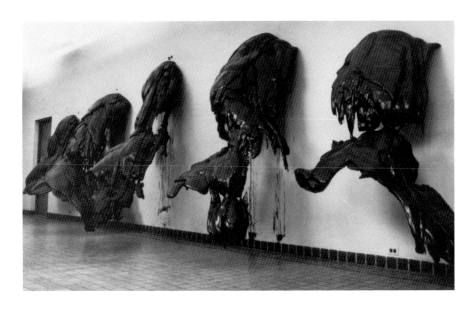

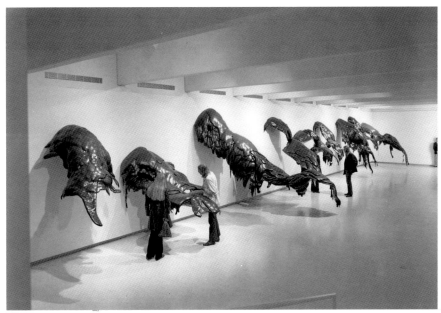

Fig. 29: Lynda Benglis, *For and Against (For Klaus)*, 1971, pigmented polyurethane foam, 10½ x 60 x 11 feet, installation at Vassar College, Poughkeepsie, New York, 1 May-6 June 1971.

Fig. 30: Lynda Benglis, *Adhesive Products*, 1971, pigmented polyurethane foam, 12 x 90 x 15 feet, installation at Walker Art Center, Minneapolis, 18 May-25 July 1971.

Fig. 31: Lynda Benglis, *Pinto*, 1971, pigmented polyurethane foam, 10½ x 41½ x 11 feet, installation at Paula Cooper Gallery, New York, 25 September-21 October 1971.

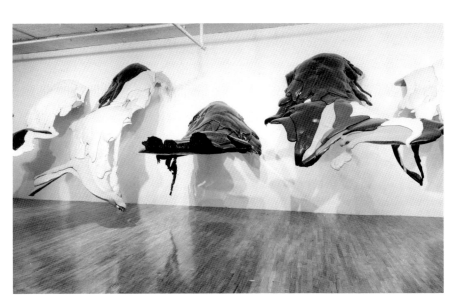

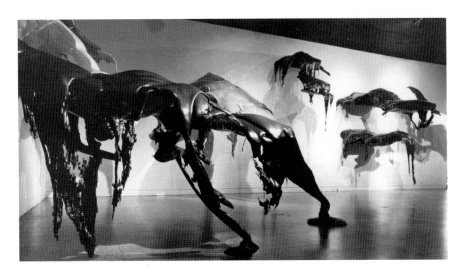

she wished to connect with and to express the fearsome yet magnificent power of natural phenomena, such as the flow of lava, the pull of gravity, the turbulent power of crashing waves, the violent force of an earthquake. She was particularly interested in natural situations that seemed "unnatural and bizarre" in the context of daily urban life and excised from the vast and timeless framework of nature. Her interests were spurred by several experiences—her memories of the rocky, dramatic terrain on the Greek island of Megiste (Kastellerizon), which she visited as a child (fig. 33); a recent road trip across the exotic landscape of northern Arizona and New Mexico to the Grand Canyon;[39] her first visit to California in May 1971, shortly after earthquake activity there;[40] and her subsequent experiences scuba diving, which reinforced her interest in buoyancy. Her fascination with the physical sensations of these phenomena was compounded by an interest in things as diverse as the swelling and billowing of cloud formations, aerial views of landscape,[41] and the gradual, rolling movements of extremely large mammals.

Benglis capitalized on the element of surprise inherent in the "superreal" imagery of her colossal forms, which stretched as much as eighty feet down the gallery. She wished to magnify the perceptual experience induced by these seemingly possessed shapes as they cascaded gracefully yet threateningly off the wall—looming overhead, defying gravity and unsuspectingly invading architectural spaces. In doing so, Benglis sought to simulate the "pure," primal sensations of natural phenomena, which although intensely physical were, for her, inextricable from an emotional quotient.

Unusual and innovative as they were, these installations were indeed oriented toward the traditional genre of landscape: so, too, are Benglis's wax paintings, with their melted terrains and central "horizon line," through which she referred to the visual tension between earth and sky. Throughout these works, Benglis clearly identified with nature. Living in the urban confines of New York instigated a kind of "internal landscape"[42] imagery for her, which was influenced in turn by continual contrast with the environment of southern California, where she lived intermittently throughout the early 1970s. These works consequently are based in part on experience, and conjured in part from the imagination. In making them, Benglis valued intuition over intellectualization; her works could be considered to exemplify the historical—and patriarchal—association of woman with subjectivity, with the frenzied forces of nature rather than those of the rational world. Whereas many women artists of the period identified with landscape from a universal, nurturant viewpoint (as personified by the mythological "mother earth"), Benglis asso-

Fig. 32: Lynda Benglis, *Totem*, 1971, pigmented polyurethane foam, 12 x 65 x 38 feet, installation at Hayden Gallery, Massachusetts Institute of Technology, Cambridge, 8 November–17 December 1971.

Fig. 33: The island of Megiste (Kastellerizon), Greece, 1990.

ciated with the more volatile and capricious side of nature's titanic forces, with the sublime and *terribilità*. She refused, however, to dichotomize nature and culture, body and mind; she was involved simultaneously with the realm of primal sensations and with cultural critique and art-historical revisionism.[43]

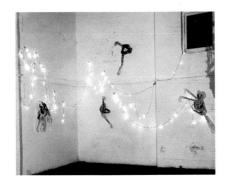

Benglis cast some smaller polyurethane works in metals several years later,[44] both to monumentalize them and to satirically invest them with the sense of permanence and the superficial cultural value implied by elements such as bronze. Compelled by shininess, she had always wanted to see the mannered, somewhat vulgar excess of her works further exaggerated—to see "that baroque form in a bronze-gold or silvery-aluminum."[45] These cast works have a disorienting sense of solidity, making their fluid forms seem all the more contradictory. *Wing*, 1975 (cat. 20, p. 82), appears ponderous, from some angles like a monstrous hand, yet from others like a gentle, amorphous veil, elegant in its subtlety and lyrical in its defiance of gravity. *Eat Meat* (cats. 18 and 19, pp. 80, 81), cast in bronze and in aluminum, is for the artist a metaphor for abundance—not just for its obvious crude sexual and scatological associations, but rather for the elemental "excretions of the gods."[46]

Exhausted by the intensity and difficulty of the production of her installations and distressed at their ephemeral nature, Benglis retreated to the studio. She concentrated for a time on the more intimate, meditative wax reliefs on which she had continued to work intermittently. The last of these pieces are intensely colored and increasingly textural, influenced in part by her trip to the Caribbean island of Martinique in the spring of 1972. She began simultaneously to experiment with the new medium of video and to work on a series of elongated "totems,"[47] such as *Hoofers I* and *Hoofers II*, 1971-72 (cats. 9 and 10, p. 73), in quest of a more "passive and . . . controlled" image.[48] Benglis's totems, approximately the width of her arm, were made of screening covered with bunting and plaster, which was then painted. They had strong figurative allusions: these glittery "hoofers" (vaudeville slang for dancers) also refer to the expert—and romanticized— movieland dance duos of the thirties and, similarly, barely graze the floor.

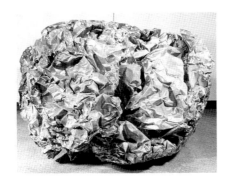

Benglis soon started to loop these elongated tubes into knots, which she manipulated into a range of suggestive configurations. Some had limb-like appendages, others were tied into tight balls reminiscent of heads or masks. Benglis painted these knots elaborately, emphasizing planar passages with her rampant decoration. Using drips of brightly colored paint and cheap dime store arts and crafts materials such as sparkles, glitter, mica and fake jewels, she embellished their surfaces, "Pollock-izing the knots with the ultra vulgar flakes of sparkle . . . drawing attention to surface, but also refracting it in some way. Denying the form through the surface."[49] These vivacious, glitzy images reflect her longstanding fascination with ritual decoration and costuming. For her installation at The Clocktower in December 1973 (fig. 34), Benglis draped strings of flashing Christmas lights around these "sparkle knots," further stressing their tawdry qualities as well as defying President Nixon's request to refrain from using Christmas lights during the energy crisis. The surface patterning of these works, however, also relates to her admiration of African sculpture, which she began to collect in 1970-71,[50] and of its "repose and tension." The knots became experiments in assimilating cubist structure with organic form, as well as studies for various surface treatments. For example, in *Peter*, 1974 (cat. 14, p. 77), Benglis applied enamel paints over heavy aluminum foil, inspired by the unusually delicate pastel surface coloration of John Chamberlain's works of 1972-73 (fig. 35) and the crumpled aluminum "dentos" of Billy Al Bengston.[51]

Fig. 34: Installation of "sparkle knots" at The Clocktower, New York, 6 December 1973-20 January 1974.

Fig. 35: John Chamberlain, *Untitled*, 1973, aluminum foil with acrylic lacquer and polyester resin, 43 x 71 x 68 inches, The Chrysler Museum, Norfolk, Virginia, on loan from Jack F. Chrysler in memory of Walter P. Chrysler, Jr.

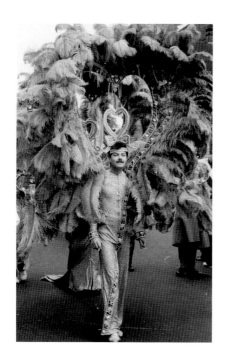

The distinctly cosmetic, frilly facades of her series of "sparkle knots" foreshadow Benglis's interest in gender stereotypes of appearance and behavior. The poses of these works reflect the mannerisms of body language and the conventions of male/female social discourse. Benglis considered the knots different "states of being: often times the different ones reminded me of people,"[52] and, indeed, she named a group of them after friends. In many ways, the "sparkle knots" are mementos: Benglis recently related them to the floral wreaths from May Day celebrations that she saw left withering on the doors of Greek houses during her summer visits.[53]

With their gesturing "limbs" and visceral look, these works epitomize the manipulation of anthropomorphic references and the study of bodily responses that permeate Benglis's art. She considered their hollowness a means of implying an internal flow of light and air through form, analogous to the vitalizing quality of breath. For Benglis, the world is known and visualized primarily through the body, through its physical and social context.

The underlying content of Benglis's "sparkle knots" is thus closely tied to her concurrent experimentations in video. In her sculptures, she explored social performance and issues of feminine ornamentation intuitively and in abstract terms; in her videotapes, she scrutinized patterns of behavior, male/female roles and issues of self-presentation from a conceptualized position. Her statement about her video work applies equally to her sculpture of the time:

> A lot of my notions about feeling or work or people is a sort of psychodrama or complexity of the way the body works, that it works in a state of physically contracting or expanding. I was interested in making symbols of these states, of the configuration of feelings of the body movements. Some of this has to do with very primal notions about what growth is, and also about what form is, and what feelings are.[54]

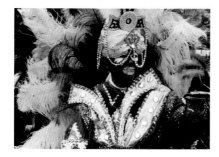

Benglis's extended sojourns in southern California during this period contributed to these interests. California culture, with its emphasis on personal freedom, body awareness and pop psychology, liberated the issues for her. In addition, the sun-filled Edenic climate—and the famed "finish fetish" of L.A. area artists—underscored the importance of light and of surface in her work.

As a young, attractive, southern woman, Benglis was perhaps unusually cognizant of acculturated, socialized female roles—of a sense of self that is mediated by a male audience, constantly aware of being seen through the eyes of others and performing to that reflected image. She was, she recalls, always challenged by gender roles and conscious of the female masquerade. Benglis described, for example, her automatic self-defensive alteration of her own appearance after arriving in New York from New Orleans:

> I knew upon arriving here that one way not to be bothered was to be tough and walk the streets very quickly—don't slow down, don't smile, don't be a nice southern girl, don't give anybody the time of day. My mother claims that my whole metabolism changed. In fact, I just got a haircut and didn't wear so much make-up and walked faster and lost a few pounds. . . .[55]

Fig. 36: Fernando La Rosa, *Gay Parade, New Orleans '89, Mardi Gras Week*, 1989, gelatin-silver print, 10 x 8 inches.

Fig. 37: Fernando La Rosa, *Zulu Parade, New Orleans '89, Mardi Gras Week*, 1989, gelatin-silver print, 8 x 10 inches.

This is the content that underlies her effusively ornamented, bedecked knots. These metaphorical characters, masks and heads reflect Benglis's interest in theater and make-up,[56] as well as the influence of the New Orleans tradition of Mardi Gras, with the flamboyant costuming and transvestism typical of carnival celebrations (figs. 36, 37). On the announcement for her show in May 1973 at Hansen Fuller Gallery in San Francisco (fig. 38, one of a series of self-referential announcements), Benglis appears holding a large unadorned plaster knot in front of her head like a grotesque elephantine mask, flanked by two bejeweled "sparkle knots" in the background. The juxtaposition is akin to

LyndaBenglis

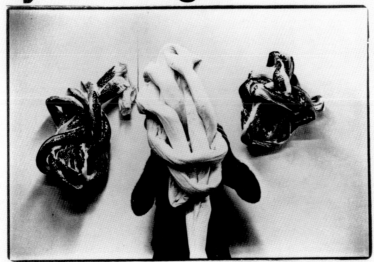

HansenFullerGallery

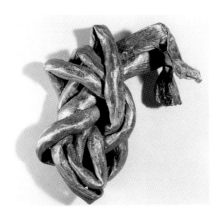

Fig. 38: Lynda Benglis, invitation for exhibition at Hansen Fuller Gallery, San Francisco, 2-26 May l973.

Fig. 39: Lynda Benglis, *Lambda*, 1972-73, aluminum, liquid metal in plastic medium and gesso on plaster; cotton bunting; aluminum screen, 29½ x 25 x 8¼ inches, collection of San Francisco Museum of Modern Art, gift of Mr. and Mrs. Alfred H. Daniels.

before and after make-over shots, and is revealing of private and public facades. Sexuality, in Benglis's work, is made a social as well as a sensory issue.

Benglis soon found a means of solidifying her malleable, delicate "sparkle knots" and endowing them with the "frozen hard" quality of her foam pourings. Through Robert Irwin, Benglis met the fabricator and designer Jack Brogan in Venice, California, in June l973. Brogan had recently acquired a metalizing gun but had not yet used it. Together they experimented with the process of spraying liquid metal over her bunting knots. *Lambda*, 1972-73 (fig. 39), was Benglis's first metalized knot. As with other reflective materials to which she has been attracted, she liked the glitzy artifice of the sprayed metal surface and the subtle way it changed in different light. Benglis exploits the primal visual magnetism of shininess and our natural, animistic reflex to such precious, glimmery surfaces: "I was attracted to [the metals] because of the notions of energy that the metals have, and . . . [like a] muskrat, you are attracted by something that shines."[57] Benglis's constant interest in desire—in "titillating the eyes and touch"[58]—was at play here, as was her fascination with California car culture and vernacular pop culture.

Benglis embarked on a series of metalized knots, titled after the phonetic military alphabet—Alpha, Bravo, Charlie, etc.—in which she was interested as a kind of code.[59] Others were named for the letters of the Greek alphabet, whose forms she thought some of these knots recalled.[60] Although Benglis continued to conceive of these works as telling metaphorical gestures, she now also thought of them as a kind of abstract handwriting that reflected intrinsic identity—as does an autograph. Each took on an individual character and symbolized an emotional state. Benglis has related these knots to *quipu*, an Incan record-keeping device consisting of a series of knotted strings which, although never deciphered, is thought to have been a means of remembering the sequence of events in stories or family histories and was often discovered at gravesites.[61] She referred, in artist's statements at the time, to her historical reference points and to a lineage of rudimentary means of communication: "The Peruvian Quipu was an alphabet of knots which was both mathematical

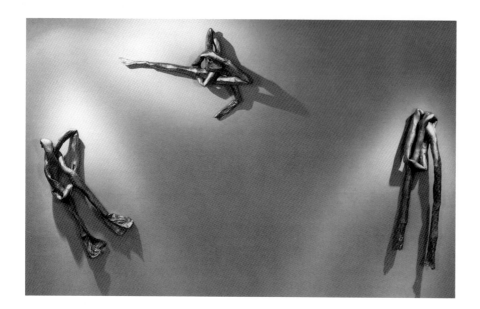

and syntactical. Early Chinese writing also began with knotting and mapping."[62] Benglis's knots were usually conceived in series, like *North, South, East, West*, 1976 (cat. 21, p. 83), or *Seven Come Eleven*, 1976 (fig. 40), and read in syntax, like a mapping of movements. Dispersed across the wall in floating arabesques, the knots appeared balletic. They began to assume a narrative sense, when seen gesturing in relation to one another in choreographic phrases that implied a distinct passage of time. The rough, accretive metal surfaces of these works are gloppy and awkward, at the opposite extreme from her prettied-up "sparkle knots." The ugly and the beautiful, attraction and repulsion, exist side by side in Benglis's art, each heightened by the contrast.

Benglis's consideration of feminist issues is critical to her work of this period. She dually confronted the male-dominated art world and the organized women's movement, whose concerns but not politics she shared. Her strategy was to inhabit and thereby appropriate the conventions she wished to expose, to work within gender stereotypes like a Trojan horse. "What I did," she explained of her personal strategy, "was pretty myself up and still act tough."[63]

Until this time, she had thought of her work largely in formal terms—primarily as an exploration of her interests in abstraction, beauty and visual metaphor—without a conscious intention of being "political."[64] By the early 1970s, however, Benglis felt compelled to make a direct statement about feminism in her work. She subsequently addressed issues of identity, control, androgyny and sexual ambiguity in her videotapes, on which she worked intensely from 1972 to 1976. Although she adamantly rejected such an approach in her sculpture, her videos are intellectualized and theoretical in orientation. Benglis approached the new medium with the same brashness with which she had earlier challenged the patriarchal authority of modernist abstraction.[65]

Fig. 40: Lynda Benglis, detail of *Seven Come Eleven*, 1976. Left to right: *Dos*, 50 x 36 x 8½ inches, private collection; *Siete*, 25 x 51 x 16½ inches, private collection, Chicago; *Ocho*, 61 x 15 x 17 inches, courtesy Paula Cooper Gallery, New York. All components copper, liquid metal in plastic and gesso on plaster; cotton bunting; aluminum screen.

Benglis used her own image in many of her videotapes, such as *On Screen*, 1972, *Document*, 1972, *Now*, 1973, and *Collage*, 1973. She did so in a consciously mechanical, stylized way: her attitude was cool but her subjects were decidedly not, and her tapes are often tinged with elements of narcissism and autoeroticism (as are so many of the home-grown video works of this era).[66] In *On Screen*, for example, she distorts her face into masklike visages and

manipulates her mouth into grotesque shapes, much as a child might play before a mirror. In doing so, she effectively "alienates the viewer from conventional notions of female beauty."[67] In *Now*, she discomfittingly "makes love to her own image"[68] by playing with her tongue suggestively against the image of her face on a video monitor. All the while, she asks, supposedly to herself (or to one aspect of herself), "Do you wish to direct me?" Benglis—or rather Benglis's image—acts dually as subject and object here; she assumes stock male *and* female roles, and is both controlling and being controlled. It is unclear, however, for whom she performs so provocatively, or if her self-centered sexuality is assumed to unsettle a male viewer.

A similar investigation of dominance and power is evident in *Document*, in which a male voice off screen orders the orientation of Benglis's head within the frame. Gradually, she goes from being directed to directing, from passive to active subject. Benglis thus symbolically dissects the attitude of the media toward women, an interest that stemmed from her contact with Warhol in the mid-1960s and, specifically, her refusal to appear in one of his erotic films and be thus objectified.[69]

In *Document*, Benglis tapes a photograph of her image onto the monitor, a scene which then appears in next-generation video on the screen. As she removed her photographed image further from first-generation reality over the course of the tape, she was "debasing the photograph, which happened to be *my* photograph."[70] At the end of the tape, Benglis writes the title and copyright over her image as it plays on the monitor, then retraces over this script on the face of the monitor when it is seen again in replay, repeating this action in successive generations and thereby layering contingent "realities." In the course of this exploration of video time, Benglis distances her image: "I was degenerating it by regenerating it,"[71] she explained. As she titled and claimed the tape by adding the copyright information—asserting herself as author—she simultaneously defaced (and denied) her image by drawing a moustache on it, in obvious reference to Marcel Duchamp's *LHOOQ*, 1919 (his alteration of the Mona Lisa whose title makes a suggestive reference to her enigmatic sexuality).[72] By invoking Duchamp, Benglis again referred to the issues of sexual indeterminacy, male and female alter egos and androgyny that preoccupied her at the time.

Female Sensibility, 1973, was made in mocking response to the persistent question of the time: were there indeed a perceptible female attitude and imagery in art?[73] Benglis was, she says, simply tired of being asked if there were a "female sensibility," and her artistic reaction was in part calculated for its shock value.[74] The tape is an audacious response to the radical feminist camp, and to the concept of a political, exclusively lesbian phase in the women's movement. In the video, color is extremely hyped, consciously artificial and vulgar, as in her sculptural works. Benglis and Marilyn Lenkowsky (wearing blue-green and red-black lipstick respectively) slowly touch and caress each other's faces; in the background play a tape of a radio talk show and strains of country-western songs with lyrics such as "when a man needs a woman" and "southern lovin'," which become ironic in the context of this imagery. All the while, Benglis dispassionately looks past Lenkowsky into a monitor, directing their actions and "sculpting visually." Benglis here continues to underscore the issue of directorial voice. As Pincus-Witten has suggested,[75] she also implied (through the visual similarity of the two women) a stylized and perhaps masturbatory self-reflexiveness that subverted the traditional male/ female relationship. As in many of Benglis's videotapes, the viewer seems peripheral rather than voyeuristic, inconsequentially made privy to a scene that is enacted as if for a mirror rather than for an audience. Chris Straayer's

remarks on *Female Sensibility* apply as well to the oblique address of Benglis's other early videos: "Just as the women seem impervious to the tape's sound track, they discourage our judgement. . . . these women do not invite our gaze. This snubbing of the viewer challenges his/her authority to objectify woman."[76]

Benglis thus addressed sex as a social formation and as a political issue, in a fashion that remains disquieting, in part perhaps because she used herself as a model. However, her forthright interest in self and sexuality as subject matter is closely related to many performance and video works of the period and indeed parallels, for example, the practices of Vito Acconci, Eleanor Antin, Bruce Nauman, Carolee Schneeman, Martha Wilson and many others.

As Benglis layered the metaphors of her sculptural works, so she layered events in her videos–taping a tape of a tape, for example, and confounding our sense of time by juxtaposing a frozen, past tense with a sense of an immediate present (which she then blithely turns around to expose as a fiction in subsequent generations). Benglis often thwarted the containment and absoluteness of video by insinuating other spaces and other characters–some present and not heard, some heard and not present–thus revealing the deceptiveness of video "reality." She pushed the synthetic colors and textures of the medium to new limits, incorporating abstract static and video "noise" with a penchant for texture that parallels her three-dimensional work. Long before appropriation became a common artistic strategy and vehicle for cultural commentary, Benglis incorporated broadcast footage in her work–sometimes as ambient information, sometimes to comment obliquely on theatricality or artifice. *The Grunions Are Running*, 1973, includes footage from a B-grade television movie showing a modern couple trapped in a ritual of some primitivisitic civilization, which Benglis juxtaposed with a spearmint gum commercial featuring a similar archetypal couple at a ritual small-town parade; *How's Tricks*, 1976, includes purloined network footage of Nixon's final days in office.

Benglis's works are often so self-referential that they seem autobiographical. For example, *Home Tape Revised*, 1972, is a chronicle in the vein of Arlene Ravens's classification of a "feminist genre . . . which reclaims and transforms autobiography."[77] In many cases, however, fact and fiction are meshed irrevocably, as they are in Benglis's well-known video collaborations with Robert Morris. Between fall 1972 and spring 1973, they used portions of each other's videotapes as raw material for their respective works. Benglis's tape *Mumble*, 1972, and Morris's tape *Exchange*, 1973, document their dueling responses to each other's art and their continuing dialogue about the nature of video and the confusion of physical desire with the desire for artistic creation. According to Benglis, hers was a "playmate association with Robert Morris" in which "I used my equipment as my defense."[78]

Mumble includes a tape of Morris, which Benglis shot in her studio, with his back to the camera and his voice largely unintelligible. An overlay of voices, mostly off camera, lies to the viewer about the identity of the figures and discusses extraneous actions going on out of camera range; the tape thus dislocates image from sound. At one point Benglis revealingly states, "Cycles and circles; repetition and self-reference; objects in the form of behavior." In *Exchange*, Morris purportedly chronicles their collaboration,[79] using the ploys of gossip and romance, yet distorts fact and fiction to the point that the two are indistinguishable. Included in the tape is footage of Carolee Schneeman posed as Manet's *Olympia* (taken from Morris's dance piece *Site*), in which her nudity is alternately concealed and revealed as he moves blank white panels in front

of her.[80] Morris's text alludes to artistic and romantic interaction and in doing so explores notions of control, revelation and sexuality. All the while, one's image is confused with one's artistic presence and authority (a topic Benglis, too, had addressed in her tapes, and one that is evident in Morris's work as early as his *I-Box*, 1962, fig. 41). The narration, for example, includes lines such as "She removed his presence from herself by converting his image into an icon"; "She compressed him into an object, he projected onto her a landscape of his feelings"; "We are witnessing a situation of terror in which a disembodied voice, say hers, keeps an image, if first hers then now his, say, at bay."

Benglis's and Morris's collaboration—a kind of call and response artistic improvisation—continued in a series of advertisements for their respective exhibitions in 1974. Benglis had been using photographs of herself on exhibition announcements for some time, to wryly comment on the use of the artist's image as a media device and also to highlight issues fundamental to her imagery. In her announcement for the "sparkle knot" show at Hansen Fuller in May 1973, her work became the mask behind which she effectively disappears (fig. 38). On the invitations for her shows at the Portland Center for the Visual Arts in June 1973, at Jack Glenn Gallery in Corona Del Mar, California, in July 1973, and at The Clocktower in New York in December 1973 (fig. 42), Benglis reproduced a family photograph of herself taken in Greece in 1952, on her first trip there with her paternal grandmother. She appears as an eleven-year-old child, with a hand jauntily on her hip, dressed in a Greek evzone outfit, the attire of a male soldier. (The "sparkle knots" in these exhibitions were, in fact, made of heavy bunting cloth similar to that of these soldiers' uniforms.) The traditional skirts of the evzones have, to contemporary eyes, a decidedly feminine quality; Benglis's resurrection of this doubly androgynous autobiographical family photograph coincides with her interest in exploring gender roles and sexual identity. Importantly, however, she herein also implied the easy exchangeability of costume and thus of personality, for one could seemingly alter at will the masquerade played for the camera.

Fig. 41: Robert Morris, *I-Box*, 1962, mixed media, 19 x 12¾ x 1⅜ inches.

Fig. 42: Lynda Benglis, invitation to exhibition at The Clocktower, New York, 6 December 1973-20 January 1974.

LYNDA BENGLIS

at

THE CLOCKTOWER

108 Leonard Street (at Broadway)

opening Thursday, December 6

through January 20

Thurs 1-8, Fri & Sat 1-6

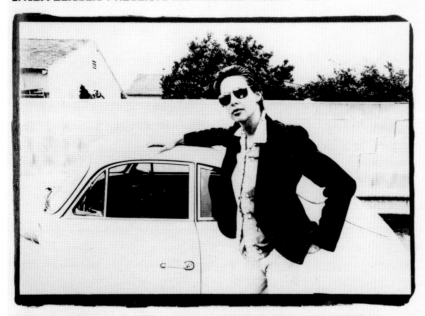

PAULA COOPER GALLERY 155 WOOSTER STREET, NEW YORK

Fig. 43: Lynda Benglis, advertisement in *Artforum*, April 1974.

Fig. 44: Robert Morris, poster for exhibition at Castelli-Sonnabend Gallery, New York, 6-27 April 1974, edition of 250, offset lithograph, 36⅞ x 23¾ inches.

For her next exhibition of metalized knots at Paula Cooper Gallery in May 1974, Benglis placed an advertisement in the April issue of *Artforum* (fig. 43) showing her in what she called her "macharina" pose: in jeans, tailored jacket and aviator sunglasses with her hair slicked back, she leaned (à la James Dean in *Rebel Without a Cause*) proudly against an old Porsche she kept in California. The work was the first in a series of what she called "sexual mockeries."[81] In it, she continued her exploration of sexual ambiguity, costuming and artistic alter egos, with a nod to Duchamp and his female persona, Rrose Sélavy (read *eros c'est la vie*). Her masculine posturing was also a way of play-acting in the boys' art game. It was, in its effect, a humorous retaliation to the frequent practice of many southern California male artists (with whom Benglis associated), of using rough-and-tumble photographs of themselves on their exhibition announcements.[82] She was also responding, however, to the growing momentum of the women's art movement and to the highly visible activities spearheaded by Miriam Shapiro, Judy Chicago and their students at Cal Arts, where Benglis had been a visiting artist.

For his exhibition at Castelli-Sonnabend Gallery in April 1974, Morris staged a poster-sized photograph of himself (fig. 44), shown bearded and naked from the waist up, in a German helmet and dark glasses, shackled with heavy chains. It was a tough, nasty and stereotypically male image that simultaneously evoked the subjugation of sado-masochism and the sinister domination of Nazism, and thus echoed the directorial themes of power and control integral to his dialogue with Benglis. After studying the history of pinups while in California, Benglis had photographer Annie Leibovitz take a cheesecake shot of her, jeans dropped to her ankles, which she then reproduced on the invitation for her exhibition at Paula Cooper Gallery in May 1974 (fig. 45).[83] Here, coy and seductively nude, Benglis presented the polar opposite persona of the impervious masculinity feigned in her "macharina" advertisement, made for this same exhibition. She explained:

> I appreciated the revered attitude [of the women's movement] and the seriousness, but I also wanted more playfulness. So, I got involved with

presing myself in photo roles such as "The Woman-on-the-Pedestal," which was a pinup à la Betty Grable. I wanted a very old-fashion pinup. So I donned a pair of high-heeled shoes. . . .

What interested me about the feminist movement was the fact that there really is emphasis on the "taboo." A lot of the highly feminized imagery— laced, stuffed, lipsticked and tamponed—had not been regarded in the context of art. This iconography was coming directly out of the feminist movement. It's often difficult to say if an image is masculine or feminine. The feminists decided to make themselves explicit. My aim was to present artwork that questioned all extremes by being extreme or outrageous.[84]

Raised in the "proper" southern tradition and initially shy about such physical display, Benglis was addressing engrained cultural taboos from the new, relaxed standpoint of the era and in the climate of California personal freedom and beach culture. The flip side of her subject was "the sexual self-consciousness I had wanted to shed, and the only way I knew how to get rid of it was to mock it."[85]

Benglis's most outrageous action, certainly the one that brought her unprecedented attention and incited vehement response, was the advertisement she placed in the November 1974 issue of *Artforum* (fig. 46). In it, she appears wearing only a pair of Hollywoodesque winged sunglasses, and holding an absurdly large, strategically placed dildo. Her belligerent hand-on-the-hip pose, downward stare and blatant sexuality presented an unrelenting challenge to the viewer, who was further confronted with her oiled frontal nudity and the burlesque artifice of the exaggerated (double-headed) phallus. The now infamous advertisement was conceived initially as an independent work, before Benglis knew that Pincus-Witten's article "Lynda Benglis: The Frozen Gesture" was to appear in the same issue. After declining the magazine's offer to run the image in the context of his article, Benglis decided (at the editor's suggestion) to buy two advertising pages for the hefty sum of $3,000, a large investment for her and nearly a quarter of her income at the time. Her astonishing, irreverent gesture was a calculated assault and a risky personal statement, one that she felt nonetheless firmly committed to make. She explained:

> . . . I felt that placing the gallery's name on the work strengthened the statement, thereby mocking the commercial aspect of the ad, the art-star system, and the way artists use themselves, their persona to sell the work. It was mocking sexuality, masochism and feminism. The context of the placement of the ad, in an art magazine, was important.[86]

Fig. 45: Lynda Benglis, invitation for exhibition at Paula Cooper Gallery, New York, 4-19 May 1974.

Fig. 46: Lynda Benglis, advertisement in *Artforum*, November 1974. See essay, pages 39-42.

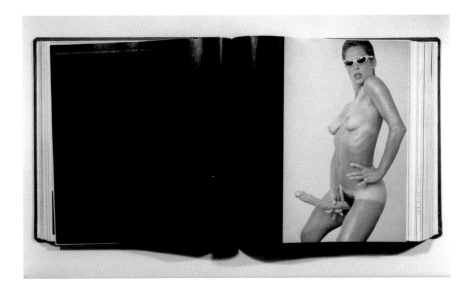

. . . I was alluding to something; mocking art and the sexual "hype" advertising. My intention was to mock the idea of having to take sexual sides—to be either a male artist or a female. . . . Also, I was mocking the media. It was a very Nixonian time; the media was very much in question. Since all advertisement was about "hype," I wanted to do the ultimate "hype." I was involved with how I could mock both sexes. The idea of a hermaphrodite is ideal because then you employ and embody without contradicting. The condition is a contradiction in itself. You embody the perfect condition in a neither/nor state. I had to take a mocking stance with the glasses because to me it's an impersonal state—not to reveal anything.[87]

Benglis's frank conflation of male and female sexuality—and of female allure and self-display with male aggressiveness—caused a furor on many fronts. Was she using the oddity of caricatured hermaphroditism as a rude metaphor, to declare there was no other way a woman could have it all—her femininity and equal artistic recognition and authority? The advertisement was a gesture made to subsume such dualities. On one hand, Benglis wanted to ridicule and debunk the Freudian concept of penis envy and to reject the concomitant theories that posited a male-centered self-image—next to which woman was always seen as inferior and lacking. She seemed to ask, angrily and rhetorically, while wielding the enormous plastic phallus like a weapon, if this indeed were still the equipment one needed to be taken seriously as an artist.

In spite of the seriousness of the questions Benglis posed, there was an edge of naughtiness and self-consciousness to her action. In the advertisement, she continued the role-playing seen in her videos and in the theatrical attire she affected at the time. Yet this work is also strongly tied to her ongoing interest in artistic context, as well as to her collaborations with Morris and their assimilation of issues of sexuality and creativity. Morris accompanied her to 42nd Street to buy the prop, which they also used in a concurrent group of staged, in-the-buff Polaroids (part of a series Benglis had been doing at the time), for which they donned other accoutrements such as a long wig and a coonskin cap. In these casual works, they struck stylized, stereotypical male and female poses, sometimes making conscious European, American or art-historical references.[88] Her *Artforum* advertisement is clearly a natural, if surprisingly public, outgrowth of these peripheral works.

Benglis's notorious image was indeed shocking for its naked self-revelation and targeted impertinence. It falls easily, however, within the context of similar artist-advertisements, such as Ed Ruscha's photo of himself beneath the sheets, sandwiched between two blonde beauties, with the caption "Ed Ruscha says goodbye to college joys," which appeared in *Artforum* in January 1967, or Judy Chicago's "and in this corner . . ." image of herself in full boxing garb, leaning against the ropes, ready to bout and staring down at the viewer in the December 1970 issue of *Artforum*. Jeff Koons's audacious representations of himself surrounded by nubile bathing beauties in *Artforum*[89] or in other media situations are but one current incidence of the practice of public posturing and the manipulation of the art media to one's own ends. Benglis, however, viewed her advertisement not as a purely personalized comment, but as a symbolic statement on the roles in which artists are often cast, a subject about which she felt very strongly.

Although the coexistence of male and female characteristics had long been a subject for artists and a constant issue in Benglis's work, her symbolism of such Jungian psychological dualities in a physical—let alone veritable, photographic—image was nonetheless startling. Although her work is, in contrast, poetic and subtle in approach (fig. 47), the words of Louise Bourgeois again

offer appropriate historical comparison for Benglis's intentions and imagery:

> There has always been sexual suggestiveness in my work. Sometimes I am totally concerned with female shapes—clusters of breasts like clouds—but often I merge the imagery—phallic breasts, male and female, active and passive. This marble sculpture—my *Femme Couteau*—embodies the polarity of woman, the destructive and the seductive. Why do women become hatchet women? They were not born that way. They were made that way out of fear. In the *Femme Couteau*, the woman turns into a blade, she is defensive. She identifies with the penis to defend herself. . . . she tries to take on the weapon of the aggressor.[90]

Many of Benglis's male contemporaries similarly questioned the psychological embodiment and the internal balance of male and female elements.[91] They often used images of androgyny, which was equally evident in the mass culture of the late 1960s and early 1970s—a time when men's hair was often long and women's short, and jeans and flowered patterns were standard attire for all. In Morris's dance piece, *Waterman Switch*, 1965 (fig. 48), for example, Lucinda Childs appeared besuited but obviously female as Morris and Yvonne Rainer, naked and clenched together, walked precariously in tandem to the strains of a schmaltzy waltz, along tracks that Childs had laid: it was as if the unsteady male/female duet here symbolized the two beings concealed and difficultly bound together within the entity of Childs, seen as everyman/everywoman.[92] In his film *Conversions*, 1971, Vito Acconci attempted to transform himself into a female, by hiding his penis between his legs, burning the hair off his breasts and pulling at them to approximate female characteristics. Similarly, with less angst and a good deal of humor, William Wegman "converted" his naked torso to that of an old woman's, convincingly using his elbows as "breasts" in his videotape *Elbows*, ca. 1971. In *Family Combinations*, 1972, a six-part photographic work, Wegman montaged images of his mother and father over his own so that he appears variously more like his father (masculine) or more like his mother (feminine).

Yet as these artists explored male and female dualities, they did so largely in objectified terms, through the physical manifestations of gender. They looked primarily at sex, but not always at the more subtle, emotionally laden topic of psycho-sexuality that compelled Benglis and numerous other female artists at the time. In her *Artforum* advertisement, Benglis dealt not just with sexual duality, but with the loaded subject of sexual politics, using the mischievous and dadaist gestures of Duchamp as her aesthetic model. Hermaphroditism provided a powerful symbol for her, one that embodied the contradictions of the issue and thus tried to overcome the tendency toward polarization. Iconographically, her image refers to the subject matter of classical Greek art, derived from the myth of Hermaphroditus, the son of Hermes (the messenger god whose winged shoes Benglis's winged sunglasses ironically echo) and Aphrodite (the goddess of love and beauty) who was united in one body with

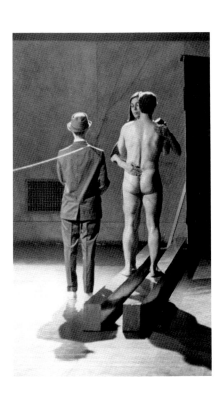

Fig. 47: Louise Bourgeois, *Femme Couteau*, 1969-70, marble, 3½ x 26⅜ x 4⅞ inches, collection of Jerry and Emily Spiegel, New York.

Fig. 48: Scene from Robert Morris's performance *Waterman Switch*, 1965 (left to right: Lucinda Childs, Yvonne Rainer, Robert Morris). Photo © Peter Moore.

a nymph, lovely maiden of nature.[93] Hermaphroditus thus incorporates not just male and female characteristics but also represents a joining of the realm of language and the intellect with that of nature and beauty.

The response to Benglis's advertisement was unprecedented, beginning with the printer's initial refusal to set the plates for it. The issue sold out of its 3,000 newsstand copies, and *Artforum* received an uncommon number of letters to the editor, which were overwhelmingly in the artist's favor.[94] Most notably, the advertisement prompted five of the magazine's editorial staff—Lawrence Alloway, Max Kozloff, Rosalind Krauss, Joseph Masheck and Annette Michelson—to "dissociate" themselves from the magazine's content in a letter to the editor in the December issue. They protested the "vulgarity" of the advertisement (which they denounced as a mockery of the goals of the women's movement) and the artist's use of *Artforum* as a vehicle of self-promotion "in the most debased sense of that term."[95] They took great personal offense at Benglis's action, for as Krauss later stated: "We thought the position represented by the ad was so degraded. We read it as saying that art writers are whores."[96] The abstaining west coast editor, Peter Plagens, wrote a tongue-in-cheek reply, with the jesting closing "yours for a cleaner SoHo," which appeared on the same page as the dissenting letter. As the controversy raged over the next several months, the eminent art historian Robert Rosenblum came forward to lambaste the self-righteousness of the coterie of editors, whom he dubbed "the Sons and Daughters of the Founding Fathers of Artforum Committee on Public Decency and Ladies' Etiquette."[97]

Benglis's objectification of herself in a manner considered virtually exhibitionist appeared to many critics, especially hardcore feminist writers, to play into the chauvinistic conventions of sexual degradation and to exacerbate the cultural tendency to consider any expression of female sexuality made by a woman as taboo (since woman had habitually symbolized purity and virtue). What Benglis saw as a matter of purchased empowerment—of a self-determined control of such stereotypes—some critics saw as a matter of complicity and of exploitation, expressed in terms of a regressive value system that the women's movement was fighting to overturn. Indeed, Benglis's statements on feminist matters were very independent; she stood apart from the doctrines of organized feminism and rejected what she saw as its insularity. In 1971, in response to the question "Why are there no great women artists?" she wrote:

> . . . How am I to simplify the composite picture "female" and "artist" in words? There is not a doubt in my mind that we still exist in a very self-conscious, sexually-repressed time. Although our culture has been and is male-dominated, the sexual experience is not unique to males nor is the art experience unique to males. Different organs and physical responses do not necessarily preclude females from the activity of art.
>
> I feel that art is an intellectual process which both questions and affirms the very nature of being. My concerns of identity within and outside the confines of my studio or working situation have everything to do with my experience. And my experience is primarily that of an artist and I am a female.[98]

Just the spring before the scandalous *Artforum* advertisement appeared, Benglis had responded satirically to the question regarding female artistic sensibility and played the devil's advocate by declaring:

> Yes, there is a shared female sensibility. Women want to please. Women are artists. Therefore, women make especially pleasing art. I, especially, like female art.[99]

Her answer, in fact, relates in part to her interest in incorporating decoration, ornamentation and other sensual pleasures in art, yet was also read as a problematic affirmation of female supplication—as a declaration of submission to

male approbation. Given such a context, her advertisement was characterized by some critics as coquettishness and aligned with the activities of, for example, Hannah Wilke, who capitalized on her glamorous image in works such as *Hannah Wilke: Super-T-Art*, 1974-76, a grid of twenty photographs over the course of which the artist transformed herself from a goddess-like female draped in a classical toga to a bare-breasted figure swathed as Christ. Such seductive posing remained suspect within the feminist camp at the time. It was as if traditional "femininity" and attractiveness were to be denied; the exploration of that aspect of female identity seemed to represent compromise and excommunicated the work from the feminist domain. Writing in *The Feminist Art Journal*, Cindy Nemser called Benglis's advertisement a "frantic bid for male attention," an "exploitation of female sexuality." Nemser rejected the possibility that Benglis's defiance could have any feminist content and relegated it to a position of nostalgia rather than progressiveness.[100] Considered from this narrow vantage point, Benglis could not manipulate or assume control of her own image, but could only be manipulated by it. Lucy Lippard summarized this unfair dilemma, in relation to contemporaneous body art:

> A woman using her own face and body has a right to do what she will with them, but it is a subtle abyss that separates men's use of women for sexual titillation from women's use of women to expose that insult. . . . Because women are considered sex objects, it is taken for granted that any woman who presents her nude body in public is doing so because she thinks she is beautiful. She is a narcissist, and Acconci, with his less romantic image and pimply back, is an artist.[101]

Like many women of her generation, Benglis chose to make a political statement in highly personal terms. Benglis's advertisement was, in essence, an attempt to repossess images and concepts of female sexuality from the male domain of culture and of art history:

> My intention was to make an allusion: a woman has to do everything herself, she has to both accept and laugh at her sexuality and go ahead and make art. Women today feel very strongly about being women and being artists. They object to being cast in certain kinds of roles. But in order to get rid of roles, you have to mock them.[102]

Miriam Schapiro lauded Benglis as a child of the media age, and declared, "In the ad she is Woman as Politician; she is also Woman as Artist, and she is Artist both making and being a Product."[103]

Benglis's audacious gesture drew its offensive strength from the use of a disturbingly raw sexual image, one that was blatant yet strangely not erotic in intent: the photograph in the advertisement was not about inciting desire but about taking power, which cast it further in the realm of transgression. Benglis represents this image—her image—with a certain cool artifice and voyeuristic remove; her eyes are concealed, her pose is highly mannered. She inhabited the format of pornography to address the sexual politics of the time, and exploited the power relationships and taboo endemic to the medium. By staging her own affront, she deterred victimization. For Benglis some seventeen years ago, as for many artists working today, pornography offered an appropriately extreme and inherently subversive vernacular format through which to examine and critique sexuality as a social function. As Carol Zemel has written, in relation to David Salle's work, such "theatrical distance enhances the depersonalized pleasure and power differential that is pornography's stock in trade."[104] Paradoxically, Benglis depersonalized her image, yet disturbingly personalized the issue by using herself as a model. Her image, and its sexual content, is only partially decontextualized and remains problematical; such confusion and indeterminacy was, in fact, part of her intent.

The *Artforum* image challenged both the feminist camp and the male hier-

archy of the art world. Benglis had carefully constructed it to speak to age-old male suppositions and to the recent feminist assumption of authority. Here she indeed acknowledges and plays to the male gaze with her stylized exhibitionism, yet does not relinquish control to that authority. Rather, she asserts a more—albeit mocking—self-defined vision of sexuality. Benglis is hardly a passive recipient here; she poses for but does not submit to the male gaze. She is not simply being seen, but is actively looking—looking back and looking down at that. Shielded by glasses, Benglis confronts the viewer with an opposition that growls at the traditional subject/object dichotomy and parodies sexual difference and prowess.[105]

Her masquerade, here, is drawn from the repressed underside of social behavior. Some feminists argue that any such image by definition is pornographic and thus automatically perpetuates a "male supremacist sexuality."[106] Yet Benglis saw this antic as an ideal vehicle for symbolizing the processes by which we are objectified,[107] processes which she denuded of all social niceties and depicted in the vocabulary of trashy brown-paper-wrapper periodicals. Female beauty here is made crass—corrupted in a hostile vision of defiance that is inescapable when seen in perpetual photographic stasis. Benglis's image plays with prohibitions: this is not the way the female nude, venerated and idealized in the context of art, is supposed to look, nor is this the way a woman in the seventies is supposed to picture herself. Her decidedly low-class image did not jibe with the upscale profile of the art magazine; neither did the farcical plastic rendition of male arousal—always, like male frontal nudity, an off-limits and uncomfortable subject in art. Benglis was hardly transmitting conventional values here; she transposed a subject based on conventions of attraction into one of potent psychological repulsion.

This image appeared in the context of *Artforum* as an advertisement, although that was not Benglis's original intent.[108] What, we must ask, was Benglis in the end promoting? A parody, a critical affront, an angry mockery, perhaps. And, as an advertiser, what audience was she buying into? In thus ostensibly advertising her artwork, she was simultaneously representing and absenting herself, and raising questions rather than answering them. Although she maintained an explicit—albeit ironically armed—authority in this problematic image, was she nonetheless underscoring stereotypes or indeed intervening with them? It must be remembered that Benglis questioned the relationship between the media and sexuality, and between the artist and his or her public image, from the standpoint of having been cast in the limelight very early in her career. Years later, her retaliatory media statement still retains its shock value and its ability to offend and expose the biases of all fronts. Regardless of its intentional duplicities and irreconcilable inferences, it remains one of the most frank and most-remembered artistic statements of a tumultuous, rebellious period. Although Benglis proceeded without the backdrop or validation of theory, her procedures and her manipulation of the media format were important harbingers of now prevalent postmodern critical strategies.

While in residence at Artpark in 1976, Benglis continued her spoof on sex as a social metaphor and her symbolic use of hermaphroditism in the collaborative videotape *The Amazing Bow-Wow*, made with Stanton Kaye. The tape is Benglis's only attempt at fiction and straight narrative. It is an offbeat tragedy about a carny couple, Rexina (played by Benglis) and Babu (played by Kaye), who adopt an unusually wise and philosophical hermaphrodite dog (costumed and played by Rena Small) who possesses the magical ability to talk. Opportunistically, they turn him/her into a cheap side-show attraction. The dog eventually gets too cozy with Rexina, his surrogate mother, and thus incites the jealous wrath of the mean Babu, who in the middle of the night

castrates the dog. Babu, however, mistakenly amputates Bow-Wow's tongue instead of his genitals, rendering the animal mute and socially impotent.

The Amazing Bow-Wow is a take-off on the myth of Oedipus Rex (e.g., "Rexina"), wherein the wizened sphinx possesses a lion's body and a woman's head, thus embodying male and female, human and animal characteristics, as does Bow-Wow. The artists also refer to the psychoanalytical theory of the Oedipus complex; the child here sleeps with the mother and is castrated by the father.[109] Yet as Babu confuses sexual power with the power of the dog to talk and communicate, the tape further comments on social silence as a form of disenfranchisement and disempowerment. For Benglis, the deadpan morality tale commented on "the predicament of society"[110] and presented ". . . a metaphor on the situation of the artist," whom American culture and the media often consign to the position of side-show oddity.

Benglis's increasing interest in the conventions of social discourse, in theatricality and in the juxtaposition of high and vernacular art translated back into her sculptures. In 1977, for *Five From Louisiana* (a kind of homecoming exhibition at the New Orleans Museum of Art), she collaborated on *Louisiana Prop Piece* (fig. 49) with her former teacher, the painter Ida Kohlmeyer. The two appropriated a stock of the large heads and figures used on Mardi Gras floats, which were often reworked annually; a figure might appear one year, for instance, as Abraham Lincoln and the next as, say, a lumberjack—an irony Benglis enjoyed. They installed these in the Great Hall, amid the museum's collection of eighteenth- and nineteenth-century Peruvian colonial paintings, creating a surreal scenario of colossal pop heads and grotesque carnival creatures perched on pedestals in front of revered fine art.

Fig. 49: Lynda Benglis and Ida Kohlmeyer, *Louisiana Prop Piece*, 1977, mixed media, installation at the New Orleans Museum of Art, 28 January-27 March 1977.

Shortly thereafter, Benglis began a series of "Lagniappes," titled with the Creole word for the small trinkets, or little extra gifts, given to a customer with a purchase. The carnivalesque spirit of the *Louisiana Prop Piece* carried over to

these vibrant and floozyish images, whose devilishly licentious look echoes the spirit of Mardi Gras masquerade (fig. 50). The "Lagniappes" are all tubular torso-like forms, in which Benglis delved even more flamboyantly into sleazy, kitsch ornamentation. They are covered with stripes of glitter, like cigar bands, and have coiffures and skirts of ruffled iridescent polypropylene paper at top and bottom.[111] Their titles, such as *Bayou Babe*, 1977 (cat. 22, p. 84), or *Baton Rouge*, 1977, reinforce their celebratory Louisiana origins. Exuberant and audacious, they seem to parade in a spectacle of femininity. They comment both on self-adornment and on the delegation of women to positions of decoration—as pleasant dolled-up accoutrements.

Benglis continued to pursue this vein of imagery and to investigate particularly female practices of bodily embellishment in a group of sensuous, goddess-like gold torsos of 1977-79. The first of these forms are very linear and, like the related cast piece *Vessel*, 1978 (cat. 25, p. 87), also refer to the shapes of archaic urns and pots. Here, the female figure is often compared to a vessel in the most primal way, thus metaphorically suggesting biological conditions (i.e., womb-as-container), fertility and the interface of internal and external spaces, an issue frequently cited as fundamental for many women artists.[112] As the series progressed, Benglis's abstracted torsos became increasingly animated, pinched at the center or at both ends to create voluptuous swelling forms. These works were made with chicken-wire armatures, onto which Benglis formed cotton, plaster and gesso; she worked, as is her habit, with the pieces on the floor and alternated their orientation throughout the process. The surfaces were then covered with gold leaf, a material consistent with Benglis's interest in highly reflective, ostentatious materials and in customs of adornment. Her use of gold, however, was triggered by the sudden rise in gold prices at this time and the concomitant public interest in the volatile gold market;[113] she subtly satirized the inflated sense of the element's preciousness by her extravagant use of it.

Fig. 50: Fernando La Rosa, *Gay Parade, New Orleans '89, Mardi Gras Week*, 1989, gelatin-silver print, 8 x 10 inches.

Fig. 51: Caryatids on the Erechtheum, the Acropolis, Athens.

Benglis endowed these torsos with unique bearing and personality. Some are Venuses from the lamé nightclub circuit. At times, she contrasts their shiny, superficial beauty with the awkwardness of their shapes, gilding images she considered "slug-like" in some cases. These works, she explained, "came from

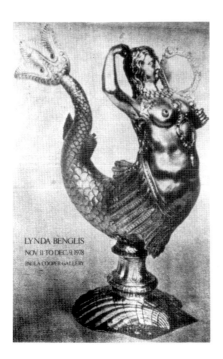

the unconscious—gold slugs that maybe should have been repressed I thought of them both as 'dumb' images and at the same time very classical forms related to Cycladic or Hellenistic art."[114] The bulbous gold torsos, with their forthright carriages, indeed reflect the fecundity of votive figurines and are reminiscent of female personages of Aegean art. Many of these columnar forms recall the erect postures of caryatids, the supportive sculptures of maidens found on classical Greek temples (fig. 51); several are titled after cities in Greece or figures from Greek mythology.

These torsos embody multiple metaphors. Their lyrical weightlessness and wave-like undulations are related to Benglis's experience of scuba diving and to her longstanding interest in the disorientation of form in space. She was fascinated with the physical sensation of buoyancy, for which she sought visual equivalents.[115] Not surprisingly, some of these torsos look distinctly aquatic, like the legendary beckoning mermaids of maritime fantasy,[116] with their chicken-wire armatures reading through the gold skin as a scalelike pattern. Benglis fully exploits the suggestive quality of these forms and their lurid surfaces. Here, the organicism and sensory effects are again as intense and powerfully felt as those of her early installation works. "They are a continuation of my icons," she explained, "all of which exist in a broad, symbolic reference to organic imagery in nature, proprioceptive responses, and to body gestures."[117]

Benglis's announcements for her exhibitions of these works underscored their content and revealed her cross-cultural comparison of female attitudes and imagery. For the invitation to the first showing of the torsos at Paula Cooper Gallery in November 1978, Benglis reproduced an ornate image of a table-top statuette of a mermaid, preening with mirror in hand (fig. 52). On the reverse, she quoted a passage from Jose Ortega y Gasset's *An Interpretation of Universal History*, in which he notes the uncanny resemblance of the "ladies" (seen in long flounced skirts and watching a bullfight) on a Minoan mosaic to a typical nineteenth-century scene in Seville.[118] To announce her exhibition of these works the following May at Dart Gallery in Chicago, Benglis used a photograph of herself dressed casually in jeans, standing in front of a group of the torsos and posed with arms folded and knee bent in a contrapposto stance similar to those of her figurative reliefs (fig. 53).

Through these configurations, Benglis addressed the issues of femininity and sexuality (seen as social, media-enforced constructs) that were central to her videotapes and advertisements. She explored what has become known to contemporary theorists as the theater of the feminine, a critical territory investigated in response to psychoanalytical thought, particularly to the theories of Jacques Lacan and his notion of femininity as a masquerade.[119] This body of discourse, along with theories of the male gaze based on Laura

Fig. 52: Lynda Benglis, invitation to exhibition at Paula Cooper Gallery, New York, 11 November-9 December 1978.

Fig. 53: Lynda Benglis, invitation to exhibition at Dart Gallery, Chicago, 11 May-8 June 1979.

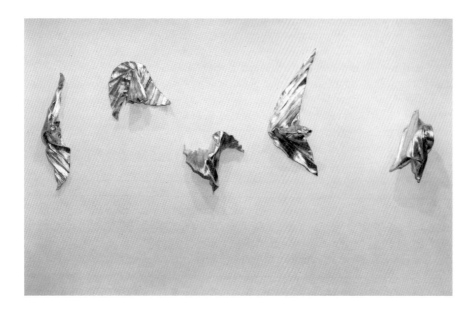

Mulvey's psychoanalytical studies of cinema, has predominated current feminist thinking and provides the foundation from which many artists are now exploring issues of gender and sexual difference.[120] Without benefit of such theoretical underpinnings, Benglis approached similar ground throughout her work of the 1970s. Her work, with its subtle sense of remove, runs parallel to current concepts and reflects, for example, Mary Ann Doane's analysis of the female "masquerade":

> The masquerade, in flaunting femininity, holds it at a distance. . . . The masquerade's resistance to patriarchal positioning would therefore lie in its denial of the production of femininity as closeness, as presence to itself The effectivity of masquerade lies precisely in its potential to manufacture a distance from the image, to generate a problematic within which the image is manipulable, producible, and readable by the woman.[121]

Such concerns are generalized within Benglis's imagery—addressed in abstracted terms and assimilated with her interest in organic form. Our response, as is her intention, remains poetic and metaphorical, rather than primarily political in reference.

The last of Benglis's gold, glamor queen torsos, the "Chicago Caryatids" of 1979, became wildly contorted, with sinuous, crinkled surfaces. After completing them, Benglis visited Crete and stopped in Paris on the way home, where she saw *Mer Egée, Grèce des Isles*, a major exhibition of Aegean art at the Louvre, from which she recalled a fragment of a funeral stele, crowned with a palmette motif.[122] Inspired by this object and interested in complicating the reflexivity of her surfaces even further, she began to pleat the screening of her armatures and fan them open into various forms. Benglis developed a new morphology: the lyrical gold images that followed recall wings, birds, shells, flowing shrouds, drapery and flowers. All are seemingly weightless visions, imbued with a sense of fleeting, fanciful movement and rococo fashion. These works were usually made as loose families of images which, when seen together, as with *Eclosion Grouping*, 1980 (fig. 54), are further animated by the implication of anecdotal relationships among the components. *One Dime Blues*, 1980 (cat. 30, p. 91), is one of several such works (e.g., *Amazing Grace* and *Cripple Creek*) named for popular songs. Its configuration refers to stylized, ritualistic dance movements, seen in partial profile like the relief figures on classical architectural friezes, whose frozen wind-whipped draperies these pleated forms recall.

Fig. 54: Lynda Benglis, *Eclosion Grouping*, 1980. Left to right: *Maya*, 45½ x 10 x 11 inches, collection of Jerry Speyer; *Amboda*, 23½ x 25½ x 11⁵⁄₁₆ inches, Philip and Cookie Wherry, Chicago; *Kaya*, 25 x 25 x 9⁷⁄₈ inches, collection of George Clark; *Pankh*, 49⅛ x 49½ x 11⅜ inches, collection of R. Hillman; *Mattha*, 27¼ x 16⁷⁄₈ x 13¾ inches, private collection.

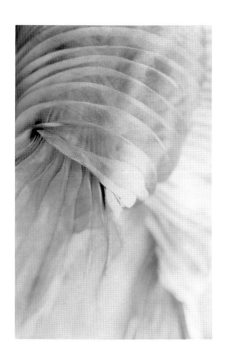

Avid experimentation with materials and techniques has always motivated Benglis's imagery, and she has often chosen to push difficult and unusual processes in unexpected directions. As she becomes proficient with a material, she develops a fertile give-and-take between its inherent possibilities and her ideas. The metalizing process, which she first used in the early 1970s, has proven for her to be an inventive means of melding image and form. Benglis returned to metalizing in 1981, and it has remained her primary medium for the past decade. Although she works with several fabricators in different parts of the country, she collaborates primarily with Jack Brogan, now in San Pedro, California, with whom she had first explored this industrial process.

Brogan, a craftsman, engineer and technical artist, works closely with Benglis to obtain the surface, finish and structural strength she desires.[123] Benglis pleats, knots and shapes fine wire mesh into a basic form (fig. 55), working with this understructure on the floor of Brogan's small factory, and then, in the final stages, on the wall. The object is then sprayed with fine layers of molten metal, using a metalizing gun into which the metal (bronze, copper, nickel or aluminum, for example) is fed as wire before being heated to about 2,500 degrees and mixed with compressed air. As the gun is passed repeatedly over the mesh (sometimes only an inch or so from the surface), the metal lodges in the armature and eventually builds up into a solid layer (fig. 56). The surface is then ground, a phase during which Benglis reworks the planes of certain passages to accentuate volume, texture and the effects of light, which are intensified by the pleats of the surface, as do the flutes of classical columns.[124] Benglis has chrome plated some of these works and at other times has experimented with chemical patinas that give her surfaces, as in *La Gonda L.G.6*, 1986 (cat. 36, p. 97), a very painterly quality.

The metalizing technique is particularly suited to Benglis's interest in transforming states of matter, in organic processes and in the comparisons of hard/ soft and liquid/solid that continue throughout her work. Her fascination with the alchemy of such processes is also manifest in her occasional small-scale

Fig. 55: Detail of wire mesh understructure before metalizing.

Fig. 56: Orlando Valle metalizing *Goliath*, 1989, by Lynda Benglis at Jack Brogan's workshop in San Pedro, California.

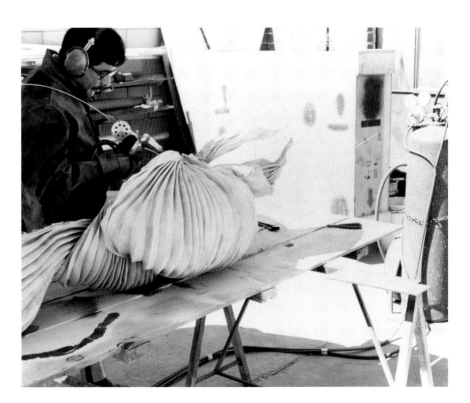

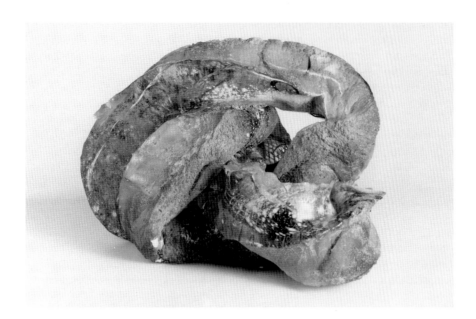

Fig. 57: Lynda Benglis, *Brindled Mad-tom*, 1985, sand-cast glass and bronze, 12¼ x 12½ x 11¾ inches, collection of High Museum of Art, Atlanta, purchase for The Elson Contemporary Glass Collection.

glass pieces (made since 1984), which are twisted and hand-shaped when molten (fig. 57).[125] These surfaces also maintain a sense of the material's inherent energy and tensile qualities. The metalized works in addition have an artifice fully in keeping with Benglis's ironic visual humor: the denseness and rigidity of the metal contrast enigmatically with the lyrical, flowing softness of her forms, whose obvious hollowness belies the permanence and monumentality associated with metal. Benglis exploits the reflectivity of the taut, skin-like metal surface, and creates an intricate facade that thwarts our comprehension of the mass and substance of these works. Although they appear transcendentally levitated, as if in orbit, the objects can in fact weigh as much as one or two hundred pounds.

Benglis's recent metalized forms seem to germinate, to have a torque and a pulse, yet simultaneously seem devoid of any sense of interior; they are mysteriously vivified. Like her early works, they suggest powerful physical sensations and natural forces, such as gravitational pull or the invisible processes of growth and decay. In spite of their anthropomorphic and often anatomical references, these objects lack all bodily presence, as if they were pure fanciful artifice or apparition. Seen silhouetted against walls and heightened by their deep theatrical shadows, the metalized forms appear disturbingly suspended in time, on a symbolic proscenium.

Many of Benglis's forms from the mid-1980s are distinctly floral, and reflect her longstanding interest in the exotic, magnificent forms of plant life. She characteristically superimposes metaphors, however, and her work remains simultaneously highly figurative; it frequently appears like deeply carved, luxuriant folds of baroque drapery that has been strangely vacated. Benglis's metalized knots are at times large bows that have been manipulated into ecstatic anthropomorphic configurations. For example, she originally thought of *Cassiopeia*, 1982 (cat. 31, p. 92), as a "bustle."[126] Usually centralized, obviously organic (and at times considered vaginal), these forms are comparable to the burgeoning, biological images similarly apparent, for example, in the paintings of Georgia O'Keeffe, and their "female" context was often taken as discomfiting.[127] Unlike Benglis's earlier gold torsos, with their extreme sense of fleshiness, her works of the mid-1980s are all skeletal understructure and skin. In spite of their elegance, they often have a slightly elegiac quality. There is a decadence to their drama, to the wild abandon of their Dionysian move-

ments and to the eroticism of their gleaming surfaces. Like the overripe fruits and opulent flowers of the northern still-life tradition, these images seem to point abstractly to the *vanitas* theme, like reminders of the transience of life and worldly pleasures.

Benglis's late knots have been discussed primarily in terms of their imagery—flowers, bows, flowing skirts and other fashions of female adornment. They have often been critically considered in the realm of frivolity to which such "girl's" imagery is typically relegated, and classified as decorative, a suspect pleasure in the vocabulary of mainstream contemporary art. Benglis, however, brings to these works her continuing interest in the theater of femininity. She chooses unabashedly to make art that is about beauty—about desire, embellishment and excess. As she has said, she focuses on "teasing the mind and the body."[128] Such visual delectation—a purely abstract, formalist definition of beauty—has of late been deemed a nostalgic and exclusivist aesthetic path. Benglis, however, has insistently asserted these metaphors, and thus established a female discourse within the realm of expressionistic abstraction.

Benglis endows her objects with an amazingly varied expressive potential, as she layers references to natural forms and cultural contexts. *Pictor*, 1983 (fig. 58), for example, is titled after a constellation in the southern hemisphere, the Latin root of which means "painter," and is thus a kind of abstract self-portrait. With its balletic movement, it (like *Perseus*, 1984, cat. 35, p. 96) has a specifically figurative, almost angelic, appearance. By constrast, *La Gonda L.G.6*, 1986 has the nearly sinister look of a dried and decaying organic specimen, with corrugations resembling the raised veins of a withering plant. It,

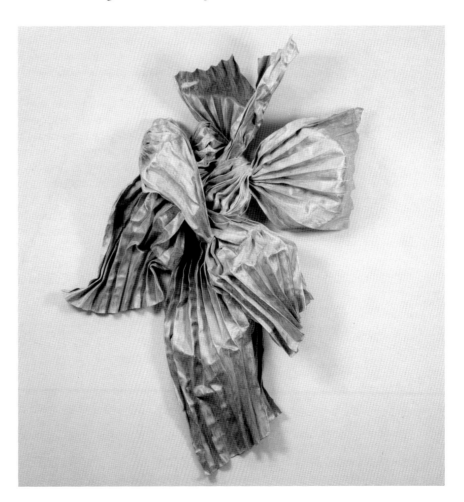

Fig. 58: Lynda Benglis, *Pictor*, 1983, zinc and aluminum on bronze mesh, 72 x 60 x 14 inches, private collection.

like others in a recent group of works, is named for an antique Italian car; these titles are, in part, an homage to the chrome surfaces (whose cool look and bulkiness appeal to the artist) and equally tell of Benglis's long interest in automobiles as compelling products of man's imagination.[129] Benglis's titles, whether taken from mythology, the names of stars or biological forms, underscore the multiplicity of her references and stimuli. Although lyrical, they frequently have an objective, scientific ring to them—her objects consequently seem discovered and classified like organic specimens.

When making these works, Benglis is essentially drawing forms in space, rather than working with mass in a traditional sculptural sense. The intertwined arabesques of her line are more readily apparent as one moves around her pieces, which read very differently from various vantage points. She has also experimented recently with pure linearity, inspired by the works and the drawings of David Smith, as seen in the welded metal assemblage pieces she completed in Greece and India in 1988 and 1989 (figs. 59, 60). In a series of neon works of the same year, such as *Red and Blue Jungle Gym* (cat. 38, p. 99), the glowing meandering tubes appear like multiple tracings of the profiles characteristic of her reliefs. With her neon works, Benglis has resumed experimentation with the high pitched, brash colors of vernacular art and has continued her fascination with the manipulation of light and its spatial effects.

By the late 1980s, Benglis's forms became increasingly complex and tense; in them, flowing curvilinear passages are interrupted by spiky angular forms. Rather than reading as one intricate but unified image or physical "gesture," her recent works incorporate multi-dominant components. Benglis now explores the interrelationship of part to part, and of part to whole in both formal and anecdotal terms. Her latest series of larger scale works are primarily about volume. Their billowing forms feel animated by an implied flow of air, like strangely organic kites blown by chaotic currents. The works are enlivened by a sense of sufflation, of biological expansion and contraction. For Benglis, they refer metaphorically to the process of respiration. *Super Two*, 1989 (cat. 39, p. 100), for example, has the feel of a pulsating organism, with its own internal energy. These turgescent works are quite different in expression from the angular forms that preceded them, which seem possessed by external rather than internal forces.

Benglis's objects of the past two years reflect a new, more luxuriant fullness and a corporeality that are nearly operatic in effect. The lumbering, ample quality of her recent works is, for the artist, tied to her fascination as a child with large animals, such as whales and elephants, and in their slow, rolling movement, which she experienced when riding elephants in India. These works, for her, come full circle to the organicism of early pieces, such as *Eat Meat* (cats. 18 and 19, pp. 80, 81), with their similar sense of bloating and fermenting. The vitality of Benglis's forms—whether frozen in animation in polyurethane or a host of richly colored metals—seems strangely distanced: it is as if her works were anxious mementos of fleeting time. Like the shed skin of a snake, a dried flower, or the elusive images in a mirror, they have an elegiac sense of simultaneous presence and absence.

Fig. 59: Lynda Benglis, *Drawing*, 1988, iron and found objects, 22 x 16 x 16 feet, installation on stone gateway, Agios Nikolaos, Crete, Greece.

Fig. 60: Lynda Benglis, *Odds and Ands #4*, 1988, iron, 99 x 48 x 55 inches, private collection, India.

Benglis titled the first show of her metalized knots ΕΙΔΩΛΑ, the classical Greek word for idols. It is an appropriate appellation for her work, rooted in meaning to the words form, image and phantom; it aptly reflects her interest in iconic presence, in the ritualization of the creative process and its metaphysical aspects. Yet the term carries connotations of excessive admiration and hedonism and, in this context, conjures up vaguely fetishistic notions of

objects bewitched by charm. Benglis has indeed created works of [cut off]
and at times pointedly vulgar–beauty and eroticism, as she has ma[cut off]
her ungainly materials with technical bravura and lush imaginatio[cut off]
joyously indulged in visual stimulation and effusiveness to a degre[cut off]
found in contemporary art. "There will always be a Puritan strain in society
that gets nervous if things are too pleasurable, too beautiful or too open," she
acknowledges. "That's the most significant legacy of feminist art; it taught us
not to be afraid to express these things."[130]

Benglis celebrates sensory experience, the intricacies of light and the primal
sense of touch. Her work is about desire, memory and metaphors suggested to
us through our anatomy–by the life of the senses as well as that of the mind.
Her work is rooted in the experiential and based on staging a heightened reality of visual and physical stimuli in which to partake. Throughout her career,
Benglis has explored–and has awakened us to–the theaters of organic nature
and of our social nature, and the pleasures and the quandaries inherent
therein.

NOTES

1. Quoted in interview with Robert James Coad in *Between Painting and Sculpture: A Study of the Work and Working Process of Lynda Benglis, Elizabeth Murray, Judy Pfaff and Gary Stephan* (Ann Arbor, Michigan: UMI Dissertation Information Service, 1988), 241 (copyright 1983).

2. "Interview: Linda [sic] Benglis," *Ocular* (Denver) 4, no. 2 (Summer 1979): 41.

3. Coad, 239, 243-44. See also interview with Ned Rifkin in Lynn Gumpert, Ned Rifkin, and Marcia Tucker, *Early Work* (New York: The New Museum, 1982), 7.

4. Rifkin, 9.

5. Benglis first saw Kline's works at The Isaac Delgado Museum of Art (now the New Orleans Museum of Art) in 1960, in the exhibition *The World of Art in 1910* (15 November-31 December), organized in celebration of the museum's fiftieth anniversary. Kline was born in 1910, and was thus included in the exhibition by the director, Sue M. Thurman. The exhibition catalogue lists four of his works (*Study in Black and White*, numbers 1-4, all dated 1960). Telephone conversations between James B. Byrnes, former director of the North Carolina Museum of Art, in Los Angeles, and Shella De Shong, research assistant, HMA, 8 June 1990, notes in HMA files; and William Fagaly, assistant director of art, New Orleans Museum of Art, and Carrie Przybilla, assistant curator of twentieth-century art, HMA, 6 July 1990, notes in HMA files.

6. Author's interview with the artist, 26 October 1989, New York, transcript in HMA files.

7. Quoted in Robert Pincus-Witten, "Lynda Benglis: The Frozen Gesture," *Artforum* (New York) 13, no. 3 (November 1974): 55.

8. *Untitled*, 1966, Plexiglas, 49 x 5 inches, is the only editioned object (excluding bronzes) Newman made. It is part of a group of four multiples (including pieces by Oldenburg, Guston, and Rivers) that were coordinated by Marion Goodman and fabricated by Bob Kulicke in editions of approximately 125. Author's telephone conversation with Annalee Newman, 5 June 1990, notes in HMA files.

9. Rifkin, 8.

10. Author's interview with the artist, 29 October 1989, East Hampton, New York, transcript in HMA files.

11. Coad, 239.

12. From Flavin's lecture at The Brooklyn Museum Art School on 18 December 1964, reprinted in " . . . in daylight or cool white," in *Dan Flavin* (Ottawa: The National Gallery of Canada, 1969), 20. An edited version of the first half of Flavin's lecture is published therein on pp. 8-22. Flavin's talk was edited for publication as "' . . . in daylight or cool white.': an autobiographical sketch," *Artforum* (New York) 4, no. 4 (December 1965): 20-24.

13. Author's conversation with the artist, 7 July 1989, New York, notes in HMA files.

14. Artist's statement in *Art in Process IV* (New York: Finch College Museum of Art, 1969), n.p.

15. Ibid.

16. *Helen Frankenthaler*, organized by the Whitney Museum of American Art and The International Council of The Museum of Modern Art, was on view at the Whitney from 20 February to 6 April 1969. The exhibition catalogue includes an essay by E. C. Goossen and was published by Frederick A. Praeger, New York. *Odalisque (Hey, Hey Frankenthaler)* is in the collection of the artist.

17. Quoted in Karen Edwards, "The Interview/9—Lynda Benglis," *The Herald* (city unknown), 13 June 1971, sec. 2:11 (copy in HMA files).

18. Quoted in S. R. Dubrowin, "Latex—One Artist's Raw Material," *Rubber Developments* (London) 24, no. 1 (1971): 11.

19. Author's conversation with the artist, 30 October 1989, East Hampton, New York, notes in HMA files.

20. "Interview: Linda [*sic*] Benglis," *Ocular*, 40.

21. Rifkin, 11.

22. Ibid.

23. Quoted in Jan Butterfield, "'Poured Art' Sculptor Reveals Technique, Approach to Style," *Fort Worth Star-Telegram*, 14 June 1970, sec. 1:6.

24. Author's conversation with the artist, 26 October 1989, New York, notes in HMA files.

25. Rifkin, 11.

26. Rifkin, 10-11. Around 1951, Pollock made a sculpture some five feet long, using discarded ink on rice paper drawings soaked in glue, which he applied over a chicken-wire armature. The work (O'Connor and Thaw, cat. no. 1054) was shown at Peridot Gallery from 27 March to 21 April 1951 in *Sculpture by Painters*; it was destroyed in the summer of 1951. In 1949-50, Pollock also made several small paint-splattered terra-cotta sculptures and a few diminutive works of wire dipped in plaster, then dripped with paint. See Francis Valentine O'Connor and Eugene Victor Thaw, *Pollock: A Catalogue Raisonné of Paintings, Drawings, and Other Works* (New Haven, Connecticut: Yale University Press, 1978), 4, 120-21, 127-30. In the interview with Rifkin, Benglis refers to Pollock's supposed ceiling-hung phosphorescent painting; however, no paintings using such pigments are listed in Pollock's catalogue raisonné. Benglis might have misconstrued a reference to *Phosphorescence*, 1947, oil and aluminum on canvas, 44 x 26 inches, which was shown at Betty Parsons Gallery in 1948. See O'Connor and Thaw, 1:182-83 (cat. no. 183).

27. Quoted in Rosalind Constable, "New Sites for New Sights," *New York Magazine* (New York) 3, no. 2 (12 January 1970): 44.

28. Coad, 239.

29. For thorough descriptions of Benglis's early installations, see Klaus Kertess, "Foam Structures," *Art and Artists* (London) 7, no. 2 (May 1972): 32-37.

30. Of these works, only *Phantom*, which has yellowed and cracked with time, still exists. One of its five components is in a private collection in Lawrence, Kansas; and four are in storage at the Student Union, Kansas State University, Manhattan. Correspondence from Raymond Goetz to Julie Graham at Paula Cooper Gallery, 26 May 1989, copy in HMA files. There are numerous documentary photographs of Benglis's installations. Excellent photographs of *Adhesive Products* are in the artist's archives. *Lynda Benglis Paints with Foam (Totem)* by Ann McIntosh and Don Schaefer (Cambridge, Massachusetts: Video/One Production, 1971, black and white, 27 minutes) is a video documentary of her installation at MIT. In the artist's archives are also six reels of color super-8 footage of the making of *Phantom*; three reels of color super-8 footage of the finished piece, *Pinto*; two reels of black and white super-8 footage of the making of *Totem*.

31. Author's interview with the artist, 26 October 1989.

32. *Phantom* was, however, only seen in regular gallery light. *For Darkness* was shown alternately in light and darkness.

33. The title refers to Klaus Kertess, a partner in Bykert Gallery (where Benglis had worked and shown) and a close friend. He wrote of *For and Against*: "What makes this piece bearable (good) is that it is not just for and against 'me' but for and against 'you,'" in "Foam Structures," *Art and Artists*, 35.

34. See Bruce Schwartz, "Adhesive Product," *The Tech* (Cambridge, Massachusetts: Massachusetts Institute of Technology), 16 November 1971, 11. At one point, Benglis used this title to refer to her entire series of polyurethane installations. The piece at MIT's Hayden Gallery was finally titled *Totem*.

35. Kertess, "Foam Structures," *Art and Artists*, 35.

36. Hilton Kramer, "Grace, Flexibility, Esthetic Tact," *New York Times*, 30 May 1971, sec. 2:19.

37. Robert Pincus-Witten, "New York:

Lynda Benglis," *Artforum* (New York) 10, no. 4 (December 1971): 79.

38. Grace Glueck, "New York: Trendless but Varied, the Season Starts," *Art in America* (New York) 59, no. 5 (September-October 1971): 122.

39. Author's interview with the artist, 29 October 1989, and telephone conversation with the artist, 20 June 1990, notes in HMA files.

40. Benglis went to California during a break in the Walker Art Center installation to see *Art and Technology* at Los Angeles County Museum of Art. She was intrigued with the "strangeness" of California culture, and with what she regarded as the unnatural force of occurrences there, such as the Charles Manson murders in the summer of 1969, which she obliquely related to extreme, destructive natural phenomena like earthquakes. There was a relatively mild quake in southern California on 9 February 1971, shortly before her first visit there.

41. Author's interview with the artist, 29 October 1989.

42. Rifkin, 10.

43. See Mary Beth Edelson, "Objections of a 'Goddess artist': An Open Letter to Thomas McEvilley," *The New Art Examiner* (Chicago) 16, no. 8 (April 1989): 34-38, for a historical summary of feminist approaches to nature, the use of the body, and earth goddess metaphors. Edelson also discusses the patriarchal devaluation of such associations with nature and the traditional polarization of nature and culture, to the detriment of women artists. Edelson's text was written in reaction to McEvilley's application of a dichotomous nature/culture construct in his lecture at Artemisia Gallery, Chicago, in the fall of 1988.

44. *Eat Meat*, 1969, cast in 1974 in bronze and aluminum; *Modern Art I*, 1970, cast in 1974 in bronze and aluminum; *Quartered Meteor*, 1969, cast in 1975 in lead (the raw material of alchemy); and *Wing*, 1970, cast in 1975 in aluminum.

45. Rifkin, 12.

46. Author's conversation with the artist, 7 July 1989, notes in HMA files.

47. As the critic Douglas Crimp noted, the cylindrical fiberglass forms of Eva Hesse's *Tori*, 1969, are antecedents of Benglis's totems. See "New York," *Art International* (Lugano) 17, no. 3 (March 1973): 41.

48. Author's interview with the artist, 29 October 1989.

49. Ibid.

50. "Interview: Linda [*sic*] Benglis,"

Ocular: 41.

51. Author's interview with the artist, 26 October 1989. Benglis knew both Chamberlain and Bengston. She was perhaps also inspired by the series of knotted and twisted urethane foam works Chamberlain made in 1969-70, many of which have painted surfaces, as much as by his candy-colored crumpled balls of 1972-73, composed of industrial weight aluminum foil, sprayed with acrylic lacquers and polyester resins. See Julie Sylvester, *John Chamberlain: A Catalogue Raisonné of the Sculpture, 1954-1985* (New York: Hudson Hills Press and The Museum of Contemporary Art, Los Angeles, 1986), 123-29. It is not inconsequential that many of the configurations of Chamberlain's works are anthropomorphized (for example, *Norma Jean Rising*, 1967, a reference to Marilyn Monroe) or that he referred to the "fit" of their component elements in sexual terms. See Carter Ratcliff, "Five American Sculptors," in *Lynda Benglis, John Chamberlain, Joel Fisher, Mel Kendrick, Robert Therrien* (Stockholm, Sweden: Magasin 3 Stockholm), n.p. Moreover, Chamberlain's use of automobile parts is related to the underlying erotics of American car culture and the fantasy of the "sexy" automobile as a reflection of the consumer's identity. See Klaus Kertess, "Color in the Round and then Some: John Chamberlain's Work, 1954-1985," in *John Chamberlain: A Catalogue Raisonné of the Sculpture, 1954-1985*, 30. Benglis's early loose knotted forms are also reminiscent of Richard Serra's vulcanized rubber-belt pieces of 1966-67, which similarly evoke Pollock's interwoven tangled webs.

Made in the late 1960s, Bengston's works were formally titled *Cantos Indentos*, in punning reference to Newman's *Stations of the Cross*. See Karen Tsujimoto, "Painting as a Visual Diary," in *Billy Al Bengston: Paintings of Three* (San Francisco: Contemporary Arts Museum, The Oakland Museum, and Chronicle Books, 1988), 25.

52. Author's interview with the artist, 26 October 1989.

53. Author's telephone conversation with the artist, 20 June 1990.

54. Rifkin, 13.

55. Author's conversation with the artist, 26 October 1989.

56. Author's interview with the artist, 29 October 1989. Benglis participated in theater productions in high school and briefly studied theatrical

make-up. Her interest in masks was longstanding, and she collected Mexican masks on her travels.

57. Quoted in France Morin, "Lynda Benglis in Conversation with France Morin," *Parachute* (Montreal), no. 6 (Spring 1977): 11. In conversation, Benglis elaborated on this oblique reference to muskrats and our attraction to shiny things, explaining that she remembered reading as a child that muskrats gathered highly reflective objects and detritus to decorate themselves, and that she considered the impulse for body ornamentation primal and animistic.

58. Author's conversation with the artist, 16 March 1990, notes in HMA files.

59. Artist's statement in *Jack Brogan: Projects* (Pasadena, California: Baxter Art Gallery, California Institute of Technology, 1980), 8.

60. Vivien Raynor, "The Art of Survival (and Vice Versa)," *The New York Times Magazine*, 17 February 1974, 50. Whereas several of the knots titled for the phonetic military alphabet were indeed modeled after specific letters, those titled for Greek letters were not.

61. *The Encyclopedia Americana: International Edition*, Vol. 23 (Danbury, Connecticut: Grolier Incorporated, 1986), 103.

62. Artist's statement in *American Artists '76: A Celebration* (San Antonio, Texas: Marion Koogler McNay Art Institute, 1976), n.p.

63. Author's interview with the artist, 30 October 1989, East Hampton, New York, transcript in HMA files.

64. Author's telephone conversation with the artist, 20 June 1990.

65. "I got involved with video. I saw it was a big macho game, a big, heroic, Abstract Expressionist macho sexist game. It's all about territory. How big?" Pincus-Witten, "Lynda Benglis: The Frozen Gesture," *Artforum* 58.

66. For a thorough discussion of Benglis's videotapes, see Robert Pincus-Witten, "Benglis' Video: Medium to Media," in *Physical and Psychological Moments in Time: A First Retrospective of the Video Work of Lynda Benglis* (Oneonta, New York: Fine Arts Center Gallery, State University of New York College at Oneonta, 1975), n.p.

67. Ibid.

68. Jonathan Price, *Video-Visions: A Medium Discovers Itself* (New York: New American Library, 1977), 187.

69. Author's interview with the artist, 29 October 1989. Warhol had asked Benglis and her boyfriend to appear in one of his films, and to make love on camera. She refused this intrusion, declaring, "I wasn't interested in being the object of someone else." She was, however, fascinated by "the fact that it was an area of consideration" and frequently refers to the incident when discussing her interest in the relationship between the media and sexuality, in sexual ambiguity, and the manipulation of private and public spaces.

70. Author's interview with the artist, 29 October 1989.

71. Ibid.

72. Pronounced in French, the initials of the punning title ("look" in English) read, *"elle a chaud au cul"* (she has a hot behind), in Duchamp's words, "a very risqué joke on the Gioconda." See Anne d' Harnoncourt and Kynaston McShine, *Marcel Duchamp* (New York: The Museum of Modern Art and Philadelphia Museum of Art, 1973), 289.

73. See Arlene Raven, *Crossing Over: Feminism and Art of Social Concern* (Ann Arbor, Michigan: UMI Research Press, 1988), 3-11, for an analysis of the issue of female sensibility, as addressed by the theories and in women's artwork of the 1970s.

74. Quoted in Morin, 10: "I had been using my face or myself in the video and this built up notions of female sensibility. . . . I got tired of people asking me: 'is there such a thing as female sensibility' and I decided to really sock it to them, I said yes this is it."

75. Pincus-Witten, "Benglis' Video: Medium to Media," in *Physical and Psychological Moments in Time*, n.p., and the author's interview with the artist, 29 October 1989.

76. Chris Straayer, "Sexuality and Video Narrative," *Afterimage* (Rochester, New York) 16, no. 10 (May 1989): 9.

77. Arlene Raven, "Star Studded: Porn Stars Perform," in *Crossing Over: Feminism and Art of Social Concern* (Ann Arbor, Michigan: UMI Research Press, 1988), 174.

78. Author's interview with the artist, 30 October 1989. It is not clear how many preliminary tapes Benglis and Morris worked on together. He mentions at least seven and hints at possibly fourteen more. See Pincus-Witten, "Benglis' Video: Medium to Media," in *Physical and Psychological Moments in Time*, n.p., and Robert Morris, "Exchange '73: From a Videotape," *Avalanche* (New York), no. 8 (Summer/Fall 1973): 23-24.

79. See Robert Morris, "Exchange '73: From a Videotape," 22-25, for the

text of the voice-over narration. Benglis, however, recalls saying "objects in front of behavior."

80. David Antin, "Art & Information, 1: Grey Paint, Robert Morris," *Artnews* (New York) 65, no. 2 (April 1966): 58.

81. "Interview: Linda [sic] Benglis," *Ocular*, 34.

82. Lucy R. Lippard, "Transformation Art," *Ms.* (New York) 4, no. 4 (October 1975): 34. Benglis said of the "macharina" advertisement, "It was self-referential, I did have that car, I was very involved with that car in Los Angeles, a car is a very important symbol, say it's a kind of extension of the body. It was referential in that art world, and Los Angeles had long been using kind of funny announcements in some ways more self-referential and punning the star system in Hollywood as well as their own situation there." Morin, 9.

83. Because of the consecutive timing of their shows, Benglis's image was misinterpreted as a direct response to Morris's poster; it was in actuality made well beforehand and was a continuation of her earlier interests. For the artists' comments regarding their mutually referential advertisements, see "Collage," *Artnews* (New York) 73, no. 7 (September 1974): 44.

84. "Interview: Linda [sic] Benglis," *Ocular*, 34.

85. Rifkin, 14.

86. "Interview: Linda [sic] Benglis," *Ocular*, 32.

87. Quoted in Sandy Ballatore, "Lynda Benglis' Humanism," *Art Week* (San Jose, California) 7, no. 21 (22 May 1976): 6.

88. Benglis had made other series of nude Polaroids, including several with the artist Ray Johnson, and printed a couple of them (thus all of these images are often erroneously referred to as postcards). Benglis showed these works in her slide lectures, such as one she presented in Buffalo on 17 February 1976 (co-sponsored by HALLWALLS Contemporary Arts Center and the Center for Media Studies, State University of New York at Buffalo), at which Robert Longo and Cindy Sherman, then students, were present.

Although Pincus-Witten claims these Polaroids are parodies of mannerist and hellenistic postures (see "Lynda Benglis: The Frozen Gesture," *Artforum* 59), Benglis denies they were appropriations. They were, she says, more off-handed parodies of sexual poses. Author's

conversation with the artist, 20 June 1990. Some of these works were shown at The Kitchen, 8-15 November 1975. The announcement for both this show and a concurrent exhibition of her sculptures at Paula Cooper Gallery featured *Parenthesis*, 1975, a pair of castings (in aluminum and in lead) of the double-headed dildo, enshrined in a velvet box, facing each other.

Benglis originally had considered staging a male/female pinup with Morris, yet ultimately decided she wanted to make the statement herself. She recounts being encouraged and "given permission" by Morris and Pincus-Witten to undertake the *Artforum* project, and being supported in her decision to work within the context of an advertisement by Paula Cooper. See Morin, 11.

89. See, respectively, *Artforum* (New York) 5, no. 5 (January 1967): 7; and 9, no. 4 (December 1970): 36; and *Art in America* (New York) 76, no. 11 (November 1988): 51.

90. Artist's statement, "Louise Bourgeois: A Merging of Male and Female," in Dorothy Seiberling, "The Female View of Erotica," *New York Magazine* (New York) 7, no. 6 (11 February 1974): 56.

91. For example, such references permeate Oldenburg's work, embedded in his seemingly banal imagery as they were in Benglis's abstractions. As he said of his scissors, for example, "I like to make my images as referential as possible, and if I can possibly refer to both the female and male anatomy, that's best. The scissors are very definitely bisexual. They can be seen as phallic, or as an ovarian symbol, and they can also be conceived of as instruments of castration." John Coplans, "The Artist Speaks: Claes Oldenburg," *Art in America* (New York) 57, no. 2 (March-April 1969): 74.

92. Antin, 58. For discussions of related contemporaneous works that address similar issues of sexuality and role-playing, see also Robert Pincus-Witten, "Scott Burton: Conceptual Performance as Sculpture," *Arts Magazine* (New York) 51, no. 1 (September 1976): 112-17; Cindy Nemser, "Four Artists of Sensuality," *Arts Magazine* (New York) 49, no. 7 (March 1975): 73-75; and Lucy R. Lippard, "The Pains and Pleasures of Rebirth: Women's Body Art," *Art in America* (New York) 64, no. 3 (May-June 1976).

93. See Michael Bonesteel, "Art and the New Androgyny," *The New Art*

Examiner (Chicago) 6, no. 10 (Summer 1979): 9.

94. At the time, *Artforum* had a circulation of about 18,000. The general press quickly picked up the story of Benglis's advertisement. See John Corry, "About New York: A Serious Dirty Picture?" *The New York Times*, 22 November 1974, 78, and Dorothy Seiberling, "The New Sexual Frankness: Good-by to Hearts and Flowers," *New York Magazine* (New York) 8, no. 7 (17 February 1975): 37-44, for evaluations of the events preceding the advertisement and of reactions. See also Walter Robinson, "Role, Style, Media," *Art-Rite* (New York), no. 10 (Fall 1975): n.p., for a cultural/economic analysis of Benglis's and other artists' "media performances." Robinson discusses the relationship of the art media to careerism and the art magazines' presentation of a fantasy of success to their subscribers. For readers' responses to the advertisement, see *Artforum* (New York) 13, no. 4 (December 1974): 9, and 13, no. 7 (March 1975): 8, 9.

95. Alloway, Kozloff, Krauss, Masheck, Michelson, "Letters," *Artforum* (New York) 13, no. 4 (December 1974): 9. Their response read:

> To the Editor:
>
> For the first time in the 13 years of *Artforum*'s existence, a group of associate editors feel compelled to dissociate themselves publicly from a portion of the magazine's content, specifically the copyrighted advertisement of Lynda Benglis photographed by Arthur Gordon and printed by courtesy of the Paula Cooper Gallery in the November, 1974, issue of the magazine. The history of the copyright mark and the "courtesy," so anomalous among the advertisement, needs to be told. Ms. Benglis, knowing that the issue was to carry an essay on her work, had submitted her photograph in color for inclusion in the editorial matter of the magazine, proposing it as a "centerfold" and offering to pay for the expenses of that inclusion. John Coplans, the editor, correctly refused this solicitation on the grounds that *Artforum* does not sell its editorial space. Its final inclusion in the magazine was therefore as a paid advertisement by some arrangement between the artist and her gallery. The copyright and the caption linger as vestiges of the artist's original intention.
>
> We want to make clear the reasons why we object to its appearance within *Artforum*'s covers:
>
> 1. In the specific context of this

journal it exists as an object of extreme vulgarity. Although we realize that it is by no means the first instance of vulgarity to appear in the magazine, it represents a qualitative leap in that genre, brutalizing ourselves and, we think, our readers.

2. *Artforum* has, over the past few years, made conscious efforts to support the movement for women's liberation, and it is therefore doubly shocking to encounter in its pages this gesture that reads as a shabby mockery of the aims of that movement.

3. Ms. Benglis's advertisement insinuates two interconnected definitions of art-world roles that are seriously open to question. One is that the artist is free to be exploitative in his or her relation to a general public and to that community of writers and readers who make *Artforum*. The other is that *Artforum* should be a natural accomplice to that exploitation, for the advertisement has pictured the journal's role as devoted to the self-promotion of artists in the most debased sense of that term. We are aware of the economic interdependencies which govern the entire chain of artistic production and distribution. Nonetheless, the credibility of our work demands that we be always on guard against such complicity, implied by the publication of this advertisement. To our great regret, we find ourselves compromised in this manner and that we owe our readers an acknowledgement of that compromise.

This incident is deeply symptomatic of conditions that call for critical analysis. As long as they infect the reality around us, these conditions shall have to be treated in our future work as writers and as editors.

Lawrence Alloway
Max Kozloff
Rosalind Krauss
Joseph Masheck
Annette Michelson
New York, N.Y.

96. Quoted in Janet Malcolm, "Profiles: A Girl of the Zeitgeist-1," *The New Yorker* (New York) 62, no. 35 (20 October 1986): 50.

97. Peter Plagens, "Letters," *Artforum* (New York) 13, no. 4 (December 1974): 9, and Robert Rosenblum, "Letters," *Artforum* (New York) 13, no. 7 (March 1975): 8-9.

98. Lynda Benglis, "Social Conditions Can Change," in "Eight Artists Reply: Why Have There Been No Great Women Artists?" *Artnews* (New York) 69, no. 9 (January 1971): 43.

99. "Un-Skirting the Issue," *Art-Rite* (New York), no. 5 (Spring 1974): 6.

100. Cindy Nemser, "Lynda Benglis—A Case of Sexual Nostalgia," *The Feminist Art Journal* (Brooklyn, New York) 3, no. 4 (Winter 1974-75): 7, 23. See also, in the same issue, Shelly Killen, "Letters," 2.

101. Lippard, "The Pains and Pleasures of Rebirth: Women's Body Art," in *Art in America*, 75.

102. Seiberling, "The New Sexual Frankness," in *New York Magazine*, 44.

103. Ibid. Perhaps the most unnerving response to Benglis's advertisement came from *Playboy* magazine, which, she recalls, wanted to use her image in an article on women artists. Benglis in return offered to do a take-off (using professional models) on a traditional pieta, depicting a beautiful girl as the madonna with a nude man in her lap—a postmodern revision that (although rejected by the magazine) seems strangely ahead of its time in addressing the latent sexuality within such traditional art historical images. Author's interview with the artist, 30 October 1989.

104. Carol Zemel, "Postmodern Pictures of Erotic Fantasy and Social Space," *Genders* (Austin, Texas), no. 4 (March 1989): 32.

105. For a theoretical discussion of masquerade in the context of fashion photography and a proposition of an alternative "female gaze," see Sylvia Kolbowski, "Playing with Dolls," in *The Critical Image: Essays on Contemporary Photography*, ed. Carol Squiers (Seattle: Bay Press, 1990), 139-54.

Benglis had been disturbed by the reaction to her Betty Grable advertisement and particularly by the comment of a female gallery-goer who asked Paula Cooper "who did that to her?". The *Artforum* advertisement was conceived to thwart any such misunderstanding of Benglis's directorial position.

106. See Thomas McEvilley, "Who Told Thee That Thou Wast Naked," *Artforum* (New York) 25, no. 6 (February 1987): 105, quoting the anti-pornography law professor Catharine MacKinnon's arguments. McEvilley, 102-8, offers an analysis of contemporary attitudes toward art and pornography.

107. See Eleanor Heartney, "A Necessary Transgression," *New Art Examiner*

(Chicago) 16, no. 3 (November 1988): 20-23. As Heartney states, "Pornography is popular among postmodern artists because it offers a vivid symbol of the process by which we are remade into objects," 20.

108. Benglis initially wanted the image to appear as a centerfold artist's statement without further context, which the editors would not permit.

109. Walter Robinson, "Storytelling, Infantilism and Zoöphily," *Art-Rite* (New York), no. 19 (June/July 1978): 30.

110. Author's interview with the artist, 29 October 1989.

111. Benglis also made two series of cast paper multiples entitled "Lagniappe I," 1978, and "Lagniappe II," 1979, whose forms are very shield-like. The surface treatment of each work in these series is unique and is strongly related to the geometric patterning of African sculpture.

112. Lucy R. Lippard, "Centers and Fragments: Women's Spaces," in *Women in American Architecture: A Historic and Contemporary Perspective*, ed. Susana Torre (New York: Whitney Library of Design/Watson-Guptill Publications, 1977), 188.

113. Gold prices first jumped during the oil crisis of 1973-74, then rose again beginning in the summer of 1977, from $140 an ounce to $350 an ounce by the summer of 1979. Gold prices, based on the London gold fixing, peaked at $670 an ounce in the first half of 1980.

114. Coad, 247.

115. Author's telephone conversation with the artist, 20 June 1990.

116. On *Daphne*, 1978, chicken wire, cotton, gesso, plaster, gold leaf, paint, mylar, 90 x 17 x 9 inches, private collection, for example, Benglis painted wavy lines and blue passages, underscoring the aquatic references (a strange contradiction given the mythological nymph's woodland habitat).

117. "Interview: Linda [sic] Benglis," *Ocular*, 42.

118. The quotation reads in full:

> This hypothesis would at least explain the surprising fact that there has been dug up in Crete a mosaic whose chronology is attributed to thirteen hundred or fourteen hundred years before Christ, in which ladies appear dressed in mantillas and long flounced skirts, seated in a box and watching, with complete verisimilitude, a bull-fight. That is to say, a picture—it is almost photographic—of what could have been seen in Seville around 1890. Certainly it would be curious to find out how many of you understand precisely what "flounces" are; because if you do not understand it, we would have a very simple but significant fact which could symbolize the radical change in Spain from 1900 up to now. In fact, I would say more: I would dare to say that if the greater part of you do not know perfectly what "flounces" means, this is due, as one of the principal causes, to Marxism. You will think me foolish or extravagant. Nevertheless, if we applied the intellectual magnifying glass to the fact, we would see how the study of this most simple, humble, and trivial fact of the present wide ignorance of that word, which in 1900 all Spaniards knew, revealed to us deep secrets of what has happened in the half century of our present history. A simple example of how the study of words leads us to the discovery of historic human realities. (Jose Ortega y Gasset, *An Interpretation of Universal History*, trans Mildred Adams [New York: W. W. Norton & Co., 1973], 136.)

Ortega y Gassett's text was derived from his inaugural course given at Instituto de Humanidades in 1948. Ron Gorchov introduced Benglis to the text. She was interested in the historical reference to "flounce" imagery as a timeless expression of cultural humanism; she used the text in rebuttal to the detached Marxist position on material culture, then popular in artistic circles. Author's conversation with the artist, 31 August 1990, notes in HMA files.

119. Originally posited by Joan Rivière, the theory of masquerade was adopted by Jacques Lacan, who considered femininity a construct created in reference to the male. He wrote: "Man here acts as the relay whereby the woman becomes this Other for herself as she is this Other for him." Jacques Lacan, *Feminine Sexuality*, ed. Juliet Mitchell and Jacqueline Rose, trans. Jacqueline Rose (New York: Pantheon Books, 1982), 93.

120. Pivotal to this discourse is Laura Mulvey's ground-breaking article "Visual Pleasure and Narrative in Cinema," *Screen* (London), no. 3 (Autumn 1975): 6-18, reprinted in *Art After Modernism: Rethinking Representation*, ed. Brian Wallis (New York: The New Museum, and Boston: David R. Godine, 1984), 361-73. See also, for example, Laura Trippi, *Girls Night Out (Femininity as Masquerade)* (New York: The New

Museum, 1988), an exhibition brochure.

121. Mary Ann Doane, "Film and the masquerade: theorizing the female spectator," *Screen* (London) 23, no. 3/4 (September-October 1982): 77, quoted in Kolbowski, "Playing with Dolls," in *The Critical Image*, 146.

122. *Mer Egée, Grèce des Isles* was on view at the Musée du Louvre from 26 April to 3 September 1979, and traveled to the Metropolitan Museum of Art in New York as *Greek Art of the Aegean Islands*. See cat. no. 169, marble finial of a funerary stele with palmettes and volutes, Parian, c. 480 B.C., height approx. 36¼ inches, Paros Museum inventory #108, illustration and entry in *Greek Art of the Aegean Islands* (New York: The Metropolitan Museum of Art, 1979), 209. Benglis had briefly experimented with fan shapes made of cloth and plaster around 1972, concurrently with her first "totems."

123. Benglis originally met Brogan through Robert Irwin, who lived above his shop in Venice, California, in the early 1970s. Brogan has also worked extensively with Irwin, Robert Therrien, and John McCracken. He collaborates closely with artists during the process of fabrication, and is highly experimental and inventive in the use of materials. See Margaret Honda, "Interview: Jack Brogan," *Visions Art Quarterly* (Los Angeles) 4, no. 3 (Summer 1990): 28-31, and Michael H. Smith, *Jack Brogan: Projects* (Pasadena, California: Baxter Art Gallery, California Institute of Technology, 1980), an exhibition catalogue.

124. Author's telephone conversation with Jack Brogan, 20 June 1990, notes in HMA files. After this initial grinding, the surfaces are repeatedly polished with grits to achieve a high sheen.

125. Benglis began to work with glass in 1984 and has made made numerous small-scale glass works, into which she has fused powdered pigments, ceramic fragments, stones, and various other substances. The roughly hewn pieces are partially sandblasted and maintain a sense of primal moltenness. In them, she frequently contrasts opaque passages and areas of glistening transparency, in keeping with her manipulation of light. The forms of these works are often coiled and snake-like. A series of recent pieces refers to fish and their adaptive coloration. Benglis has also made occasional works in the media of fabric, cast paper, prints, and collage; her works in paper and in silk (and their intense hues) have been particularly influenced by her extended stays in India.

126. Author's conversation with the artist, 7 July 1989.

127. See Anna C. Chave, "O'Keeffe and the Masculine Gaze," *Art in America* (New York) 78, no. 1 (January 1990): 115-25, 177-79, for a discussion of O'Keeffe's obsession with a "female" visual vocabulary and concomitant disparaging critical reactions to her work.

128. Author's telephone conversation with the artist, 16 March 1990, notes in HMA files.

129. Author's interview with the artist, 29 October 1989.

130. Quoted in Marlena Donohue, "Expressing Herself," *Los Angeles Times*, 29 July 1989, sec. 5:2.

WORKS IN THE EXHIBITION

1. *Untitled*, 1966, pigmented beeswax and gesso on masonite, wood,
 65 x 5 x 1½ inches, Collection of Helen Herrick and Milton Brutten,
 Philadelphia.

2. *Untitled*, ca. 1966, pigmented beeswax and gesso on masonite, wood,
23³/₄ x 7³/₄ x 1¹/₁₆ inches, Collection of Richard Tuttle.

3. *Untitled*, 1966-67, pigmented beeswax and gesso on masonite, wood,
 65½ x 5⅝ x 1¼ inches, Private Collection.

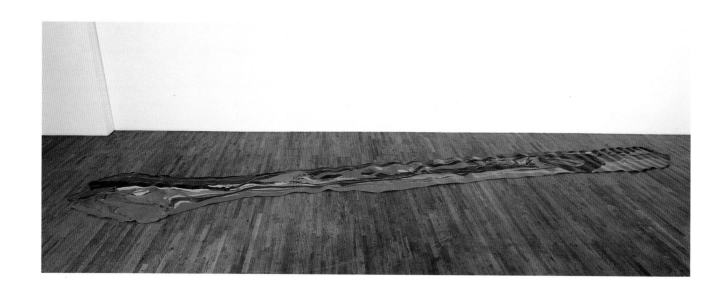

4. *Fallen Painting*, 1968, pigmented latex rubber, ¼ x 69¼ x 355 inches,
 Private Collection.

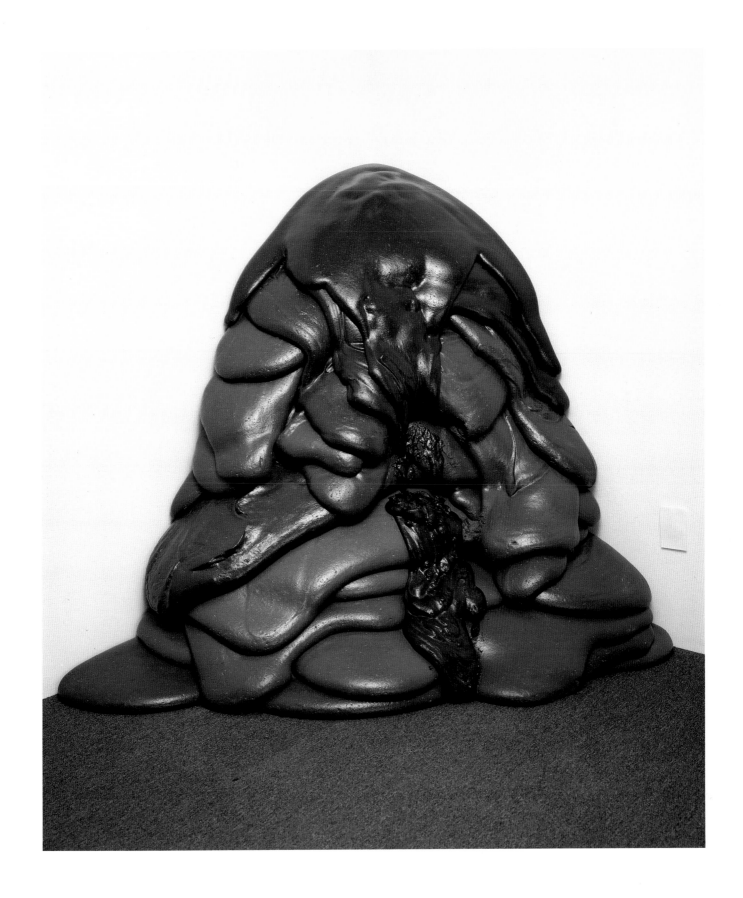

5. *For Carl Andre*, 1970, pigmented polyurethane foam, 56¼ x 53½ x 46½ inches, Collection of The Modern Art Museum of Fort Worth, Museum purchase, The Benjamin J. Tillar Memorial Trust.

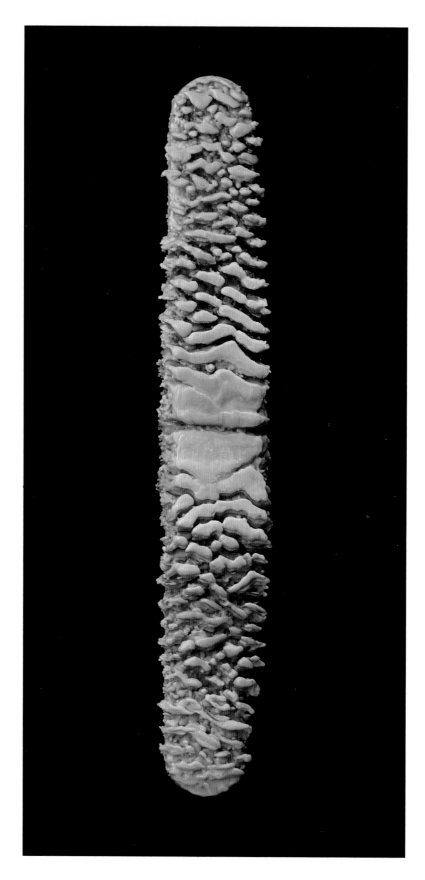

6. *Excess*, 1971, pigmented beeswax, damar resin and gesso on masonite, wood, 36 x 5 x 3½ inches, Collection of the Walker Art Center, Minneapolis, Art Center Acquisition Fund, 1972.

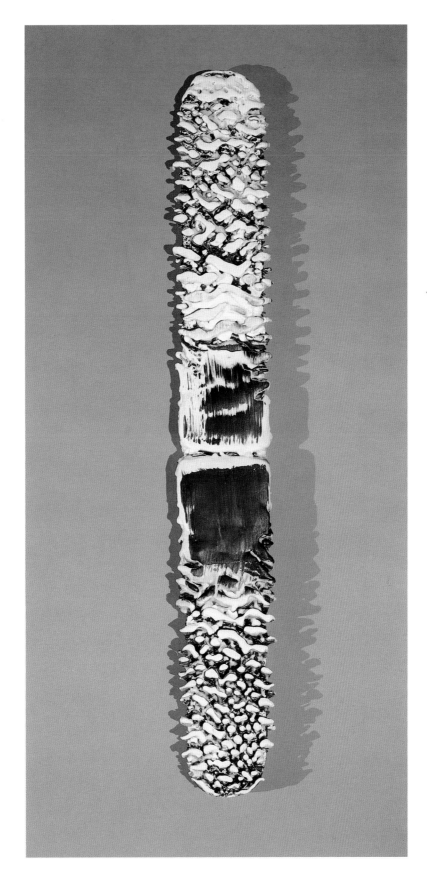

7. *Untitled* (from the "Pinto" series), 1971, pigmented beeswax, damar resin
and gesso on masonite, wood, 36 x 4½ x 1⅓ inches, Collection of the New
Orleans Museum of Art, gift of Mr. and Mrs. Leonard Glade.

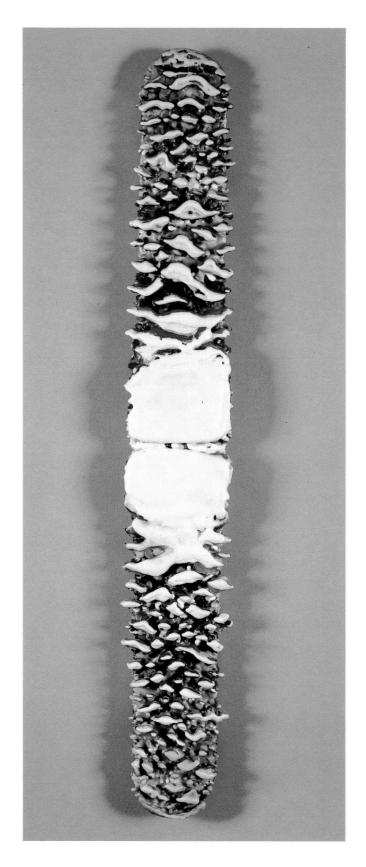

8. *Untitled*, 1971, pigmented beeswax, damar resin and gesso on masonite, wood, 36¼ x 5½ x 2⅝ inches, Collection of Camille and Paul Oliver-Hoffmann.

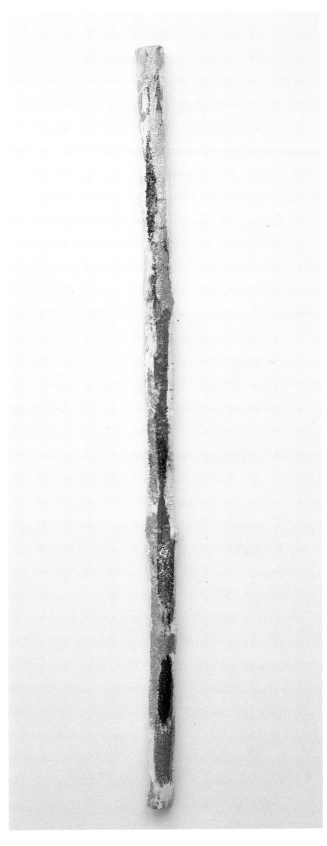

9. *Hoofers I*, 1971-72, glitter, acrylic, pigments and gesso on plaster, cotton bunting, aluminum screen, 102 x 5½ x 4 inches, Courtesy Paula Cooper Gallery, New York.

10. *Hoofers II*, 1971-72, glitter, acrylic, pigments and gesso on plaster, cotton bunting, aluminum screen, 102 x 4½ x 3 inches, Courtesy Paula Cooper Gallery, New York.

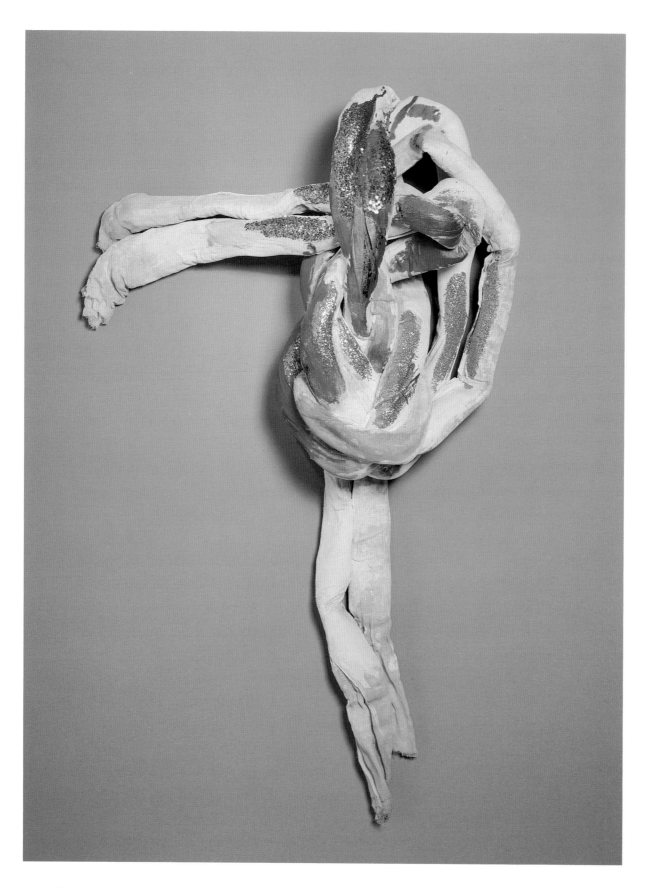

11. *Epsilon*, 1972, acrylic, enamel, glitter and gesso on plaster, cotton bunting,
aluminum screen, 37 x 30 x 12 inches, Collection of the Philadelphia
Museum of Art, gift of Donald Droll.

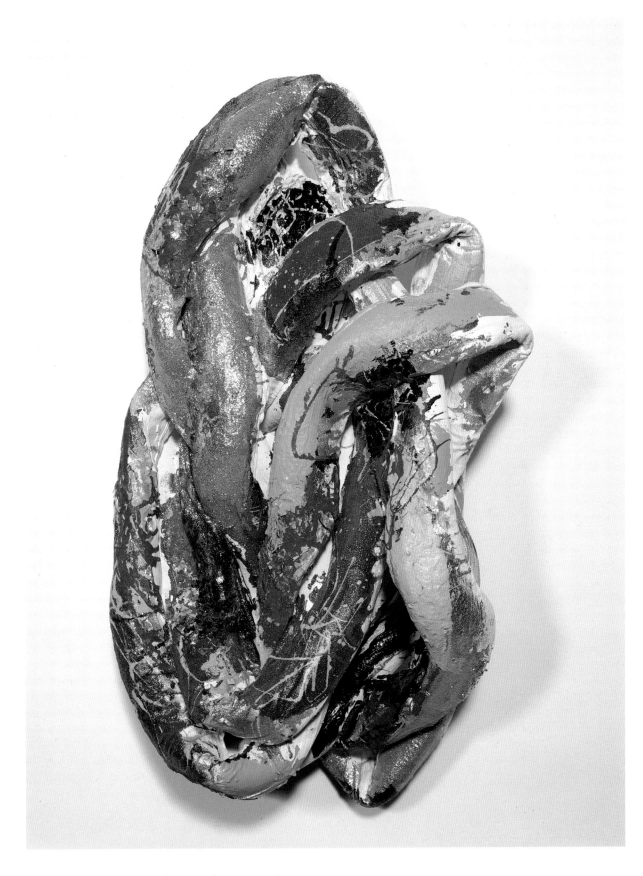

12. *Valencia I*, 1973, acrylic, enamel, glitter and gesso on plaster, cotton
 bunting, aluminum screen, 27 x 16 x 12 inches, Collection of Mr. and
 Mrs. Donnelley Erdman, Aspen, Colorado.

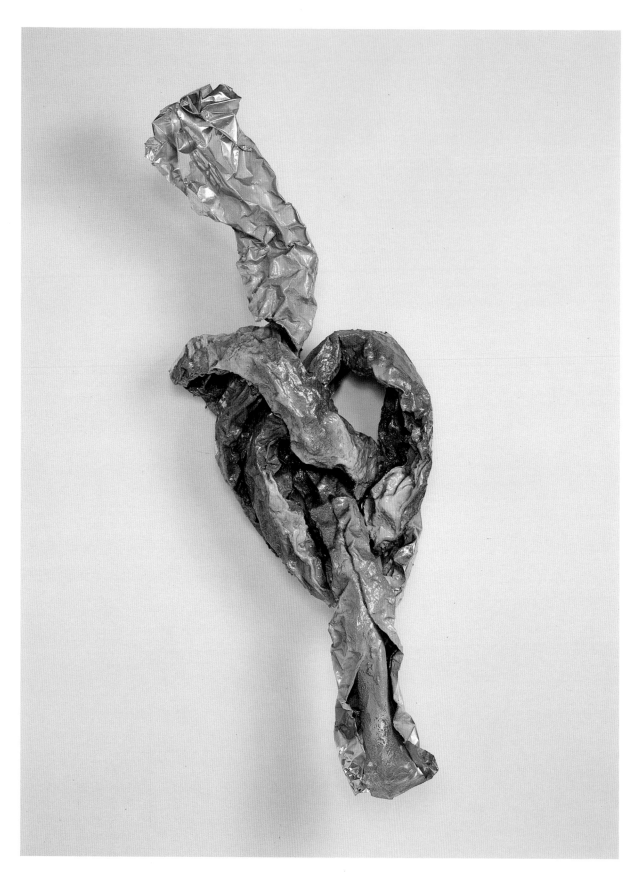

13. *Klaus*, 1974, enamel, glitter, acrylic resin and hot glue on aluminum foil,
 aluminum screen, 53 x 18 x 12 inches, Collection of Sondra and Charles
 Gilman, Jr.

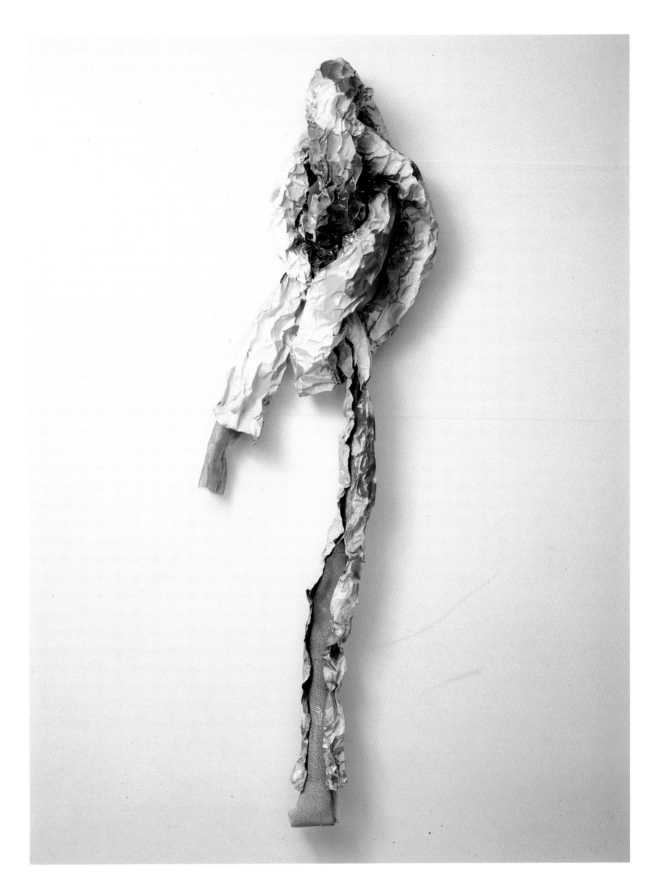

14. *Peter*, 1974, enamel, acrylic resin and hot glue on aluminum foil, aluminum screen, 65 x 15 x 13 inches, Collection of A. J. Aronow, New York.

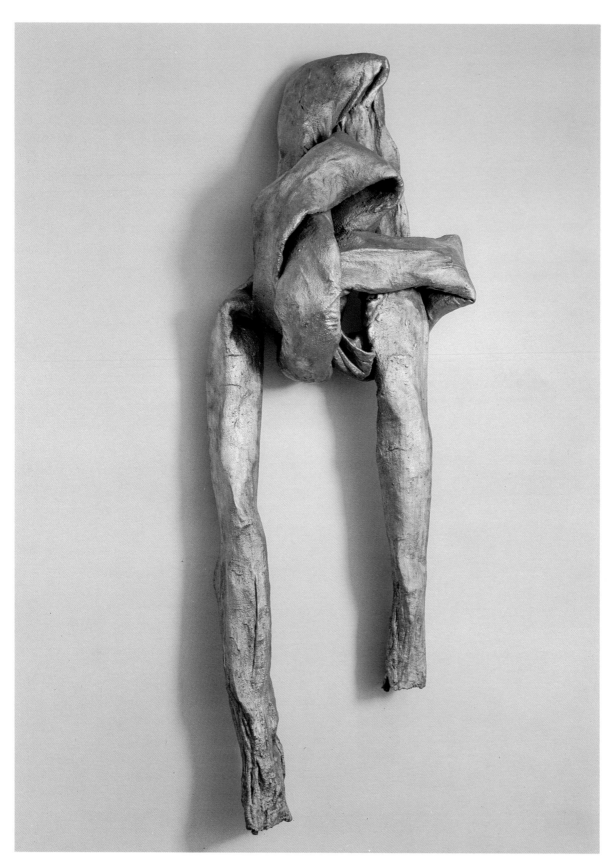

15. *Victor*, 1974, zinc, tin, liquid metal in plastic medium and gesso on plaster, cotton bunting, aluminum screen, 69 x 26 x 16 inches, Collection of The Museum of Modern Art, New York, purchased with the aid of funds from the National Endowment for the Arts and an anonymous donor, 1975.

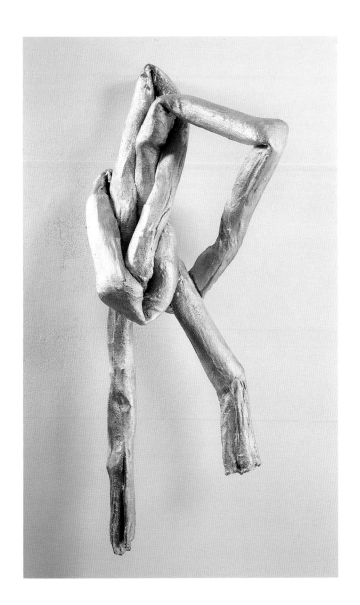

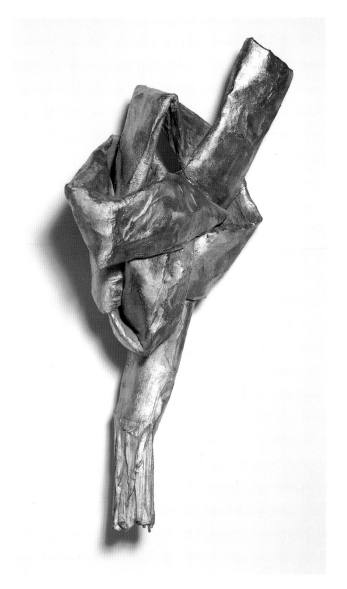

16. *Foxtrot*, 1974-75, zinc, tin, liquid metal in plastic medium and gesso on plaster, cotton bunting, aluminum screen, ca. 52 x 23 x 15 inches, Collection of Mr. and Mrs. M. A. Benglis, Lake Charles, Louisiana.

17. *Alpha II*, 1975, zinc, tin, liquid metal in plastic medium and gesso on plaster, cotton bunting, aluminum screen, 73 x 29 x 24 inches, Courtesy Margo Leavin Gallery, Los Angeles.

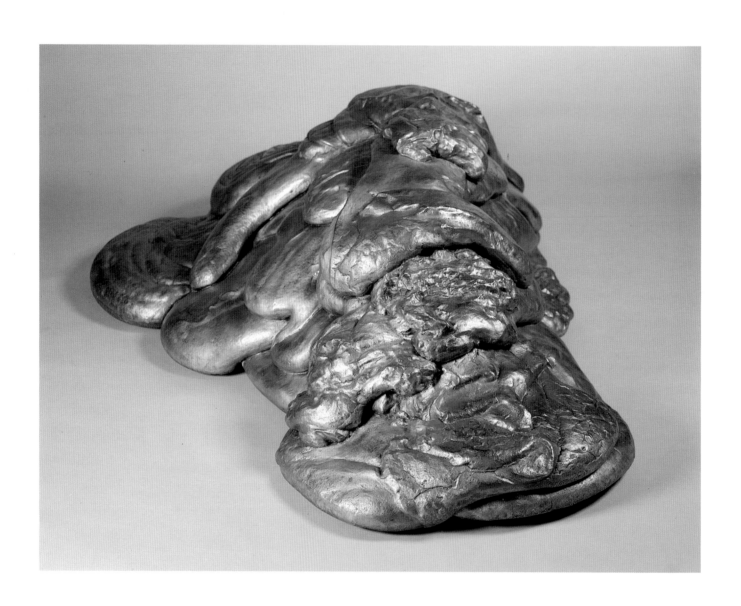

18. *Eat Meat*, 1975, cast aluminum, 24 x 80 x 54 inches, Collection of Anne and William J. Hokin.

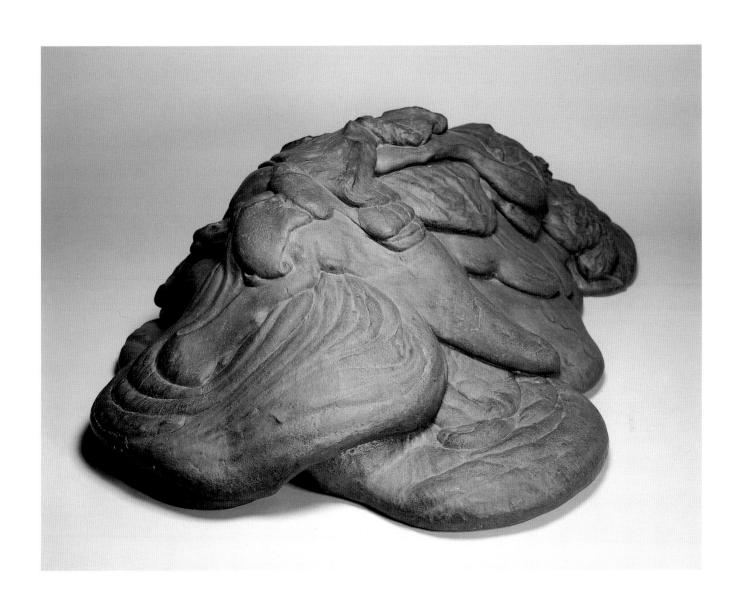

19. *Eat Meat*, 1975, cast bronze, 24 x 80 x 54 inches, Private Collection.

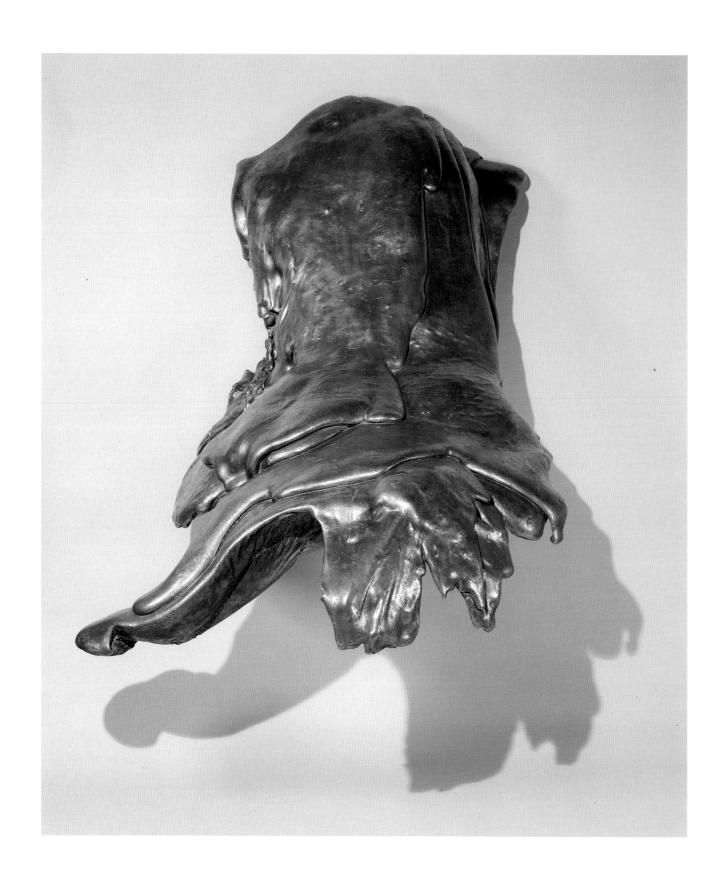

20. *Wing*, 1975, cast aluminum, 67 x 59¼ x 60 inches, Courtesy Paula Cooper
 Gallery, New York, and Margo Leavin Gallery, Los Angeles.

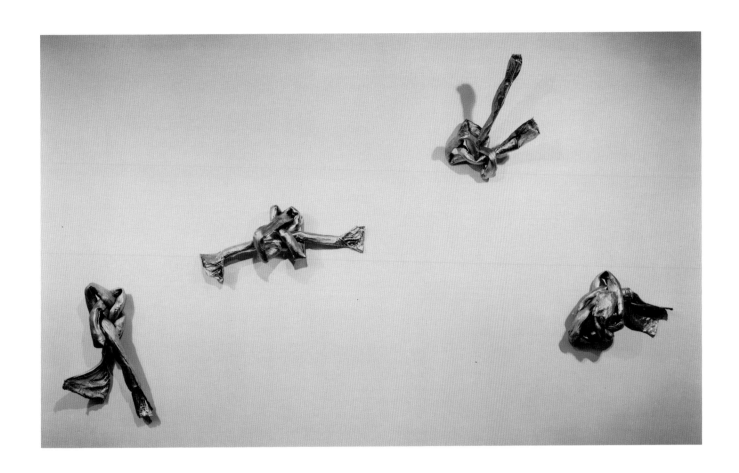

21. *North, South, East, West*, 1976, zinc, tin, liquid metal in plastic medium and gesso on plaster, cotton bunting, aluminum screen. Four parts, left to right: 40 x 23 x 15½, 51 x 27 x 14, 37 x 29 x 19, 60 x 24 x 17 inches, Collection of Anne and William J. Hokin.

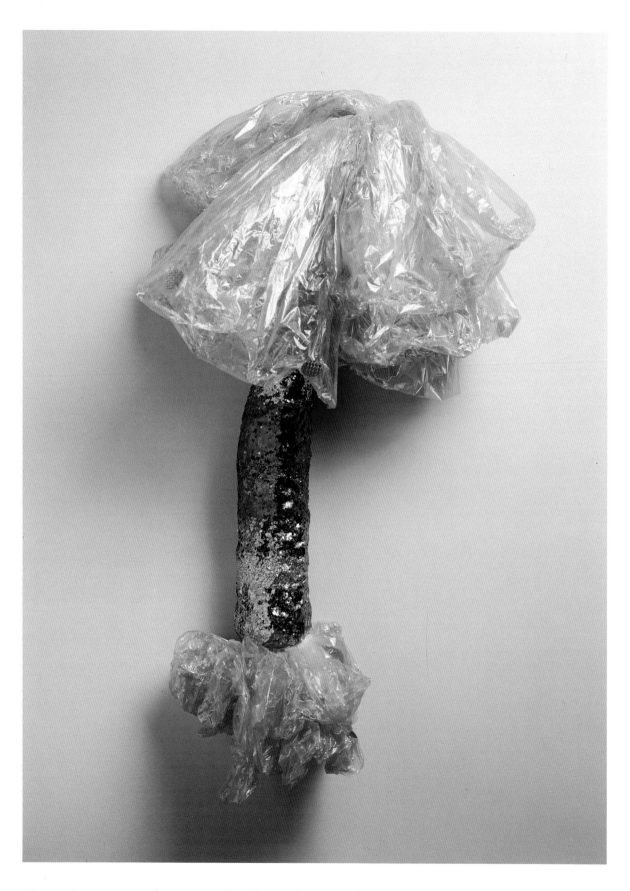

22. *Lagniappe: Bayou Babe*, 1977, acrylic, glitter and gesso on plaster, cotton
 bunting, aluminum screen, polypropylene, 32 x 8 x 9 inches, Collection
 of Phillip G. Schrager.

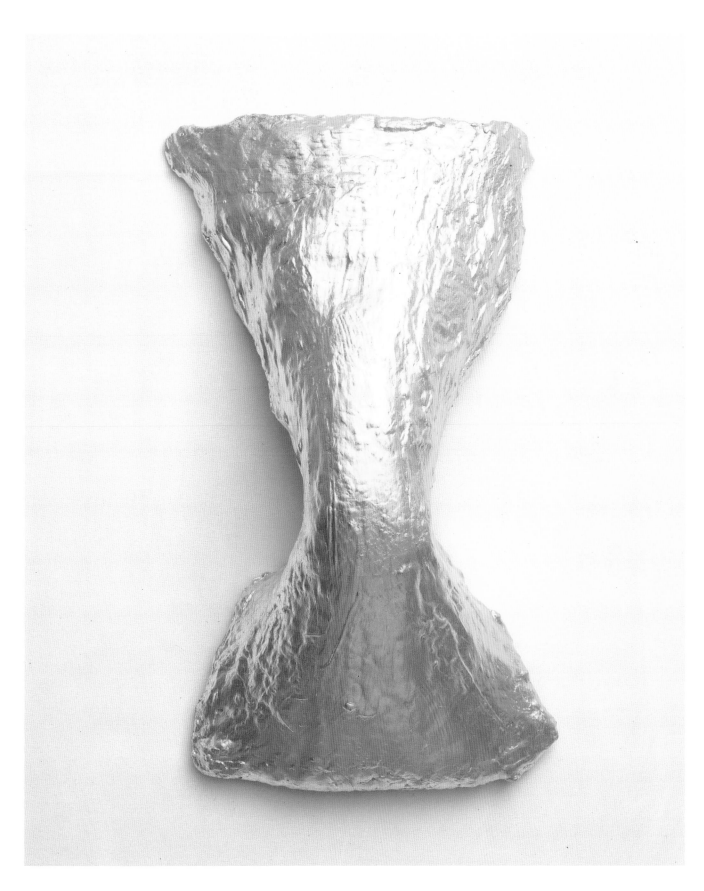

23. *Megiste*, 1978, gold leaf, oil-based sizing and gesso on plaster, cotton
 bunting, chicken wire, 45 x 26 x 11½ inches, Private Collection.

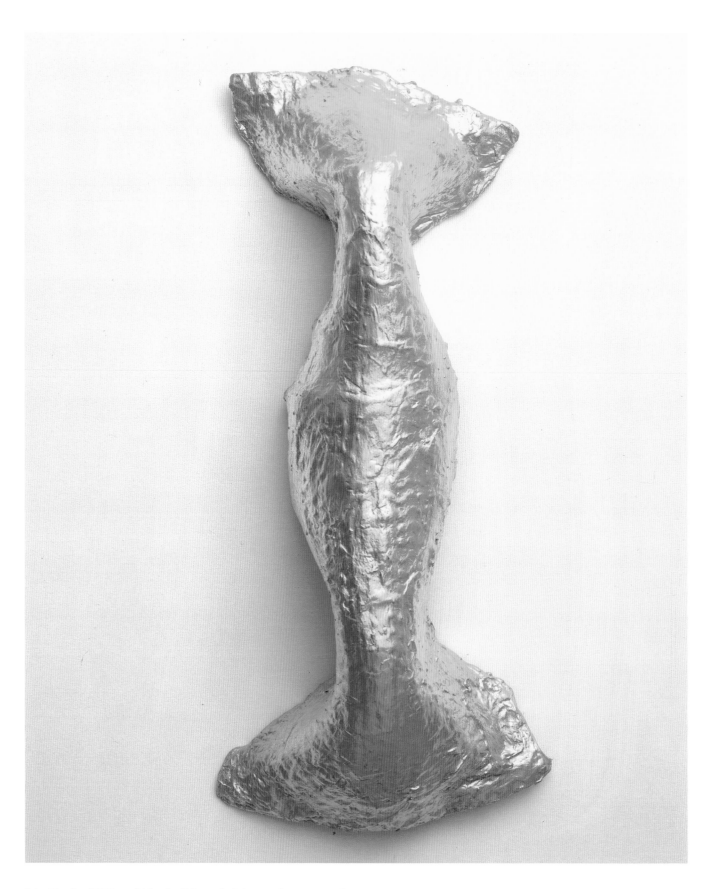

24. *Rhodos*, 1978, gold leaf, oil-based sizing and gesso on plaster, cotton
 bunting, chicken wire, 55½ x 26 x 11 inches, Courtesy Paula Cooper
 Gallery, New York.

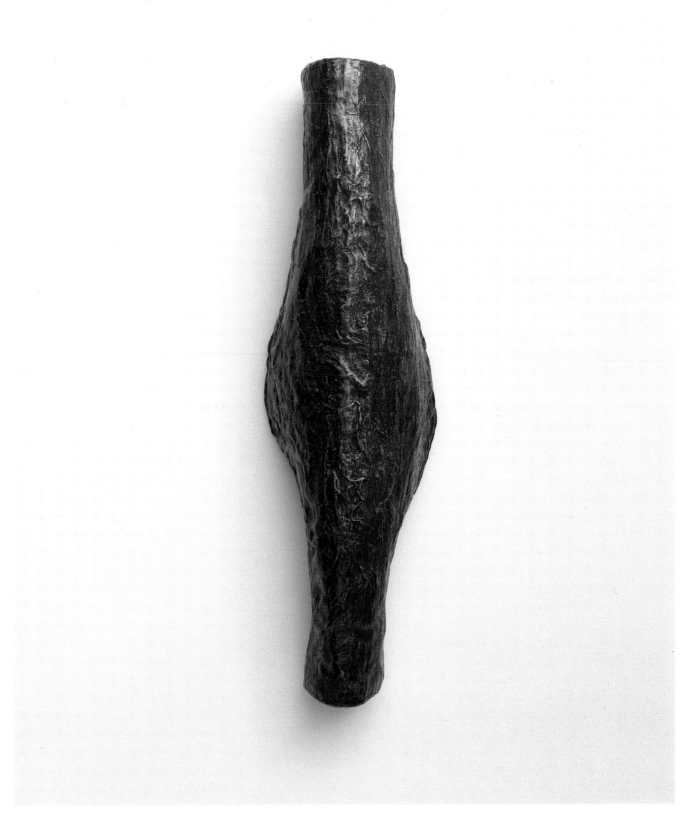

25. *Vessel*, 1978, cast bronze, 35 x 4½ x 12 inches, Courtesy Paula Cooper
 Gallery, New York.

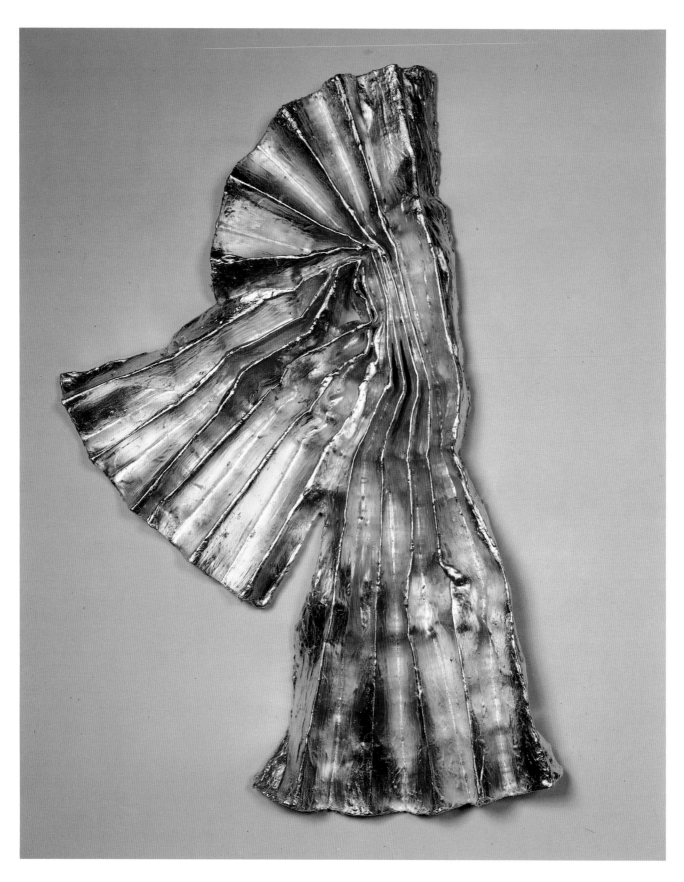

26. *Fanfarinade*, 1979, gold leaf, oil-based sizing and gesso on plaster, bronze
 screen, 36 x 21 x 3¼ inches, Collection of Gerd Metzdorff, Vancouver,
 Canada.

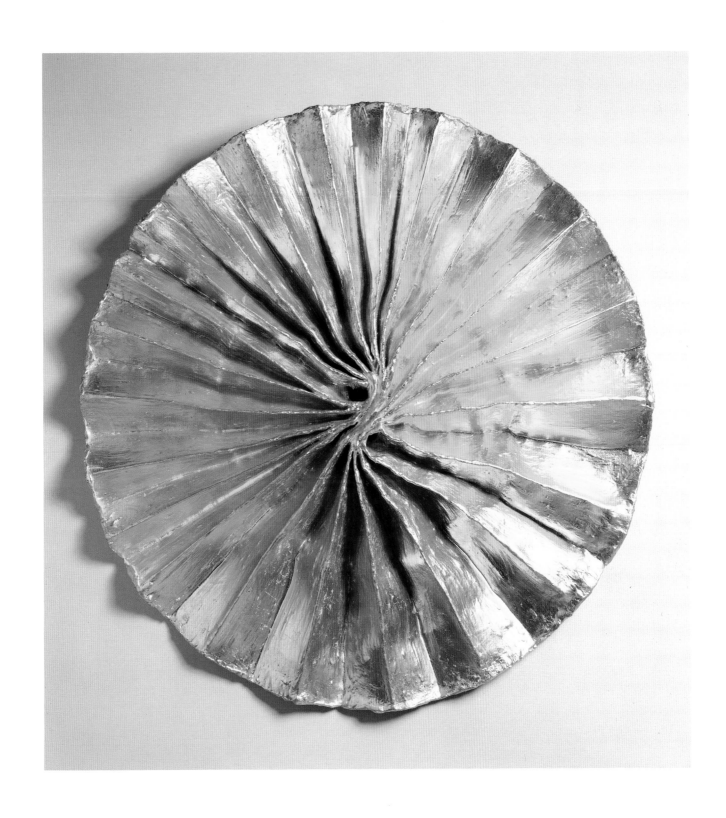

27. *Gilgit*, 1980, gold leaf, oil-based sizing and gesso on plaster, bronze screen, 36 x 36 x 3¼ inches, Collection of Sally Sirkin Lewis and Bernard Lewis, Beverly Hills, California.

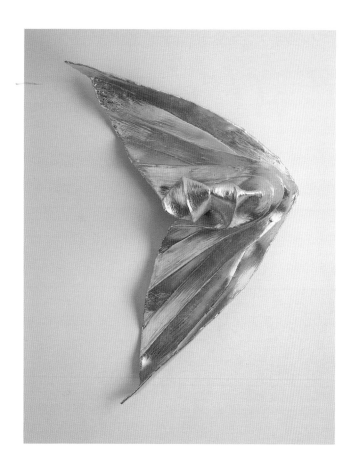

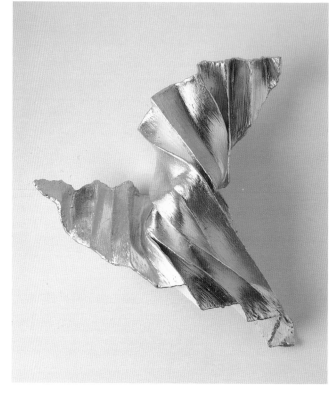

28. *Nar*, 1980, gold leaf, oil-based sizing and gesso on plaster, bronze screen, 32½ x 25 x 10¾ inches, Collection of Barbara and George Erb, Birmingham, Michigan.

29. *Nari*, 1980, gold leaf, oil-based sizing and gesso on plaster, bronze screen, 24 x 22 x 9 inches, Collection of Barbara and George Erb, Birmingham, Michigan.

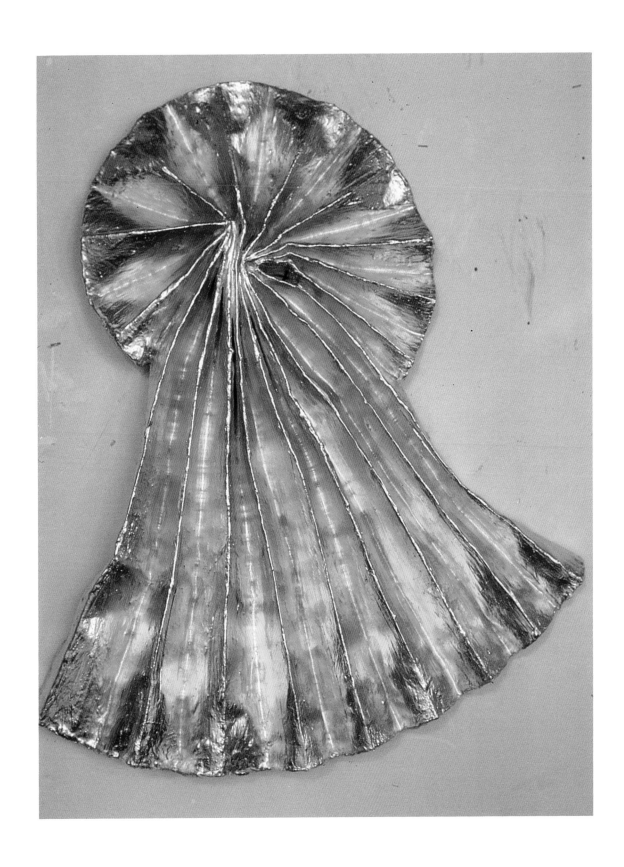

30. *One Dime Blues*, 1980, gold leaf, oil-based sizing and gesso on plaster, bronze screen, 35½ x 31 x 3 inches, Collection of Iris and Allen Mink, Los Angeles.

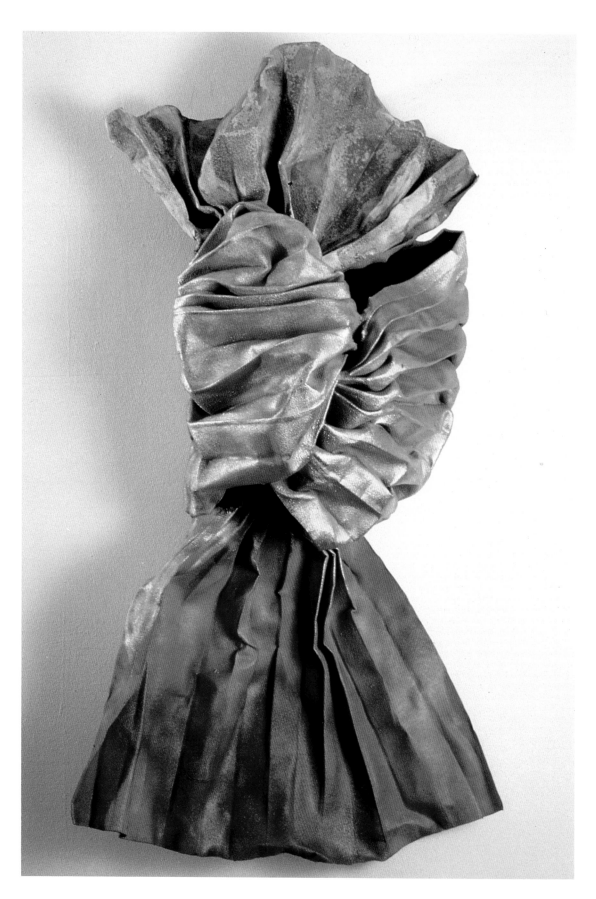

31. *Cassiopeia*, 1982, zinc and copper on bronze mesh, patina, 48 x 27 x 14 inches, Collection of Jeanne Randall Malkin, Chicago.

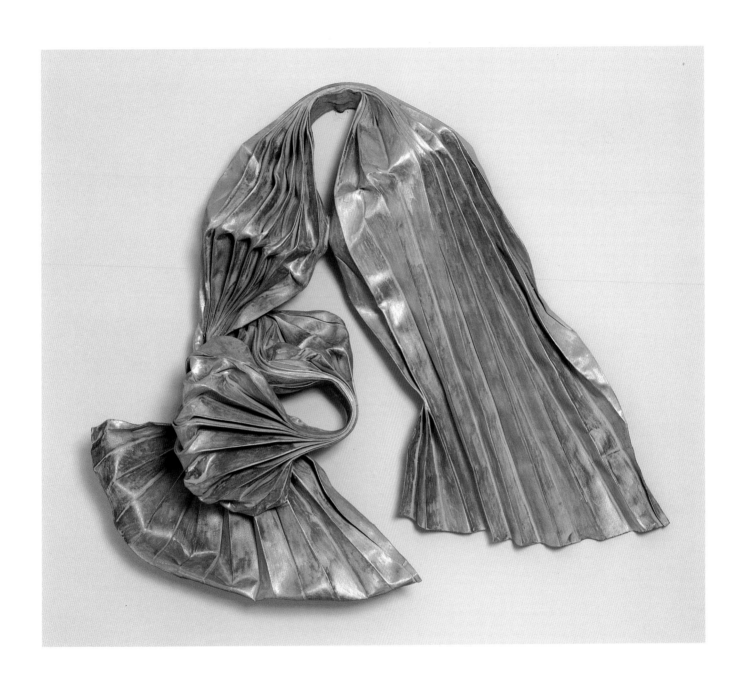

32. *Hydra*, 1982, zinc and aluminum on bronze mesh, 48½ x 48 x 12 inches,
Collection of Sue and Steven Antebi.

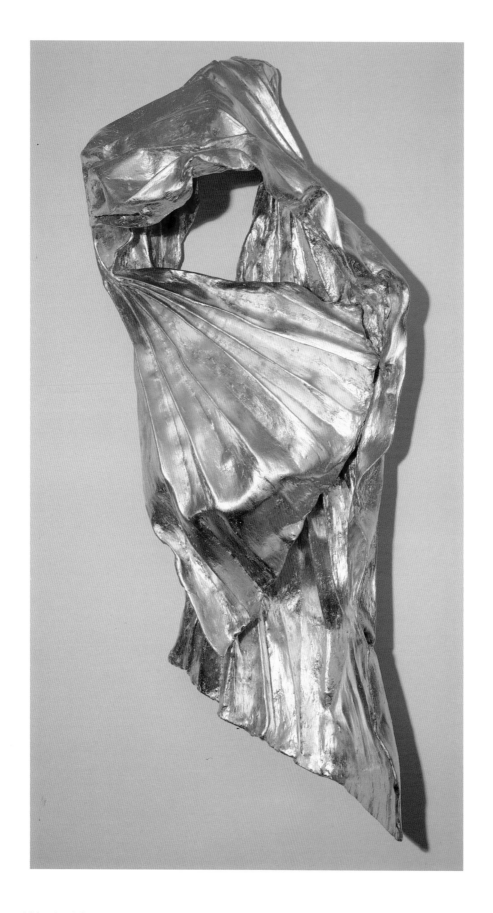

33. *Patel II*, 1982, gold leaf, oil-based sizing and gesso on plaster, bronze mesh,
64 x 24 x 20 inches, Private Collection.

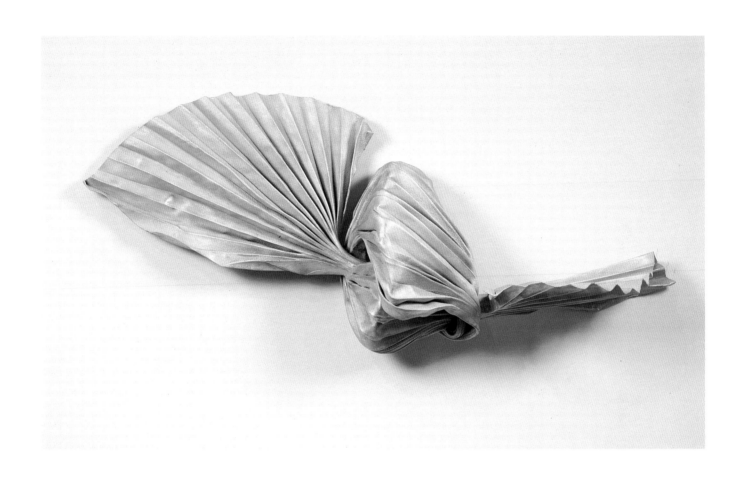

34. *Mirtak*, 1983, zinc and aluminum on bronze mesh, 22 x 55½ x 12½
 inches, Private Collection.

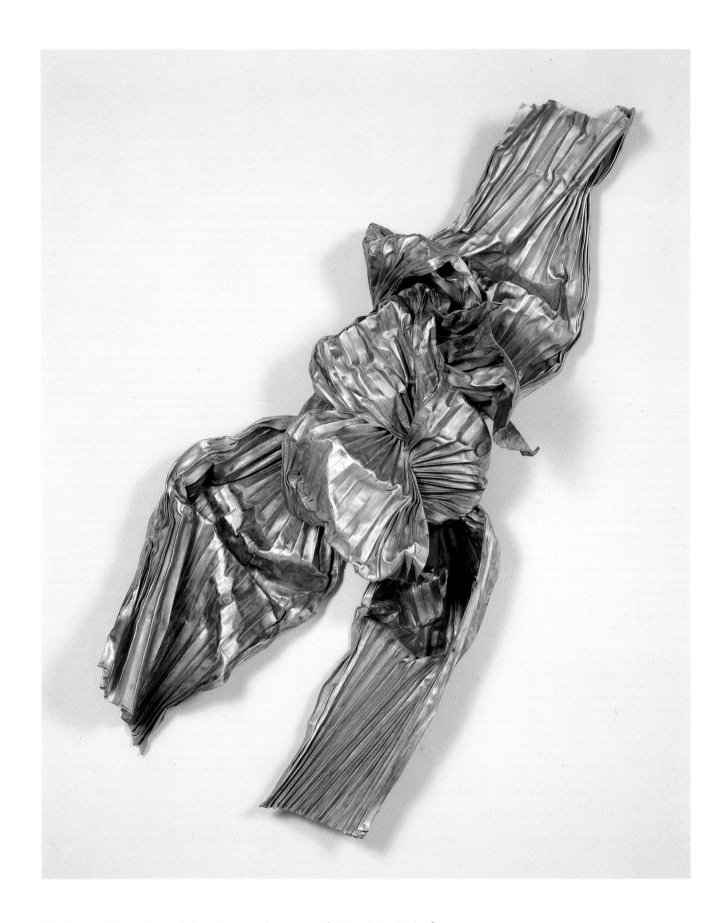

35. *Perseus*, 1984, zinc and aluminum on bronze mesh, 81 x 56 x 24 inches,
 Courtesy Margo Leavin Gallery, Los Angeles.

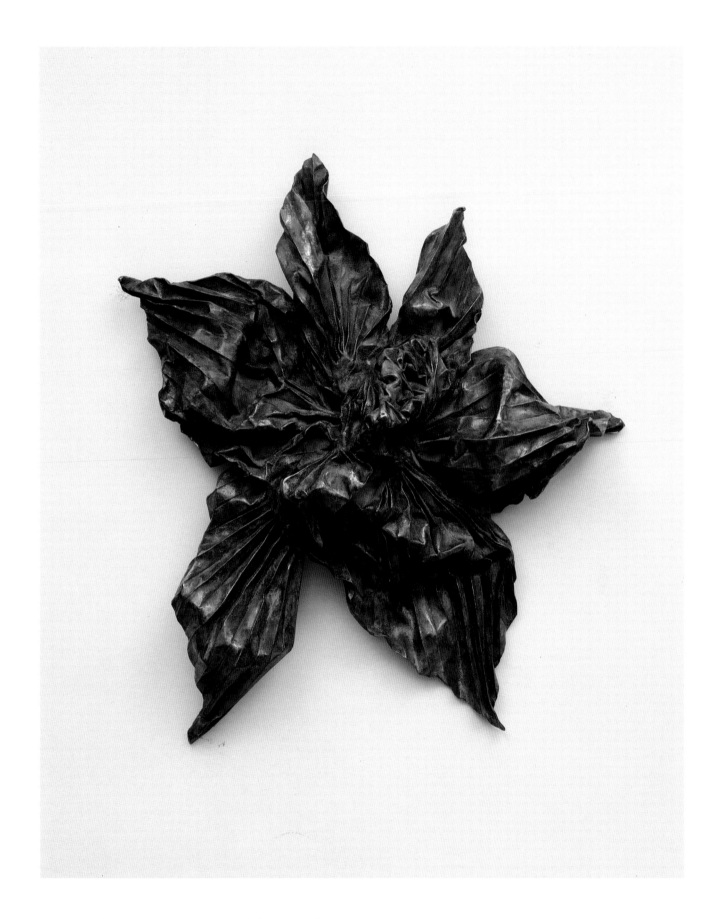

36. *La Gonda L. G. 6*, 1986, bronze and chrome on bronze mesh, 43 x 48 x 13 inches, Courtesy Paula Cooper Gallery, New York.

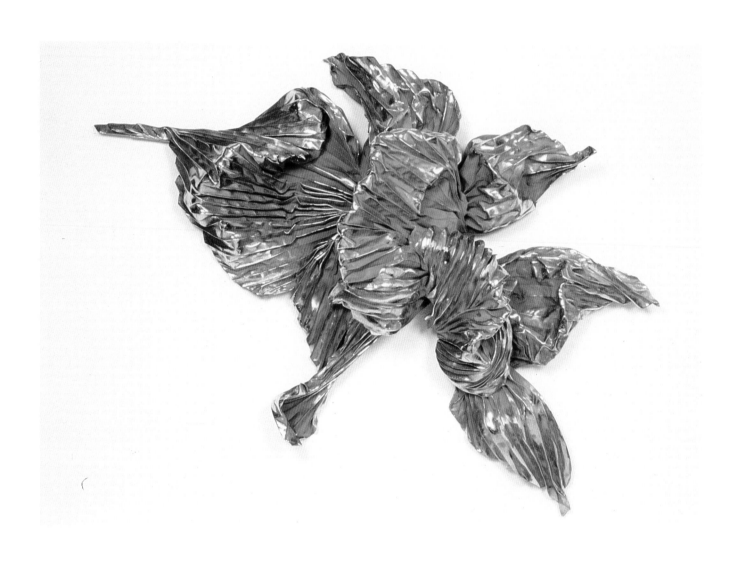

37. *Twin Coach*, 1988, copper on wire mesh, 55 x 65 x 15 inches, Courtesy
Paula Cooper Gallery, New York.

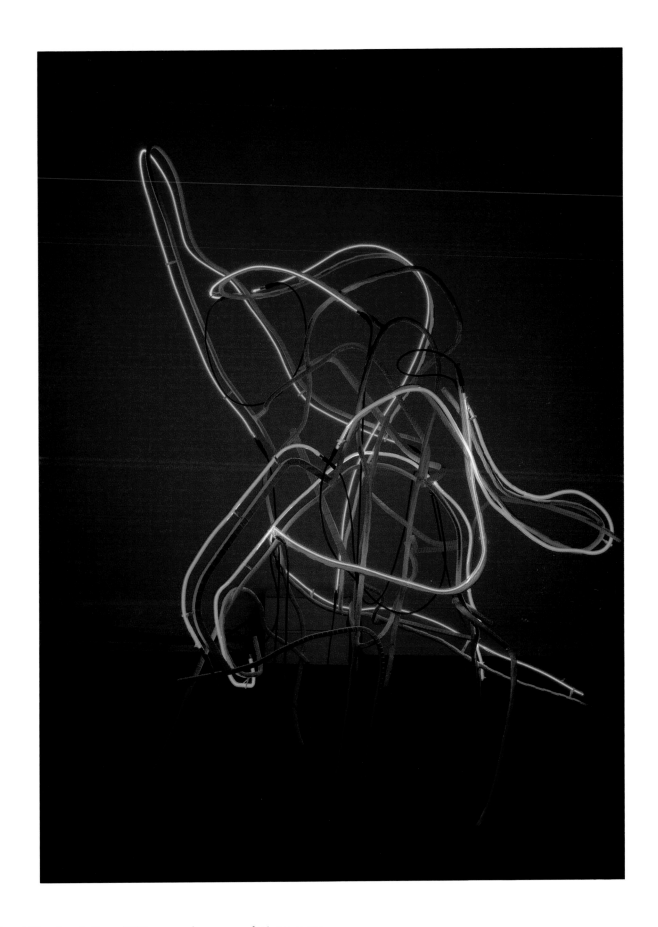

38. *Red and Blue Jungle Gym*, 1988, enamel on wrought iron, neon,
86 x 84 x 60 inches, Courtesy Tilden-Foley Gallery, New Orleans.

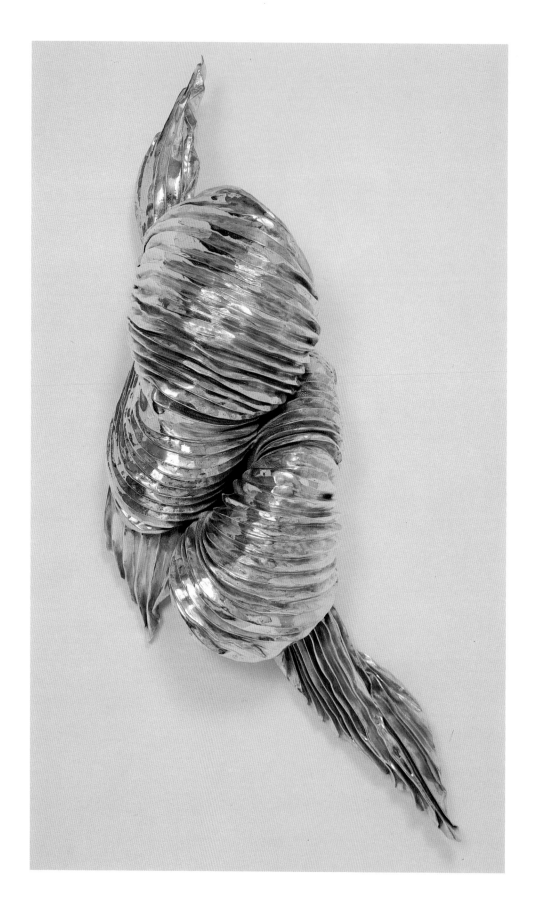

39. *Super Two*, 1989, aluminum on stainless steel mesh, 67 x 32 x 18 inches, Collection of Frederick Weisman Company.

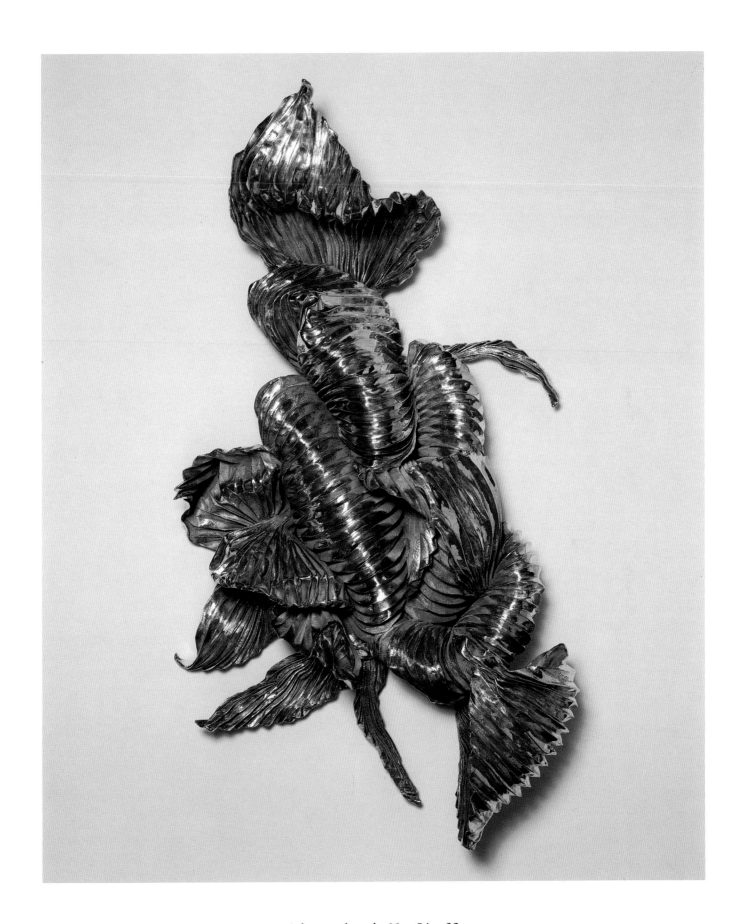

41. *Isabella Borgward*, 1990, aluminum on stainless steel mesh, 88 x 54 x 22
 inches, Collection of Mr. and Mrs. Graham Gund.

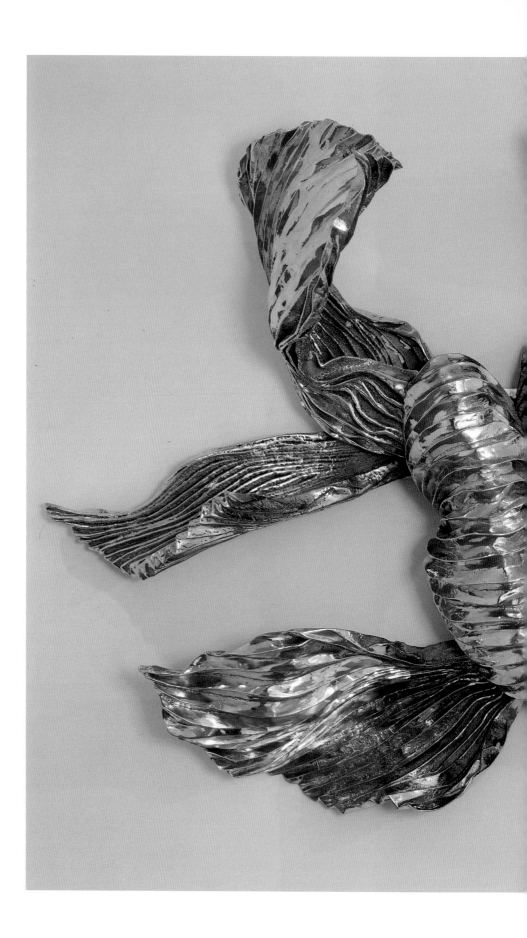

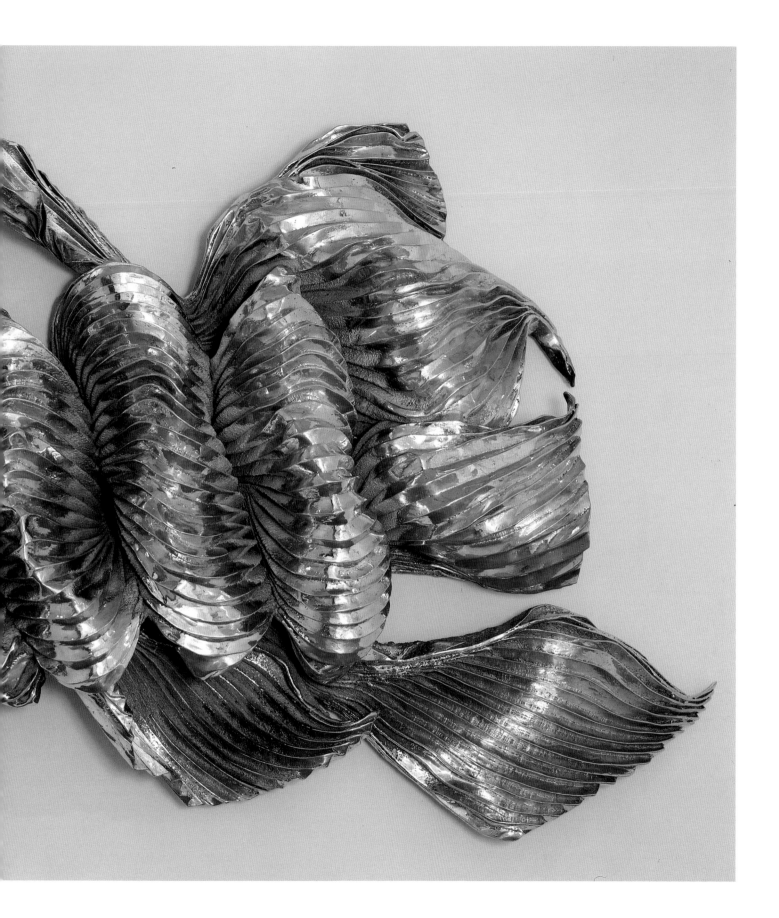

40. *Eclat*, 1990, aluminum on stainless steel mesh, 65 x 105 x 31 inches,
 Courtesy Paula Cooper Gallery, New York.

Synopses of Videotapes

Fig. 61: *Noise*

Noise, 1972 [August]

Black and white; 7 minutes, 15 seconds
Location: Baxter Street studio, New York
Cast: Jennifer Bartlett, Gordon Hart, Robert Israel,
Roberta Smith, John Torreano, Richard Tuttle
Voice from off camera: Lynda Benglis

Synopsis: The opening sequence shows Benglis writing the title across the face of a video monitor, on which is seen a tape of Benglis writing across a monitor filled with static. The entire screen then goes to static briefly; when the picture returns, it shows a monitor on which plays a tape of another monitor, which, in turn, shows Richard Tuttle talking to Benglis (who is off camera). Tuttle is seen in a fairly tight close-up. The picture is grainy and distorted, since it is several generations removed from the original. The sound track is also distorted by re-recordings—conversation is largely unintelligible, voices are reduced to little more than noise (hence the title). Suddenly, the picture disintegrates into static, then quickly returns to show Jennifer Bartlett talking to Benglis, who is still off camera. Bartlett's image is seen removed by several generations, and the sound and picture are consequently also distorted. This sequence—static/talking figure/static—is repeated several times, each time with a different friend (in order of appearance: Gordon Hart, Robert Israel, Roberta Smith and John Torreano). In each case, the image is several generations removed from the original and the sound is grossly distorted (except for a few seconds during the sequence with Smith when both voices become very clear as they discuss adapting "the equipment," presumably video, to be able to see oneself). Torreano (who sings "Danny Boy" instead of conversing with Benglis) is shown full-length rather than in close-up. In order to fit him into the frame, Benglis turned the camera sideways: when replayed, the picture appears sideways. While retaping this footage off of the monitor, Benglis first shows Torreano sideways, as he appears in the original, then adjusts the picture by turning the camera until Torreano is right-side-up once again.

In *Noise*, the earliest of her video works, Benglis layers several of the motifs and techniques that she explores separately in later tapes. Here, as in *On Screen* (made later in 1972), Benglis calls attention to edits by allowing the video image to disintegrate to static between cuts. Re-taping off of monitors (which results in a distanced, distorted view of the original) is a device Benglis used in most of her video works. She also frequently layered many generations of images by repeating an action in front of a monitor on which a tape of the artist performing the same activity plays, as, for example, in *Document*, 1972, and *Now*, 1973. The disassociation of sound and re-recording is also typical of Benglis's video work, especially *On Screen* and *Mumble*, both completed later the same year.

Home Tape Revised, 1972 [summer]

Black and white; 25 minutes, 25 seconds
Location: Baxter Street studio, New York; Lake Charles,
Louisiana; and Petal, Mississippi
Cast: Klaus Kertess, Benglis's mother, father, sisters
Jane and Karen, paternal grandmother, maternal
grandparents, various aunts, uncles and cousins
Voice-over: Lynda Benglis

Synopsis: The tape begins with a shot of Kertess typing, then cuts to footage of Benglis's visit to the office of her father's building supply company in Lake Charles, Louisiana. Part of this footage is then repeated, this time taped off of a video monitor as Benglis describes the action on screen and comments about the various people who appear. The tape on the monitor proceeds with shots of the Benglis family at home in Lake Charles, of Benglis's visit with her mother and sisters to her maternal grandparents'

Fig. 62: *Home Tape Revised*

home in Mississippi, and of their return trip to Lake Charles. Benglis continues her narrative over the hum of an air conditioner. She frequently adds arcane bits of information, such as "That's Uncle George, who had the operation." Several scenes are repeated two or three times, each time taped off of a monitor rather than simply replayed; as the image is further removed from the original footage, each generation becomes increasingly distorted. Some of the repeat showings are narrated and Benglis often comments, "I said that before." At other times, scenes are repeated without any sound. In the final sequence of *Home Tape Revised*, the camera returns to the scene in which Kertess is typing, seen in first generation. Kertess stops typing, removes the paper from the typewriter and reads:

> June 19, 1972. I have to read, read because I write. Read to counteract the now of video time. Read to be more or less self-conscious. Read now. Now. Now I will read some ends. The end of my last short story. This is the fourth shortest story I have written tonight. That was the beginning too. The end of my first video script. An image that imagined this image or not at all. The end of my last video script. The end of my last video script.

As was her practice, Benglis again applied the technique of taping from a monitor on which the original scene is replayed. By doing this, Benglis calls into question the notion of the "real" time of video; by adding a voice that introduces extraneous information, but does not clarify the action on screen, Benglis further heightens the viewer's distrust and sense of remove from the image. Kertess appears directly before the viewer, but quickly begins to read what he has already written rather than speak directly to the "audience," thus creating an immediate sense of past tense. "Read to counteract the now of video time," he says, underscoring the artificial, perpetual "present" time of video.

ON SCREEN, 1972 [November]

Black and white; 7 minutes, 12 seconds
Location: Baxter Street studio, New York.
Cast: Lynda Benglis

Synopsis: The opening shot shows a video monitor filled with static. The camera zooms in, then out. The entire screen goes to static for a moment, then the monitor reappears, playing a tape of Benglis sitting in front of a monitor, grimacing and making odd noises at the camera (much as Bruce Nauman had done in his film *Pulling Mouth*, 1969). Again, the entire screen goes briefly to static, then to a picture of the monitor. This time Benglis enters the frame, sits in front of the monitor, and makes sounds and faces at the camera while the previous tape of the same thing plays behind her. The picture goes to static for an instant, then this footage of Benglis is replayed on the monitor on screen. As the monitor fills with static, the camera zooms in until the screen of the monitor fills the frame: the original footage of Benglis making faces in front of a blank monitor is then replayed. When this picture again goes to static, the camera zooms out to reveal the edges of the monitor. The footage (two generations of Benglis making faces) begins again; this time, however, Benglis enters the frame and sits in front of the monitor, and begins making sounds and expressions along with the tape. The monitor then goes to

Fig. 63: *On Screen*

static before it plays a tape of Benglis writing "On Screen Copyright Nov. '72 Lynda Benglis" across the face of a monitor. Simultaneously, Benglis steps in front of the monitor on which this tape runs and writes the same text across its screen, just slightly out of register with the video image.

Benglis instructs that the sound should be played as loudly as possible. The sound track is very noisy, regardless; each successive generation of static and of Benglis's noises includes the cumulative recorded distortions from the previous generations. As the sound becomes increasingly distorted, it grows more and more abstract and at times oppressive, and is unrelated to the image on screen.

In *On Screen*, Benglis manipulates generations of video footage to confound our sense of time: she implies an infinite regression of time and space—Benglis making faces in front of a monitor of her making faces in front of a monitor of her . . . ad infinitum. The viewer retains a sense of the images' sequentiality, although the sequence of creation is not revealed in a logical, orderly fashion and is heavily obscured by the random layering and continual repetition of aural and visual components.

DOCUMENT, 1972 [December]

Black and white; 8 minutes
Location: Baxter Street studio, New York
Cast: Lynda Benglis
Voice from off camera: Nathan Rabin

Synopsis: A man off screen directs the position of Benglis's head (seen in profile) in relation to the blank video monitor behind her. The clicking of a camera can be heard, then silence. The next shot shows a video monitor; taped to its center is a still photo of Benglis in profile, seen in front of her image on a video monitor. Benglis steps into the frame and writes the title of the work, *Document*, across the face of the screen, then retraces what she has just written. The camera zooms in on the photograph until it fills the frame, then zooms out to its original position. Benglis then writes the copyright notice across the bottom of the screen and again retraces what she has just written. In a Duchampian gesture, she draws a moustache on each of her images. She then retraces the copyright and the moustaches. The camera once more zooms in on the still photo and then zooms out to its original position. The footage of Benglis retracing the copyright and the moustaches is replayed. A phone begins to ring off camera, and Benglis once more retraces the copyright.

Fig. 64: *Document*

Benglis here calls into question the notion of "original." At any given time there are several images—moving and still—of Benglis on screen. By zooming in on the still photo, the viewer is made acutely aware of the many generations of images, and how easily one might be deceived into believing that the image on screen is "really" Benglis in front of a video monitor. The nature of video "reality" also is challenged by the sound, most of which originates off camera, thereby underscoring the limits of video space.

MUMBLE, 1972 [December]

Black and white; 21 minutes, 21 seconds
Location: Baxter Street studio, New York
Cast: Jim Benglis, Marilyn Lenkowsky [Gorchov], Robert Morris
Voices from off camera: Lynda Benglis, Klaus Kertess

Synopsis: This tape is a collaboration between Robert Morris and Benglis. The initial footage for this tape was shot by Benglis. Morris used this same footage, as well as some of the footage and sound track from Benglis's *Mumble*, to make his video *Exchange*, 1973. The opening voice-over for *Exchange* conveys a sense of their give-and-take:

Fig. 65: *Mumble*

> This is a tape he made of a tape she made of a tape he made in her studio. This is a tape he made of a tape she made. On screen is her tape of his tape. His tape is the last image in the background which she re-photographed with other faces. This tape is of that. His tape was raw material. This tape on screen is raw material. Re-photographing his tape made it her work. Or commenting on it made it her work. Or both. She is heard but never seen. Nothing here has been re-photographed. Can it then be raw material?

The initial footage shows Morris standing with his back to the camera smoking a cigar, drinking a glass of wine, and speaking in Marxist terms about work and its relationship

to art: "Production is the object of labor. Work is voluntary. Artists have economic relationships with roles." This footage is played several times: Lenkowsky and Jim Benglis (the artist's brother) appear, alternately and together, at the sides of the monitor on which this footage is playing and they repeat what Morris says. The resulting tapes are replayed on the monitor: all the segments seem to be repeated several times. Thus, the original footage of Morris is often obscured by one or both of the other figures and is distorted by several generations of removal. The order of the segments seems random; the raw, first generation footage of Morris (without the other figures) is not shown until late in the tape.

Benglis adds her own flat, uninflected narration to this confusing collage of images. Her statements only sporadically correspond with the action on screen, for example "Morris said, 'I think I want to talk about work . . . work is voluntary.' Morris I don't think said that." Other information seems irrelevant (for instance, "The cat jumped into my lap"), or purposefully confusing ("It was the voice off screen that said that, not the figure off screen"). She repeats many of her statements, particularly "The phone is ringing in the next room" (when no phone can be heard) and "Robin Torreano is weaving downstairs." Some of her statements are obviously untrue: she says, for example, "Ron Gorchov is the figure in the center" (Gorchov never appears on the tape). At one point, Benglis admits to the unreliability of her statements: "I feel a lot of pressure on myself talking like this. This isn't necessarily true though." Benglis's voice often drowns out the sound of the figures on screen. The sound is further distorted by Kertess, who, like Benglis, is never seen. His voice is much softer and less distinct than Benglis's, and often seems to come from one of the figures on screen. He too repeats things that Morris says, along with "mumumumumble."

Although the viewer is inclined to accept Benglis's narrative, it is quickly called into question. Her frequent statements about actions that take place off camera invite distrust since they cannot be verified. These statements also point out the limits of the camera's field of vision and undermine the convenient fiction that what is presented is complete unto itself. Benglis's frequent repetition of phrases soon renders the words meaningless; in the end, they convey no real information and serve rather as an abstract, rhythmic pulse.

ENCLOSURE, 1973 [winter]

Black and white; 8 minutes
Location: Baxter Street studio, New York
Cast: Klaus Kertess

Synopsis: In *Enclosure*, Benglis keeps her hand-held camera in constant, unsteady motion as she randomly scans her studio. The camera lingers occasionally on Klaus Kertess (who holds a cat) or on one of two televisions in the room. While on camera, Kertess is quite still and either stares directly back at the camera or else at something (presumably one of the televisions) across the room. One television plays a tape of a hockey game (later used in *Collage*) and the other plays a tape that shows Kertess or the cat in close-up. Kertess changes position several times– first he is seen sitting, then standing, then sitting again—but the changes occur while the camera is directed elsewhere. The tape is virtually silent; Kertess never speaks and the volume is turned off on the televisions. The only sounds are those made by Benglis (the camera person) as she moves around the studio and those that drift up from the street. At one point, the sound of children playing is heard. The camera quickly follows the sound; it zooms out the window, locates the children on a playground across the street, dwells there for a moment, then returns indoors and briefly scans the room before the tape abruptly ends.

Fig. 66: *Enclosure*

There is a dreaminess to *Enclosure* that is almost stifling. The constant motion of the camera calls attention to the limits of its field of vision: the walls of the studio are the ultimate "enclosure" of the camera's eye. The two televisions do not offer escape; one monitor constantly refers back to Kertess or the cat. The occasional glimpse of the hockey game makes it impossible to follow as a game; instead it reads as abstract movement, like a graceful dance. The open window and the sound of the children seem to suggest release, yet the confines of the studio are never truly broken.

The motion of the camera in *Enclosure* recalls several of the films of Michael Snow, particularly ↔ *(Back and Forth)*, 1969, in which the camera similarly– though more methodically–pans around the interior of a room. Benglis also pays homage to Stan Brakhage, particularly his *Desistfilm*, 1954. In this study of a teenagers' gathering at which nothing in particular happens, Brakhage used expressionistic devices such as extreme close-up, erratic camera movements and confrontations between the subjects

and the camera—techniques that Benglis uses in *Enclosure* to the same end. These pseudo-documentary observations become, in fact, metaphors for states of mind.

DISCREPANCY, 1973 [spring]

Black and white; 13 minutes, 4 seconds
Location: Topanga Canyon, California
Cast: Two children
Voice off camera: Lynda Benglis

Fig. 67: *Discrepancy*

Synopsis: This tape is one continuous, unedited take. The camera is initially positioned to show a view out of a window. The sounds of birds, traffic and children playing can be heard in the background. The camera slowly zooms out of the window and then back to its original position. The sounds of radio call-in talk shows and country-western music (a slightly shortened version of the sound track used in *Female Sensibility*) are added. The camera remains static for the next ten minutes, occasionally zooming a little to the outside or shifting to focus on the reflections of the trees on the window panes: eventually it returns to its original focus. Suddenly, the camera swings left and focuses out another window, showing two children playing with a dog. The sound of the radio is replaced by that of Benglis talking on the telephone.

There is a distinct discrepancy between the visual and aural components of the tape. The viewer, initially presented with a contemplative view of nature, is frequently distracted by the chatter of the radio. As the camera zooms in and out, it establishes a dichotomy: indoors and outdoors, the man-made and the natural. The window frame echoes the limited view framed by the camera, while the wide expanse of the outdoors and the reflections in the window panes suggest the infinite possiblities of the world just beyond view, as the dog and children seen at the end of the tape seem to indicate.

THE GRUNIONS ARE RUNNING, 1973 [probably late May]

Black and white; 5 minutes
Location: Topanga Canyon studio, California
Cast: None; imagery was shot off of television,
appropriated from "Creature Features" and
a commercial

Fig. 68: *The Grunions are Running*

Synopsis: The sound track for this tape is a recording of frogs croaking outside Benglis's Topanga Canyon studio; it is a squeaky white noise that becomes totally abstract. The screen shows a television tuned to a Japanese science-fiction movie, in which a modern-day couple is trapped in an ancient civilization that is threatened by a laser-breathing dragon. At one point, the "Creature Feature" (an afternoon television movie series) is interrupted by a chewing gum commercial, in which the marching band and young-couple-in-love oddly echo the ritual scenes and idealized modern couple of the movie. The movie resumes, a super submarine comes to the rescue and defeats the dragon, the world is saved and the video ends abruptly.

Throughout the tape, Benglis's camera randomly zooms in and out, focusing on various parts of the television screen to emphasize certain parts of the movie, such as a speech made by the leader of the ancient society. The visuals take on an absurdity, since all dialogue and aural clues have been replaced by a constant, ambiant sound. Thus the similarities between the movie and the commercial are heightened, causing each to seem more artificial.

Now, 1973 [fall]

Color; 12 minutes, 30 seconds
Location: Hunter College, New York
Cast: Lynda Benglis
Technical assistance: Tony Vlakovich

Synopsis: The tape begins with Benglis (seen in profile at the right of the screen) commanding, "Start recording. I said start recording." On the monitor behind her, her image appears in profile, facing her, at the left of the screen, and begins to make noises and faces, as in *On Screen*. Benglis makes faces and sounds in return and plays against her video image, making it appear as though she is kissing herself. At one point the screen goes blank. The entire sequence is then replayed on the monitor, with Benglis in front of it again, this time at left, facing right, and again mimicking the faces and sounds being made by her corresponding video profile. Segments of the tape are then

Fig. 69: *Now*

replayed randomly. Throughout, both on and off camera, Benglis asks "Now?" and "Do you wish to direct me?" and repeats commands such as "Start the camera." The tape ends as the monitor goes to static, and then is shut off.

The random sequencing, layering of images and frequent invocation of "now"—phrased as both question and command—focuses attention on when "now" really is. The viewer loses any idea of how the present image was generated. A sense of narrative dissolves; the conventional concepts of video time are revealed to be abstract and easily manipulated. This is Benglis's first color tape, and she exploits color to the fullest by bumping it up to a highly artificial level.

The tape has a distinctly erotic narcissism, as Benglis seductively manipulates her own image over and over. The sexual tension is heightened as she challenges traditional gender roles: Benglis is both the female/supplicant who asks "Do you wish to direct me?" and the male/aggressor who commands "Now."

COLLAGE, 1973 [fall]

Color; 10 minutes
Location: Hunter College, New York
Cast: Lynda Benglis
Technical assistance: Tony Vlakovich

Synopsis: Three basic vignettes are replayed in various combinations on this tape: the first is a hockey game, taped off of a black and white television (the same footage is used in *Enclosure*); the second is footage of arms swinging quickly across the screen (which is frequently echoed by the arms that appear in front of the video monitor); the third is a segment of tape that shows a hand holding, in succession, one, two and then three oranges. As in Benglis's earlier tapes, most of the segments are shown in at least the second generation, and the entire tape is shot from, or in front of, a video monitor. At the end of the tape, Benglis is seen in front of the monitor on which the other images still play. In a manner that recalls the repetitive actions of Richard Serra's film *Hand Catching Lead*, 1968, Benglis mechanically bites an orange and spits out the pieces of peel.

The sequencing of the visual components refutes any sense of narrative. Each segment has a strong, almost rhythmic movement that becomes an abstraction, in part because of the vivid color contrasts. The viewer becomes fascinated by the bright colors, rapid movements and complex layers of images on the screen; the sound track is noisy but indistinct, full of feedback and static, and essentially unrelated to the images.

Fig. 70: *Collage*

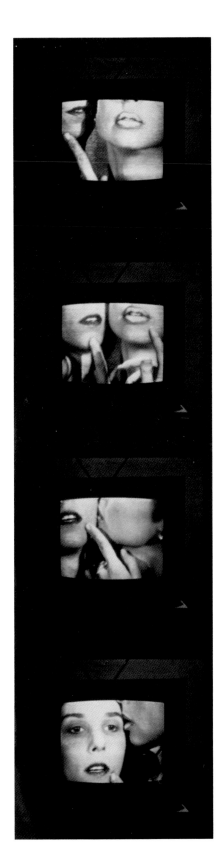

Fig. 71: *Female Sensibility*

FEMALE SENSIBILITY, 1973 [December]

Color; 14 minutes
Location: Hunter College, New York
Cast: Lynda Benglis, Marilyn Lenkowsky [Gorchov]
Technical assistance: Tony Vlakovich

Synopsis: Both women are heavily made-up: Lenkowsky in dark red-black lipstick, Benglis in pale blue-green lipstick. The entire video is shot in close-up, so that only a portion of each face is visible. Benglis begins to kiss Lenkowsky's face, directing the movements of Lenkowsky's head with a single finger on her chin. Their interaction is highly stylized and mannered, and limited to their heads and hands. At times both women seem involved, although they often trade off directing the action (kissing and caressing) and allowing themselves to be directed.

There is a distinct self-consciousness in all of this; at one point the camera catches Benglis eyeing the action on a monitor off screen. Her interest is not in her partner, but rather in staging their images and actions for the camera. As in *Now*, there is an element of narcissism here, underscored by the similarity in appearance between the two women. *Female Sensibility* mocks traditional heterosexual gender roles: both women appear somewhat androgynous, and they take turns directing or submitting to each other. The video is Benglis's emphatic response to the notion of a distinctly feminine artistic sensiblity and to the belief in a necessary lesbian phase in the women's movement—ideas that were often debated in the early 1970s.

The sound track (a slightly longer version than was used in *Discrepancy*) was taken from AM radio in southern California, and includes segments from several different call-in talk shows interspersed with country-western music. It is loud, boisterous and very public—a counterpoint to the prolonged and intimate action on screen.

HOW'S TRICKS, 1976 [spring]

Color; 34 minutes
Made in collaboration with Stanton Kaye
Location: Venice studio, California
Cast: Lynda Benglis, Stanton Kaye, Bobby Reynolds

Synopsis: The opening shot is a tight close-up of Kaye talking with Benglis, who is off camera. Kaye moves around a lot and thus is constantly bobbing in and out of frame. While easy-listening music plays in the background, they discuss honesty, the role of the artist, vulnerability, disguises and role-playing. At one point, Benglis says that she is not sure that she ever wants to be known or recognized again. From this intellectualized yet rather personal conversation, the tape moves into a quasi-narrative format, in which several separate elements are interwoven. Bobby Reynolds (a real carny who also appears in *The Amazing Bow-Wow*) is cast as a clownish carnival barker who recites various nonsensical rhymes and speeches. He is frequently interrupted by Benglis and Kaye, who are making a tape of his performance while arguing over camera angles and light levels. Several scenes are shot in silhouette or involve shadow play, such as the scene in which a clown (Reynolds again) performs a trick with a magic box for Benglis's amusement. Interspersed among these scenes is bootleg footage of President Richard M. Nixon—dubbed "Tricky Dick" at the time—preparing to address the nation during his final days in office. He jokes awkwardly with reporters and the Secret Service while a television crew checks the light and sound, and adjusts the camera angle. The taping of Reynold's performance and the taping of Nixon's media performance are implicitly compared.

This sequence is followed by another conversation between Benglis, on screen, and Kaye, who questions her from off camera. They talk about happiness, acquiring and sorting information, consumption and freedom. This is followed by more shadow play, the White House footage and shots of Reynolds as carny barker. In one very amusing scene, Reynolds demonstrates the "uses" of a replica of Marcel Duchamp's *Bicycle Wheel*, 1913. In the final sequence, Reynolds performs a "cut the girl in half" magic trick, with Benglis, in costume, as his assistant/victim. He asks Benglis to lie down in a magician's box, then with apparent glee begins to "cut" her up by inserting many cutting plates at odd angles. At one point, he reaches into the box, pulls off Benglis's costume and tosses it off camera. The trick is interrupted by a brief shot of the White House (taken from the purloined footage). The final scene is shot in silhouette: the box springs open and Benglis slowly stands up, striking the same pose she used for her infamous *Artforum* advertisement in November 1974.

Benglis and Kaye's conversations are rather cerebral, and seem to be continuations

Fig. 72: *How's Tricks*

of private discussions. In her stated desire to remain unrecognized, Benglis obliquely refers to the continuing public controversy the *Artforum* advertisement generated and its effects, declaring, "there's always something sexual about taking anything on. . . . Consumption is sexual."

There is a crudeness to *How's Tricks*, Benglis's first venture into narrative fiction. No attempt is made to hide the mechanics of making the tape. At one point while Benglis and Kaye argue about the tape they are making of Reynolds, Kaye is seen reaching over to turn off the video recorder, and thus the scene ends. Toward the beginning of the tape, a teddy bear is used to prop up homemade credits that are changed by a hand that reaches into the frame. The signs say "Tribute to//Jack Smith (Hi ya Smitty, how's tricks)//from Stanton and Lynda//with Bobby Reynolds//in Venice c 1976." The closing credits, on similar homemade signs, are propped up on a plaster statue of Christ, partially smeared with red.

How's Tricks is indebted stylistically to the late Jack Smith. Smith was an underground filmmaker whose quasi-narrative films evolved from his interest in psychological states. He essentially dispensed with plot but retained scenic structure. Each scene blends into the next as their boundaries are deliberately obscured; their sequence is determined by rhythm and dramatic effect, not by the need for logical plot exposition. Technically, Smith's films are deliberately crude: film stock is unevenly exposed, editing is minimal and arbitrary, music is nostalgic and repetitive.

The Nixon footage (which is essentially out-takes) exposes the media structure that props up public personae and thus reveals the disjuncture between the media's presentation and behind-the-scenes reality. *How's Tricks* points out how easily television's "magic box" is able to distort and deceive. The glee and transparency with which the various "magic" tricks are presented also points to the willingness by which a captive audience is misled.

Fig. 73: *The Amazing Bow-Wow*

THE AMAZING BOW-WOW, 1976-1977 [summer 1976-spring 1977]

Color; 30 minutes, 20 seconds
Made in collaboration with Stanton Kaye
Location: Artpark, Lewiston, New York; Allentown, Pennsylvania; and Klaus Kertess's backyard, East Hampton, New York
Cast: Lynda Benglis, Stanton Kaye, Bobby Reynolds, Rena Small, with appearances by Ree Morton, Pat Oleszko, Jim Roche
Written by Lynda Benglis and Stanton Kaye; directed by Stanton Kaye; produced by Lynda Benglis; costume by Rena Small; camera and editing by "Long John Slim"; on-line engineering by John Baker; music by Peter Ives; lyrics by Stanton Kaye. Sets and technical assistance provided by Reynolds-Waller International Sideshow.

Synopsis: This is the only one of Benglis's videos that has a discernable plot; it is something of a morality tale. The story is about a dog, Bow-Wow (Small), that is given to Rexina (Benglis) and Babu (Kaye) by a carnival barker (Reynolds). The dog is a hermaphrodite; Rexina and Babu quickly decide to exploit this and turn Bow-Wow into a sideshow act in hopes of making a fortune. They soon discover that the dog can also talk, which makes it an even more popular carny attraction. Rexina, who always refers to Bow-Wow as "he," is the dog's constant companion. This makes Babu, who always refers to the dog as "she," jealous. One night, while Rexina maternally comforts the restless Bow-Wow, the dog's penis accidently lands in Rexina's lap. Babu witnesses the scene and becomes enraged. Later that night, he sneaks into Bow-Wow's room and attempts to castrate the dog. The next morning, however, he discovers that he has mistakenly cut out the dog's tongue. As a consequence of this mutilation, the dog's head begins to whither, becoming skeletal and hideously ugly, thus ruining Bow-Wow and his carnival career.

The story is a farce based on the Oedipal complex: in trying to prevent Bow-Wow (Rexina's surrogate son) from usurping his place in Rexina's (the mother's) affections, Babu actually brings about his own demise. The phallus has long been a symbol of power, and Babu's intention in castrating the dog was to disempower it. Babu's mistake, however, rendered Bow-Wow silent and thus socially impotent.

In the catalogue published by Artpark, Benglis and Kaye state that their intention was to examine the moral position of the artist in society. Bow-Wow symbolizes the artist:

allowed to express him/herself, he/she is a creature of special potential; silenced, not only does the artist suffer–Bow-Wow becomes hideously ugly–but everyone's life is diminished. The tape is also a wry commentary on the ways that society, particularly the media, treats and exploits artists (here symbolized by the "classical" hermaphrodite) as entertaining oddities.

The tape is dedicated to the late Ree Morton, who was in residence at Artpark that summer and appears briefly in one of the crowd scenes.

MTV ARTBREAK, 1987 [May]

Color; 30 seconds
Location: Caesar Video Graphics, New York
Cast: Robert Kovich, Iris Hoffman
Music composed and performed by John King

Fig. 74: *MTV Artbreak*

Synopsis: A man and a woman are shown against a studio backdrop of a beach scene. They are kissing. She is first seen with her back to the camera; his kisses seem passionate and he looks intently at her as he mashes his face against hers. The angle changes, and he then has his back to the camera, his passion still evidenced by his wiggling ears. The woman, on the other hand, appears uninvolved; her eyes roam around and she seems surprised when she finally focuses on him, though they have been kissing for several seconds. The man tries to involve her by pulling her arms around him in an embrace, but she remains limp and non-participatory, like a rag doll. No words are spoken. The sound track combines the croaking frogs heard in *The Grunions Are Running* with a frantic rhythmic music that suggests a chase scene and adds to the sense of tension between the man and woman, although his pursuit of her is more psychological than physical.

This brief tape recapitulates one of Benglis's favorite themes from her early videos: the man is seen trying, in vain, to direct the woman but cannot win her over, even though she allows herself to be manipulated physically.

Note: Although the following tapes are cited (perhaps erroneously) in video catalogues or other publications, the artist does not recall them or include them in her oeuvre. (None of the tapes has been located.) Synopses are derived from the cited source.

SURFACE SOAP, 1972

Black and white; 8 minutes
Cited in "Part VI: Video and the New Imagery,"
Art + Cinema 1, no. 1 (January 1973): 34.
Cast: None

Synopsis: Footage appropriated from a television soap opera is distorted by the use of wide angles, audio feedback, visual static, picture rotation and random repetition of sequences.

FACE TAPE, 1972

Black and white
Cited in "Reviews and Previews," *Arts Magazine*,
72, no. 3 (March 1973): 82.
Cast: Lynda Benglis

Synopsis: Benglis makes faces at the camera and replays the tape on a monitor behind her, creating several generations of images.

Compiled by Carrie Przybilla

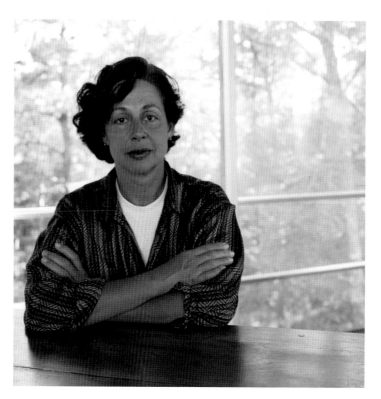

Fig. 75: Lynda Benglis, October 1990.

1941

Lynda Marie Benglis born on October 25 in Lake Charles, Louisiana, the first of five
children of Michael Benglis (second generation Greek-American, owner of a build-
ing supply business) and Leah Blackwelder Benglis (daughter of a Presbyterian
minister).

1952

Travels for the first time to Megiste (a small Greek island, also called Kastellerizon,
approximately eighty miles east of Rhodes that is the Benglis ancestral home) with
her paternal grandmother, Mary (Marigo) Stnos Benglis. Photo of eleven-year-old
Benglis in an evzone (Greek soldier) costume taken at this time.
After years of civil war, Greece adopts a parliamentary government.

1959

Enters McNeese College, Lake Charles, Louisiana. Studies art and philosophy,
particularly interested in logic.

1960

Transfers to The H. Sophie Newcomb Memorial College for Women, Tulane University,
New Orleans. Studies art with Ida Kohlmeyer, Hal Carnie, Pat Trivigno and graduate
assistant Zoltan Buki. Continues to study philosophy.
Sees the work of Franz Kline in *The World of Art in 1910*, an exhibition at the Isaac
Delgado Museum of Art, New Orleans (15 November-31 December); it is her first
encounter with abstract expressionism.
John F. Kennedy elected president.

1962

Receives scholarship to Yale Norfolk Summer School, Norfolk, Connecticut, but is
 unable to attend.

1963

Completes all B.F.A. requirements except foreign language courses.
Attends Yale Norfolk Summer School.
Teaches third grade in Jefferson Parish, Louisiana, during the 1963-64 school year
 while completing undergraduate language requirement.
John F. Kennedy assassinated.

1964

Receives B.F.A. in painting from The H. Sophie Newcomb Memorial College for
 Women. Moves to New York; first home/studio is an apartment on 11th Street
 between 1st and 2nd Avenues.
Enters The Brooklyn Museum Art School; studies painting with Reuben Tam. Meets
 Gordon Hart, also a student at the school, with whom she meets many artists
 working in New York, including Barnett Newman, Frank Stella, Bridget Riley
 and Larry Poons.

1965

Receives Max Beckman Scholarship for second semester at The Brooklyn Museum
 School of Art; drops out of school before the semester is over.
In the spring, travels to Greece with her paternal grandmother.
Marries painter Gordon Hart.
Sees exhibition of Ralph Humphrey's gray "frame" paintings at Green Gallery, New
 York, in the spring.
In summer, receives teaching certificate from New York University.
Supports herself by substitute teaching at Grace Church School in the fall.
"ABC Art," by Barbara Rose, appears in the October issue of *Art in America*.

1966

Sees Brice Marden monochromatic paintings at Park Place Gallery, New York, in the
 summer.
Works as gallery assistant at the newly opened Bykert Gallery, owned by Klaus Kertess
 and Jeffrey Byers. (Continues working there through 1968.)
"Notes on Sculpture," by Robert Morris, published in the February issue of *Artforum*.
Lucy Lippard organizes *Eccentric Abstraction* at Fischbach Gallery, New York
 (20 September-8 October). In November, her article of the same title appears in *Art
 International*.
Manufacturing lofts in lower Manhattan are rezoned and legalized as living spaces,
 spurring the birth of the district south of Houston Street known as SoHo.

1967

Travels in Greece again with her paternal grandmother.
Benglis and Hart take an apartment/ studio at 328 East 9th Street.
Advertisement depicting artist Ed Ruscha in ménage à trois appears in the January
 issue of *Artforum*.
King Constantine goes into exile after a military coup in Greece.
Carl Andre coins the term "post-studio" to describe his art.

1968

Lives and works in Robert Duran's studio on Grand Street over the summer. In the fall,
 moves to studio at 140 Baxter Street, where she continues to work until 1977. Other
 colleagues at this time include Carl Andre, Jennifer Bartlett, Michael Goldberg, Ron
 Gorchov (with whom she establishes an ongoing dialogue), Stanton Kaye, Klaus
 Kertess and Marilyn Lenkowsky.
Wax paintings included in a group show at Bykert Gallery.
"Anti Form," by Robert Morris, published in the April issue of *Artforum*.
Martin Luther King, Jr., assassinated on April 4.
Robert F. Kennedy assassinated on June 5.
Paula Cooper opens one of the first art galleries in SoHo at 98-100 Prince Street in
 the fall.
The Visual Studies Workshop, an experimental media workshop, opens in Rochester,
 New York.
Richard M. Nixon elected president.

1969

Works as Paula Cooper's secretary in January and February.
In May, pours *Bounce* at Bykert Gallery, the first public showing of her latex work.

Whitney Museum of American Art, New York, presents *Anti-Illusion: Procedures/Materials* (19 May-6 July). Benglis's work is to be included, but she withdraws it when denied permission to pour a work *in situ* and when extant work can not be properly installed.

Planet (a poured latex work originally created for the Whitney show) included in the exhibition *Other Ideas* at the Detroit Institute of Art (10 September-19 October). *Contraband* (also created for the Whitney show) exhibited at Paula Cooper Gallery in September.

Begins working with polyurethane foam in the fall.

Bullitt (a semi-flexible foam piece) included in the *1969 Annual Exhibition* at the Whitney Museum of American Art, New York (16 December-1 February 1970).

Pours untitled latex piece at the University of Rhode Island, Kingston.

Helen Frankenthaler, a retrospective, held at the Whitney Museum of American Art (20 February-6 April).

Three-day rock festival takes place on a farm near Woodstock, New York, and becomes a landmark of the emerging counterculture.

1970

Life publishes "Fling, Dribble and Dip," by David Bourdon, in the February 27 issue. The article focuses on the work of emerging sculptors Lynda Benglis, Eva Hesse, Richard Serra and Richard Van Buren.

Pours *For Carl Andre* at Fort Worth Art Center Museum, Texas.

Marriage with Gordon Hart ends.

Creates *Brunhilde*, her first foam piece to project off the wall, at Galerie Müller, Cologne, West Germany (26 June-23 July).

Begins teaching sculpture at the University of Rochester in the fall and commutes between Rochester and New York. Teaches at Rochester through the 1971-72 academic year. Experiments with video equipment in her classes.

Pours *Ithaca* at Ithaca College, Ithaca, New York (13 October-8 November).

Women Artists in Revolution (WAR) protests the Whitney Museum of American Art against the low number of women included in the *1969 Annual Exhibition*. In the summer, Women in the Arts picket the Whitney and The Museum of Modern Art to call attention to the unequal representation of work by women in their exhibitions.

Eva Hesse dies on May 29 of a brain tumor at the age of thirty-three.

Barnett Newman dies on July 4 of a heart attack at the age of sixty-five.

Advertisement depicting Judy Chicago as a boxer appears in the December issue of *Artforum*.

1971

Pours *Phantom* for *The Kansas State University Union Art Gallery and the Kansas State University Department of Art Invitational Exhibition '71*, Manhattan (4 February-13 March).

Pours *For and Against* (also called *For Klaus*) for the exhibition *Twenty Six By Twenty Six* at Vassar College, Poughkeepsie, New York (1 May-6 June).

Creates *Adhesive Products* at Walker Art Center, Minneapolis, for *New Works for New Spaces* (18 May-25 July). While making this piece, meets Robert Irwin and Larry Bell, whose works are also in the exhibition.

In early May, makes first trip to California to see the exhibition *Art and Technology* at the Los Angeles County Museum of Art (10 May-29 August).

Pours *For Darkness* for *Directions 3: Ten Artists* at the Milwaukee Art Center (19 June-8 August).

Pours *Pinto* at Paula Cooper Gallery (25 September-21 October).

Pours *Totem* at Massachusetts Institute of Technology, Cambridge (8 November-17December).

Begins collaborating with Robert Morris, which results in her videotape *Mumble*, 1972, and Morris's videotape *Exchange*, 1973.

Linda Nochlin's article "Why Have There Been No Great Women Artists?" appears in the January issue of *Artnews*.

The New York Times publishes the Pentagon Papers.

1972

Teaches at Hunter College, New York, during spring and fall semesters.

Travels to Martinique in the spring.

Visiting artist at Yale Norfolk Summer School.

Security guard discovers a break-in at Democratic Party National Headquarters at Watergate in Washington, D.C.

U.S. Congress passes the Equal Rights Amendment.

Nixon re-elected.

The Institute for Art and Urban Resources opens The Clocktower in New York.

The Feminist Art Program (a student project under the direction of Judy Chicago and Miriam Shapiro at the California Institute for the Arts, Valencia) converts a series of rooms in a run-down mansion into *Womanhouse*, an ongoing exhibition that focuses on women's experiences.

1973

Teaches at the California Institute of the Arts during spring semester. Lives in Gwen Murrill's studio in Topanga Canyon.

Travels to Portland, Oregon, for *Dimensional Paintings by Lynda Benglis* at the Portland Center for the Visual Arts (13 June-15 July). Meets Mel Katz, from whom she learns about the process of metallizing.

In June, Robert Irwin introduces Benglis to engineer/designer Jack Brogan, with whom she subsequently experiments with metallizing.

Takes filmmaking course at the California Institute of the Arts in the summer. Sublets studio in Venice, California, from Jim Ganzer. Becomes friends with artists who have studios nearby, including Billy Adler, Peter Alexander, Chuck Arnoldi, Billy Al Bengston, Ron Cooper, Guy Dill, Bryan Hunt, Alexis Smith, William Wegman and Tom Wudl.

Uses childhood photograph of herself in evzone costume for invitations to exhibitions at the Portland Center for the Visual Arts in June; Jack Glenn Gallery, Corona Del Mar, California, in July, and The Clocktower, New York, in December.

In the fall, takes studio at Andalusia Avenue and West Washington Boulevard in Venice, California (through 1978). Begins making frequent trips between New York and California.

Teaches at Hunter College for fall semester.

Installation of "sparkle knots" at The Clocktower (6 December-20 January 1974), which she strings with Christmas lights, partly in response to Nixon's request that Americans forego Christmas light displays to help ease the energy crisis, caused by an embargo imposed by the oil-producing countries of the Middle East.

The Women's Building, devoted entirely to women's issues and work by contemporary women artists, opens in Los Angeles.

Greek monarchy legally abolished.

Paula Cooper Gallery moves to 155 Wooster Street.

1974

Teaches at the California Institute of the Arts from January through May.

Advertisement with photograph of herself with hair slicked back, wearing sunglasses and leaning against her Porsche (taken in 1973) appears in the April issue of *Artforum*.

Robert Morris uses a photograph of himself (bare-chested and wearing a Nazi helmet, sunglasses and chains) on the poster/invitation for his exhibition at Castelli-Sonnabend Gallery, New York, in April.

Annie Leibovitz's "cheesecake" photograph of Benglis, à la Betty Grable, used on the invitation to Benglis's exhibition *Lynda Benglis presents Metallized Knots* at Paula Cooper Gallery in May.

Benglis runs "dildo" advertisement in November issue of *Artforum*, which also includes Robert Pincus-Witten's article on her work, "The Frozen Gesture." Five of the six editors of the magazine sign a letter of protest that appears in December issue. The advertisement provokes controversy over whether it is art or a publicity stunt, a feminist statement or a sexist exploitation of women.

Artpark, a 200-acre, state-funded, public park devoted to the visual and performing arts, opens in Lewiston, New York.

Nixon resigns.

Greece adopts a republican government.

1975

Receives John Simon Guggenheim Memorial Fellowship and casts poured polyurethane foam pieces in metal.

Begins working with the fabricators at General Plasma, Los Angeles, on metal pieces.

Visiting lecturer at Princeton University, New Jersey (1 February-15 March).

Installs *Primary Structures (Paula's Props)* at Paula Cooper Gallery, New York (8 November-3 December).

Saigon falls to the Viet Cong; American troops return from Vietnam.

1976

Teaches at the California Institute of the Arts in April and from September through December.

Resident artist at Artpark; uses grounds of the park as a backdrop for parts of *The Amazing Bow-Wow*, a videotape made in collaboration with Stanton Kaye. A number

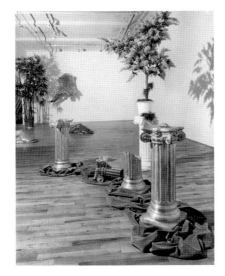

Fig. 76: Lynda Benglis, *Primary Structures (Paula's Props)*, 1975, lead, aluminum, plaster, plastic plants and velvet, approximately 97 x 99 x 63 inches, private collection, installation at Paula Cooper Gallery, New York, 8 November-3 December 1975.

of the artists also at Artpark that summer appear in the tape, including Ree Morton, Jim Roche and Pat Oleszko.

Receives Australian Art Council Award and is included in *Recent International Forms in Art: The 1976 Biennale of Sydney* (13 November-19 December).

The Dow Jones industrial average tops the 1,000 mark.

The Institute for Art and Urban Resources opens Projects Studios 1 (P.S. 1) in Long Island City, Queens, New York.

1977

Collaborates with former teacher Ida Kohlmeyer on *Louisiana Prop Piece* for exhibition *Five from Louisiana* at the New Orleans Museum of Art (28 January-27 March).

Visiting artist, Kent State University, Ohio (28 March to 25 April); while there, first experiments with glass casting.

Moves to present studio at 222 The Bowery in the fall.

Ree Morton dies on April 30 at the age of forty, as a result of an automobile accident.

1978

Creates "Lagniappe I," her first cast handmade paper series, at Exeter Press, New York.

Visiting artist at Skowhegan School of Painting and Sculpture, Maine, in the summer.

Invitation for "flounces" exhibition at Paula Cooper Gallery in November includes José Ortega y Gasset quote.

1979

Receives an artist's grant from the National Endowment for the Arts.

Returns to Skowhegan School of Painting and Sculpture as artist-in-residence for July and August.

Sees *Mer Egée, Grèce des Isles*, an exhibition of Aegean art, at the Louvre, Paris (26 April-3 September), on return from trip to Italy and Greece.

In October, makes first trip to Ahmadabad, India. Begins making frequent trips to India and Greece.

1980

Teaches at Hunter College for spring semester.

Receives commission to create *Pantang*, a fabric wall piece, for new Hartsfield Atlanta International Airport.

Gold prices reach a record high on the international market.

Ronald Reagan elected president.

1981

Breaks ground for home and studio in East Hampton, New York.

Receives commission to create *Nalia*, a bronze and copper outdoor sculpture, for the Leo W. O'Brien Federal Building, Albany, New York.

Artist-in-residence at the University of Arizona, Tucson, for the spring.

Begins working with Target Metallizing to fabricate metal pieces in New York.

Teaches at Hunter College for fall semester.

MTV, the first television channel devoted entirely to music-videos, goes on the air in August.

Acquired Immune Deficiency Syndrome (AIDS) first detected among homosexual men in Los Angeles.

1982

Proposed Equal Rights Amendment expires in June, three states short of ratification.

1983

Receives commission to design a poster for the 1984 Summer Olympics in Los Angeles.

Receives commission to create *The Wave (The Wave of the World)*, one of thirteen artists' projects accepted by the 1984 World's Fair International Water Sculpture Competition in New Orleans.

1984

Visiting artist at The New York Experimental Glass Workshop, New York.

Founding of the Guerrilla Girls, a collective of women artists in New York who don gorilla masks to maintain their anonymity while staging protests to call attention to discrimination against women artists and artists of color.

1985

Visiting professor, School of the Visual Arts, Fine Arts Workshop, New York (through 1987).

Artist-in-residence at the Pilchuck Glass School, Stanwood, Washington, during the summer.

Begins working with Petrochem to fabricate metal pieces in Lake Charles, Louisiana.

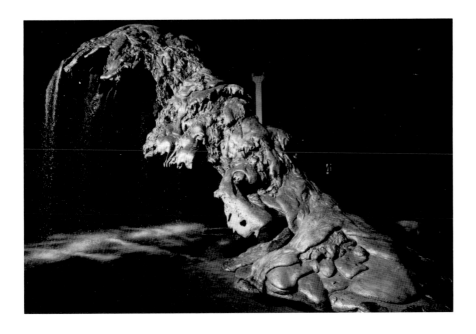

Fig. 77: Lynda Benglis, *The Wave (The Wave of the World)*, 1984, cast bronze, 9 x 9 x 17 feet, collection of Carl J. Eberts, New Orleans, installation at the 1984 World's Fair, New Orleans.

1987

AIDS Coalition To Unleash Power (ACT-UP) formed to call attention to the AIDS crisis.
After reaching a record high on August 17, the Dow Jones industrial average drops 508 points on October 15, the largest one-day drop in its history.

1988

Visiting artist at Tandem Press, University of Wisconsin—Madison (3-14 May).
Artist-in-residence at the Minos Beach Art Symposium, Crete, Greece (11 June-30 September).
Panelist, Delphi Art Symposium, Greece.
Welded metal sculpture included in Olympiad of Art Sculpture Park, Seoul, South Korea.
George Bush elected president.

1989

Receives National Council of Arts Administration grant.

1990

Continues to live and work in New York; East Hampton, New York; and Ahmadabad, India.

Compiled by Carrie Przybilla

COLLECTIONS AND COMMISSIONS

PUBLIC COLLECTIONS

Albright-Knox Art Gallery, Buffalo
Allen Memorial Art Museum, Oberlin, Ohio
Art Museum of South Texas, Corpus Christi
Australian National Gallery, Canberra
Birmingham Museum of Art, Alabama
The Corcoran Gallery of Art, Washington, D.C.
The Detroit Institute of Arts
Gihon Foundation, Santa Fe
Grey Art Gallery & Study Center, New York University
High Museum of Art, Atlanta
Hokkaido Museum of Modern Art, Sapporo, Japan
The Israel Museum, Jerusalem
K-State Union at Kansas State University, Manhattan
Lannan Foundation, Los Angeles
Los Angeles County Museum of Art
Miami-Dade Community College, Florida
Milwaukee Art Museum
The Modern Art Museum of Fort Worth, Texas
The Museum of Fine Arts, Houston
The Museum of Modern Art, New York
National Gallery of Victoria, Melbourne, Australia
National Museum of American Art, Smithsonian Institution, Washington, D.C.
The Nelson-Atkins Museum of Art, Kansas City, Missouri
New Orleans Museum of Art
Philadelphia Museum of Art
Solomon R. Guggenheim Museum, New York
Storm King Art Center, Mountainville, New York
University Art Gallery, New Mexico State University, Las Cruces
University of South Florida Art Museum, Tampa
Walker Art Center, Minneapolis
Whitney Museum of American Art, New York

COMMISSIONS

Fairmont Hotel (now the Hyatt Regency), Denver
First City Center, Dallas (commissioned by Cadillac Fairview Urban Development Inc., now Prentiss Properties Limited, Inc.)
Hartsfield Atlanta International Airport
Leo W. O'Brien Federal Building, Albany, New York (commissioned through the General Services Administration Art-in-Architecture program)
Pacific Telesis Center, San Francisco
The Prudential Insurance Company of America (Northern Group Operations Office), Parsippany, New Jersey

CORPORATE COLLECTIONS

BP America, Inc., Cleveland
BankAmerica Corporation, San Francisco
Bedford Properties, Inc., Carlsbad, California
Burroughs Wellcome Co., Research Triangle Park, North Carolina
Captiva Corporation, Denver
Citibank/Citicorp, New York
The Chase Manhattan Bank, N.A., New York
Columbia Savings and Loan Association, Beverly Hills, California
Fixtures Furniture, Kansas City, Missouri
Frederick Weisman Company, Los Angeles
Frito-Lay, Inc., Plano, Texas
Goldman, Sachs & Co., New York
Hasbro, Inc., New York
Merrill Lynch & Co., Inc., New York
Newsweek, New York
Philip Morris Companies Inc., New York
Pitney-Bowes Inc., Stamford, Connecticut
The Prudential Insurance Company of America, Newark, New Jersey
The Readers Digest Association, Inc., Pleasantville, New York
Shearson Lehman Hutton Inc., New York
Southwestern Bell Corporation, St. Louis

EXHIBITION HISTORY

ONE-ARTIST EXHIBITIONS

1969

Main Gallery, Fine Arts Center, University of Rhode Island, Kingston. *Lynda Benglis.*

1970

Paula Cooper Gallery, New York. *Lynda Benglis,* 8 February-4 March.

Janie C. Lee Gallery, Dallas. *Lynda Benglis,* 23 May-21 June.

Galerie Müller, Cologne, West Germany. *Lynda Benglis,* 26 June-23 July.

1971

Union Art Gallery, Kansas State University, Manhattan. *The Kansas State University Union Art Gallery and the Kansas State University Department of Art Invitational Exhibition '71,* 4 February-13 March.

Paula Cooper Gallery, New York. *Lynda Benglis,* 25 September-21 October.

Hayden Gallery, Massachusetts Institute of Technology, Cambridge. *Lynda Benglis: Polyurethane Foam, Two-Component System,* 8 November-17 December.

1972

Hansen Fuller Gallery, San Francisco. *Lynda Benglis: Wax Paintings,* 1-26 February.

1973

Hansen Fuller Gallery, San Francisco. *Lynda Benglis: Paintings and Videotapes,* 2-26 May.

Portland Center for the Visual Arts, Oregon. *Dimensional Paintings by Lynda Benglis,* 13 June-15 July.

Jack Glenn Gallery, Corona Del Mar, California. *Lynda Benglis,* 21 July-10 August.

Texas Gallery, Houston. *Lynda Benglis,* 18 November-10 December.

The Clocktower, The Institute for Art and Urban Resources, New York. *Lynda Benglis,* 6 December-20 January 1974.

1974

Paula Cooper Gallery, New York. *Lynda Benglis presents Metallized Knots,* 4-29 May.

Hansen Fuller Gallery, San Francisco. *Lynda Benglis: Knots,* 29 October-23 November.

1975

Fine Arts Center Gallery, State University College of New York at Oneonta, New York. *Physical and Psychological Moments in Time: A First Retrospective of the Video Work of Lynda Benglis,* 29 January-26 February. Traveled to Stedelijk van Abbemuseum, Eindhoven, The Netherlands. Catalogue, text by Robert Pincus-Witten. Reprinted in Robert Pincus-Witten. *Postminimalism.* New York: Out of London Press, 1977; and in Robert Pincus-Witten. *Postminimalism into Maximalism: American Art 1966-1986.* Ann Arbor, Michigan: UMI Research Press, 1987.

The Kitchen, New York. *Video Polaroids,* 8-15 November.

Paula Cooper Gallery, New York. *Lynda Benglis: Sculpture,* 8 November-3 December.

Texas Gallery, Houston. *Lynda Benglis,* 8-29 November.

1976

Paula Cooper Gallery, Los Angeles. *Lynda Benglis: Metallized Knots and Wax Paintings,* 1-22 May.

1977

Margo Leavin Gallery, Los Angeles. *7 Come 11: A Series of Recent Sculpture by Lynda Benglis,* 20 May-30 June.

Douglas Drake Gallery, Kansas City, Missouri. *Lynda Benglis: Copper Knots and Floor Sculpture,* 4-30 November.

1978

Paula Cooper Gallery, New York. *Lynda Benglis,* 11 November-9 December.

1979

Texas Gallery, Houston. *Lynda Benglis: New Works,* 17 January-10 February.

Dart Gallery, Chicago. *Lynda Benglis: New Works,* 11 May-8 June.

Galerie Albert Baronian, Brussels. *Lynda Benglis,* 11 June-31 December.

Paula Cooper Gallery, New York. *Lynda Benglis,* June.

Real Art Ways, New Haven, Connecticut. *Lynda Benglis: Wall Sculptures and Floor Installations,* 5 October-3 November.

Hansen Fuller Goldeen Gallery, San Francisco. *Lynda Benglis: Bodies and Fans*, 23 October-20 November.

Georgia State University Art Gallery, Georgia State University, Atlanta. *Lynda Benglis: Recent Works*, 26 October-16 November. Brochure.

1980

Teaching Gallery, University of South Florida, Tampa. *Lynda Benglis: 1968-1978*, 8 February-6 March. Traveled to the Lowe Art Museum, University of Miami, Coral Gables, Florida, in affiliation with Miami-Dade Community College, Miami, Florida. Catalogue, text by Peter Schjeldahl.

Margo Leavin Gallery, Los Angeles. *Lynda Benglis*, 22 March-12 April.

Portland Center for the Visual Arts, Oregon. *Recent Works by Lynda Benglis*, 10 May-13 June.

Texas Gallery, Houston. *Fans (Air) Kites (Air) Airport (Air). Lynda Benglis: "Patang." The Atlanta Airport Commission and New Works Executed in Ahmedabad, India*, 14 June-9 July.

Paula Cooper Gallery, New York. *Lynda Benglis: Aquanots*, 16 September-11 October.

Heath Gallery, Atlanta. *Lynda Benglis: Recent Works*, 20 September-16 October.

Susanne Hilberry Gallery, Birmingham, Michigan. *Lynda Benglis: New Work*, 22 November-31 December.

Woodland Gallery, Chatham College, Pittsburgh. *Lynda Benglis*, November.

1981

Cirrus Gallery, Los Angeles. *Lynda Benglis*, 3 February-7 March.

Galerie Albert Baronian, Brussels. *Lynda Benglis: Indian Wood Blocks*, 22 March-14 April.

University of Arizona Museum of Art, University of Arizona, Tucson. *Lynda Benglis: Drawings from India*, 26 April-18 May. Catalogue, text by Wayne Enstice.

Dart Gallery, Chicago. *Lynda Benglis: New Work*, 9 October-4 November.

Jacksonville Art Museum, Florida. *Lynda Benglis: Recent Gold Pieces*, 5-29 November.

Texas Gallery, Houston. *Lynda Benglis: Sculptures*, 5 December-2 January 1982.

1982

Okun-Thomas Gallery, St. Louis. *Lynda Benglis: Sculpture and Works on Paper*, 9 January-6 February.

Margo Leavin Gallery, Los Angeles. *Lynda Benglis. Flux and Fusion: An Exhibition of Sculpture from 1970 to the Present*, 15 January-20 February.

Paula Cooper Gallery, New York. *Benglis: ΕΙΔΩΛΛ*, 30 October-27 November.

Fuller Goldeen Gallery, San Francisco. *Lynda Benglis*, 3-27 November.

1983

Susanne Hilberry Gallery, Birmingham, Michigan. *Lynda Benglis: New Sculpture*, 17 June-30 July.

Dart Gallery, Chicago. *Lynda Benglis*, 5 November-7 December.

1984

Paula Cooper Gallery, New York. *Lynda Benglis: New Sculpture*, 22 March-14 April.

Texas Gallery, Houston. *Lynda Benglis: New Sculptures*, 11 September-20 October.

Tilden-Foley Gallery, New Orleans. *Lynda Benglis*, 20 October-7 November.

1985

Margo Leavin Gallery, Los Angeles. *Lynda Benglis: Works in Glass*, 16 February-23 March. Brochure, text by David Shapiro.

Susanne Hilberry Gallery, Birmingham, Michigan. *Lynda Benglis: New Works in Glass*, 28 September-26 October.

Heath Gallery, Atlanta. *Lynda Benglis: Recent Wall Pieces and Glass Sculpture*, 16 November-14 December.

1986

Fuller Goldeen Gallery, San Francisco. *Lynda Benglis*, 3 April-3 May.

Tilden-Foley Gallery, New Orleans. *Lynda Benglis*, 23 April-22 May.

Dart Gallery, Chicago. *Lynda Benglis: Glass*, October.

1987

Paula Cooper Gallery, New York. *Lynda Benglis: Recent Sculpture*, 25 March-18 April.

Landfall East, New York. *Lynda Benglis: Monoprints/Windy Hill Series*, April.

Margo Leavin Gallery, Los Angeles. *Lynda Benglis: New Sculpture*, 16 May-20 June.

1988

Cumberland Gallery, Nashville. *Lynda Benglis: Recent Sculpture and Works on Paper*, 9 April-14 May.

Fuller Gross Gallery, San Francisco. *Lynda Benglis*, 6 December-7 January 1989.

1989

Tilden-Foley Gallery, New Orleans. *Lynda Benglis*, 1 April-10 May.

Michael Murphy Gallery, Tampa. *Florida Fan Dance: A Palmetto Series. Monotype Prints by Lynda Benglis*, 7-30 April.

Hester Merwin Ayers Gallery, Atlantic Center for the Arts, New Smyrna Beach, Florida. *Drawing with Materials: Process and Image. Works by Lynda Benglis*, 3 July-31 August. Brochure, text by Donna Blagdan.

Margo Leavin Gallery, Los Angeles. *Lynda Benglis: New Sculpture*, 8 July-12 August.

1990

Richard Gray Gallery, Chicago. *Lynda Benglis: Recent Sculpture*, 23 March-10 May.

Linda Farris Gallery, Seattle. *Lynda Benglis: Sculpture and Silk Paintings*, 2-31 August.

Sena Galleries West, Santa Fe, New Mexico. *Lynda Benglis*, 24 August-14 September.

Paula Cooper Gallery, New York. *Lynda Benglis: Trophies*, 4-29 September.

GROUP EXHIBITIONS

1969

Bykert Gallery, New York. *Lynda Benglis, Charles Close, Richard Van Buren, David Paul*, 20 May-20 June.

Carmen Lamanna Gallery, Toronto. *Group Exhibition*, 21 July-18 August.

The Detroit Institute of Arts. *Other Ideas*, 10 September-19 October. Catalogue, introduction by Samuel Wagstaff.

Paula Cooper Gallery, New York. *Lynda Benglis, Gary Dubosen, Alan Shields*, 20 September-15 October.

Städtische Künsthalle Düsseldorf. *Prospect '69*, 30 September-12 October.

Finch College Museum of Art, Finch College, New York. *Art and Process IV*, 11 December-26 January 1970. Catalogue, foreword by Elayne H. Varian, artist's statement.

Whitney Museum of American Art, New York. *1969 Annual Exhibition: Contemporary American Painting*, 16 December-1 February 1970. Catalogue, foreword by John I. H. Baur.

Paula Cooper Gallery, New York. *Drawing Show*, December.

Winters Gallery, Winters College, York University, Toronto.

1970

The Aldrich Museum of Contemporary Art, Ridgefield, Connecticut. *Highlights of the 1969-1970 Art Season*, 21 June-13 September. Catalogue, introduction by Larry Aldrich.

Paula Cooper Gallery, New York. *Referendum 70 Exhibition*, September.

Ithaca College Museum of Art, Ithaca College, Ithaca, New York. *Benglis, Sanderson, Van Buren*, 13 October-8 November.

Lobby, College of Architecture and Urban Studies, Virginia Polytechnic Institute, Blacksburg. *Lynda Benglis and Mike Goldberg*, fall.

New Gallery for Contemporary Art, Cleveland. *Small Works*, 4 December-10 January 1971.

Rhode Island School of Design Museum of Art, Rhode Island School of Design,

Providence. *Art for Your Collection, IX,* 9-20 December.

Paula Cooper Gallery, New York. *Drawing Show,* December-January 1971.

Paula Cooper Gallery, New York. *Lynda Benglis, George Kuehn, Richard Van Buren.*

1971

Mansfield Art Center, Ohio. *Into the Seventies: Paintings and Graphics from the New Gallery,* 17-30 January.

Members' Penthouse, The Museum of Modern Art, New York. *MOMA's Restaurant,* 26 January-30 February.

Vassar College Art Gallery, Vassar College, Poughkeepsie, New York. *Twenty-Six by Twenty-Six,* 1 May-6 June. Catalogue, texts by Mary Delahoyd, Marguerite Klobe, Robin Brown, Nancy Cara Ackerman, and Stephen Martin.

Bykert Gallery, New York. *Group Exhibition,* 18 May-22 June.

Walker Art Center, Minneapolis. *New Works for New Spaces,* 18 May-25 July. Catalogue, text by Martin Friedman.

Milwaukee Art Center. *Directions 3: Eight Artists,* 19 June-8 August. Catalogue, introduction by John Lloyd Taylor.

Paula Cooper Gallery, New York. *Group Exhibition,* June.

Memorial Art Gallery, University of Rochester, New York. *University of Rochester Studio Arts Faculty,* 3-26 December. Catalogue, text by Ira Licht.

Forum Kunst Rottweil, West Germany. *Lynda Benglis and Allen Hacklin.*

Windham College, Putney, Vermont. *Paula Cooper Gallery Group.*

1972

Hurlbutt Gallery, Greenwich Public Library, Connecticut. *New York '72: Paula Cooper Gallery Group,* 6-29 January.

Richard Gray Gallery, Chicago. *New York Artists,* 7 March-6 April.

GEDOK (Gemeinschaft der Künstlerinnen und Künstfreunde) Künsthaus, Hamburg. *American Women Artists Show,* 14 April-14 May. Catalogue, introduction by Lil Picard, foreword by Alexander C. Johnpoll, text by Sibylle Niester.

School of Art Gallery, Kent State University, Ohio. *Kent Women's Invitational Exhibition,* 16-28 April.

Walker Art Center, Minneapolis. *Painting: New Options,* 23 April-4 June. Catalogue, introduction by Dean Swanson, text by Philip Larson.

Indianapolis Museum of Art. *Painting and Sculpture Today,* 26 April-4 June. Catalogue, foreword by Carl J. Weinhardt, Jr., introduction by Richard L. Warrum.

The Art Institute of Chicago. *32nd Annual Exhibition: Contemporary Works of Art,* 16 May-25 June. Brochure.

Paula Cooper Gallery, New York. *Group Exhibition,* 3-21 June.

Lakeview Center for the Arts and Sciences, Peoria, Illinois. *American Women: 20th Century,* 15 September-29 October. Catalogue, preface by Lowell Adams, introduction by Ida Kohlmeyer.

The Detroit Institute of Arts. *12 Statements Beyond the 60's,* 27 September-5 November. Catalogue.

The Suffolk Museum, Stony Brook, New York. *Unmanly Art,* 14 October-24 November. Brochure, text by June Blum.

Paula Cooper Gallery, New York. *Small Series,* 9 December-13 January 1973.

1973

Whitney Museum of American Art, New York. *1973 Biennial Exhibition: Contemporary American Art,* 10 January-18 March. Catalogue, foreword by John I. H. Baur.

Memorial Art Gallery, University of Rochester, New York. *University of Rochester Studio Art Faculty,* 12 January-17 February.

Yale University Art Gallery, Yale University, New Haven, Connecticut. *Options and Alternatives: Some Directions in Recent American Art,* 4 April-16 May. Catalogue, preface by Alan Shestack, texts by Anne Coffin Hanson, Klaus Kertess, and Annette Michelson; text on Benglis by Elliott Schwartz.

The Contemporary Arts Center, Cincinnati. *Options 73/30,* 25 September-11 November. Catalogue, introduction by Jack Boulton.

Paula Cooper Gallery, New York. *Drawings and Other Work,* 15 December-9 January 1974.

1974

Paula Cooper Gallery, New York. *Group Exhibition,* spring.

Paula Cooper Gallery, New York. *Group Exhibition,* fall.

Paula Cooper Gallery, New York. *Drawings and Other Work,* 7 December-8 January 1975.

Galerie John Doyle, Paris. *Choice Dealer/ Dealer's Choice: New York Cultural Center Opening Exhibition.*

John Doyle Gallery, Chicago.

1975

Texas Gallery, Houston. *Arnoldi, Benglis, Bengston, Wudl,* 1-25 February.

The Baltimore Museum of Art. *Fourteen Artists,* 15 April-1 June. Catalogue, text by Brenda Richardson.

The Clocktower, The Institute for Art and Urban Resources, New York. *Selections from the Collection of Herbert and Dorothy Vogel,* 19 April-17 May.

Paula Cooper Gallery, New York. *Group Exhibition,* spring.

Rayburn Building, Washington, D.C., and West Broadway Gallery, New York. *Artists' Rights Today,* June.

Institute of Contemporary Art, University of Pennsylvania, Philadelphia. *Painting, Drawing and Sculpture of the 60's and 70's from the Dorothy and Herbert Vogel Collection,* 7 October-18 November. Traveled to The Contemporary Arts Center, Cincinnati. Catalogue, foreword by Suzanne Delehanty.

Fine Arts Building, New York. *Lives,* 29 November-20 December.

The Bronx Museum of the Arts, New York. *The Year of the Woman.*

Fine Arts Building, New York. *Photography/Not Photography.*

New York Cultural Center. *New Editions 1974-75.*

Paula Cooper Gallery, New York. *Group Exhibition.*

1976

HALLWALLS Contemporary Arts Center, Buffalo. *Approaching Painting: Part III,* 10 February-1 March.

Auckland City Art Gallery, New Zealand. *First Pan Pacific Biennale, 1976: Colour Photography and Its Derivatives,* 20 March-20 April.

Aarhus Künstmuseum, Vennelystparken, Denmark. *The Liberation: 14 Women Artists,* 10 April-2 May. Traveled to Galerie Asbaoek, Copenhagen, Denmark. Catalogue, introduction by Kristian Jakobsen, texts by Charlotte Christensen and Jane Livingston.

Nassau County Center for the Fine Arts, Roslyn, New York. *Nine Sculptors: On the Ground, In the Water, Off the Wall,* 2 May-25 July. Brochure, text by Jean E. Feinberg.

Marion Koogler McNay Art Institute, San Antonio. *American Artists: A Celebration,* 23 May-1 August. Catalogue, preface by John Palmer Leeper, introduction by Alice C. Simkins.

Texas Gallery, Houston. *A Selection of New Work,* 1-30 June.

Members' Penthouse, The Museum of Modern Art, New York. *Handmade Paper: Prints and Unique Works,* 28 June-12 September. Traveled to General Electric Company, Fairfield, Connecticut.

Stamford Museum and Nature Center, Connecticut. *Contemporary American Sculptors Not Included in the Whitney Museum's Concurrent "Two Hundred Years of American Sculpture Exhibition,"* 10 July-30 August. Checklist.

Otis Art Institute Art Gallery, Otis Art Institute, Los Angeles. *Five Contemporary Artists: Albuquerque, Arnoldi, Benglis, Castoro, Steir,* 2 September-3 October.

The Museum of Modern Art, New York. *Reinstallation of the Painting and Sculpture Collection*, 3 September-9 November.

The Art Gallery of New South Wales, Sydney, Australia. *Recent International Forms in Art: The 1976 Biennale of Sydney*, 13 November-19 December. Catalogue, introduction by Thomas G. McCullough.

Susanne Hilberry Gallery, Birmingham, Michigan. *Opening Exhibition*, 10 December-5 January 1977.

BlumHelman Gallery, New York. *Benefit Exhibition for "Einstein on the Beach."*

The Broxton Gallery, Los Angeles. *Sequential Imagery in Photography.*

1977

Paula Cooper Gallery, New York. *Group Exhibition*, 4-26 January.

Cedars-Sinai Medical Center, Los Angeles. *A Women's Exhibition*, 9 January-19 February.

New Orleans Museum of Art. *Five from Louisiana*, 28 January-27 March. Catalogue, introduction by E. John Bullard and William A. Fagaly, texts by Tennessee Williams, Liza Béar, Philip Glass, Calvin Tomkins, and Calvin Harlan. Published as supplement to *The Times-Picayune* (New Orleans), 30 January. Text by Tennessee Williams, reprinted in "Lynda Benglis." *Parachute* (Montreal, Canada), no. 6 (Spring 1977): 92-93.

Solomon R. Guggenheim Museum, New York. *Recent Acquisitions*, 4-27 February.

Joseloff Gallery, University of Hartford, Connecticut. *Materials of Art: Plastic*, 9-25 February.

New Jersey State Museum, Trenton. *For the Mind and Eye: Artwork by Nine Americans*, 23 April-12 June.

Hansen Fuller Gallery, San Francisco. *Lynda Benglis and William Weege*, 2-31 August.

Southwestern College Art Gallery, Southwestern College, Chula Vista, California. *Group Exhibition*, 8 September-30 November.

Museum of Contemporary Art, Chicago. *A View of a Decade: 1967-1977*, 10 September-10 November. Catalogue, texts by Martin Friedman, Robert Pincus-Witten, and Peter Gay.

Paula Cooper Gallery, New York. *Group Exhibition*, 10 September-12 October.

The Brooklyn Museum, New York. *Contemporary Women: Consciousness and Content*, 1 October-27 November. Catalogue, text by Joan Semmel.

1978

Daniel Weinberg Gallery, San Francisco. *Up Against the Wall*, 28 January-25 February.

Georgia State University Art Gallery, Georgia State University, Atlanta. *Eleven Artists*, 30 January-17 February.

Whitney Museum of American Art, Downtown at Federal Reserve Plaza, New York. *Art at Work: Recent Art from Corporate Collections*, 9 March-11 April.

Paula Cooper Gallery, New York. *Group Exhibition*, 9 September-4 October.

Stedelijk Museum, Amsterdam. *Made by Sculptors*, 14 September-5 November. Catalogue, text by Geert Van Beijeren.

Philbrook Art Center, Tulsa. *Sculpture: Modern Works*, 15 October-23 November. Brochure.

Members' Penthouse, The Museum of Modern Art, New York. *Gold*, 29 November-19 February.

Holly Solomon Gallery, New York. *Gold/Silver*, 20 December-10 January 1979.

1979

Hampshire College Art Gallery, Hampshire College, Amherst, Massachusetts. *Images of the Self*, 19 February-14 March.

Otis Art Institute Art Gallery, Otis Art Institute, Los Angeles. *Artattack*, 14 March-15 April.

Susanne Hilberry Gallery, Birmingham, Michigan. *Lynda Benglis and Ron Gorchov*, 14 April-12 May.

Hamilton Gallery, New York. *Color and Structure*, 5 May-2 June.

The Museum of Modern Art, New York. *Contemporary Sculpture: Selections from the Collection of the Museum of Modern Art*, 18 May-7 August. Catalogue, foreword by Kynaston McShine.

The Aspen Center for the Visual Arts, Colorado. *American Portraits of the Sixties and Seventies*, 1 June-31 August. Catalogue, introduction by Philip Yenawine, text by Julia C. Augur.

Palazzo Reale, Milan. *Pittura-Ambiente*, 9 June-16 September. Catalogue, texts by Renato Barilli and Francesca Alinovi.

Margo Leavin Gallery, Los Angeles. *An Exhibition of Selected Acquisitions*, 4 August-15 September.

Ben Shahn Galleries, William Paterson College, Wayne, New Jersey. *Painting: Five Views*, 1-30 September. Catalogue, introduction and text by Nancy Einreinhofer.

Toni Birckhead Gallery, Cincinnati. *First Exhibition*, 19 October-25 November.

1980

Contemporary Arts Museum, Houston. *Extensions*, 20 January-2 March. Catalogue, text by Linda L. Cathcart.

Joe and Emily Lowe Art Gallery, Syracuse University, New York. *Current/New York*, 27 January-24 February. Catalogue, introduction by Joseph A. Scala.

Whitney Museum of American Art, Downtown at Federal Reserve Plaza, New York. *Painting in Relief*, 30 January-5 March. Catalogue, text by Lisa Phillips.

David Winton Bell Gallery, Brown University, Providence. *Invitational*, 1-24 February.

Galerie Yvon Lambert, Paris. *Paula Cooper at Yvon Lambert*, 16 February-15 March.

Institute of Contemporary Art, University of Pennsylvania, Philadelphia. *Urban Encounters: Art, Architecture, Audience*, 19 March-30 April. Catalogue, texts by Janet Kardon, Lawrence Alloway, Ian L. McHarg, and Nancy Foote.

University Gallery, University of Massachusetts, Amherst. *Sculpture on the Wall: Relief Sculpture of the Seventies*, 29 March-4 May. Catalogue, introduction by Hugh M. Davies.

Jeffrey Fuller Fine Art, Philadelphia. *Painted Structure*, 18 April-21 May.

Baxter Art Gallery, California Institute of Technology, Pasadena. *Jack Brogan: Projects*, 15 May-29 June. Catalogue, introduction by Michael H. Smith.

The San Diego Museum of Art. *Sculpture in California: 1975-1980*, 18 May-6 July. Catalogue, text by Richard Armstrong.

Paula Cooper Gallery, New York. *Lynda Benglis, Jonathan Borofsky, Peter Campus, Michael Hurson: Works on Paper*, 24 May-14 June.

Max Hutchinson Gallery, New York. *Contemporary American Sculpture*, 29 May-3 July.

American Pavilion, Venice Biennale, Italy. *Drawings: The Pluralist Decade*, 1 June-30 September. Organized by Institute of Contemporary Art, University of Pennsylvania, Philadelphia. A version of the exhibition traveled to Institute of Contemporary Art, University of Pennsylvania, Philadelphia; and Museum of Contemporary Art, Chicago. Catalogue, texts by Janet Kardon, John Hallmark Neff, Rosalind Krauss, Richard Lorber, Edit De Ak, John Perreault, and Howard N. Fox.

University Gallery, Southern Methodist University, Dallas. *Works by Women*, 1 June-1 September. Organized by The Gihon Foundation, Dallas. Traveled to Rudder Tower Exhibit Hall, Texas A & M University, College Station; Cultural Activities Center, Temple, Texas; The Art Center, Waco, Texas; Tyler Museum of Art, Texas; Wichita Falls Museum and Art Center, Texas; Student Center Gallery, Texas Christian University, Ft. Worth; Northwood Institute Art Center, Cedar Hill, Texas; Clyde H. Wells Fine Arts Center, Tarleton State University, Stephenville, Texas; Abilene Fine Arts Museum, Texas; Scurry County Museum, West-

ern Texas College, Snyder; Stephen F. Austin University, Nacogdoches, Texas; Cameron University Gallery, Lawton, Oklahoma; Victoria Regional Museum, Texas; Amarillo Art Center, Texas; Longview Museum and Arts Center, Texas; John E. Conner Museum, Texas A & M University, Kingsville; Charles B. Goddard Center, Ardmore, Oklahoma; Meadows Art Museum, Centenary College of Louisiana, Shreveport; Weil Gallery, Corpus Christi, Texas; The Warehouse Living Arts Center, Corsicana, Texas; University Gallery, Angelo State University, San Angelo, Texas; Museum of the Southwest, Midland, Texas; Museum of the Big Bend, Alpine, Texas; Firehouse Arts Center, Norman, Oklahoma; Texas Women's University, Denton; Dallas Public Library; The Central Exchange, Kansas City, Missouri; Arkansas Arts Center, Little Rock; Memphis Brooks Museum of Art, Tennessee; Union Gallery, Louisiana State University, Baton Rouge; McAllen International Museum, Texas; School of Art and Architecture Gallery, Louisiana Tech University, Ruston; Alexandria Museum, Louisiana; Michelson-Reves Museum of Art, Marshall, Texas; Plano Cultural Arts Center, Texas; Haggar Gallery, University of Dallas, Irving, Texas; Edwin A. Ulrich Museum of Art, Wichita State University, Kansas; The Museum, Texas Tech University, Lubbock; The Museum of East Texas, Lufkin; The Museum of Arts and Sciences, Macon, Georgia; The Gertrude Herbert Memorial Institute of Art, Augusta, Georgia; The Rosenberg Library, Galveston, Texas; RGK Foundation, Austin, Texas; Midwest Museum of American Art, Elkhart, Indiana; and Mitchell Museum, Mount Vernon, Illinois. Brochure.

Museum of Contemporary Art, Chicago. *Three Dimensional Painting*, 2 August-9 November. Catalogue, introduction by Judith Tannenbaum.

Albright-Knox Art Gallery, Buffalo. *With Paper, About Paper*, 12 September-26 October. Traveled to The Museum of Fine Arts, Springfield, Massachusetts. Catalogue, foreword by Robert T. Buck, text by Charlotta Kotik.

The Third Floor Gallery, Forrest Avenue Consortium, Atlanta. *Flight Patterns*, 12 September-4 October.

Nielsen Gallery, Boston. *Working with Bummy Huss Paper*, 1-31 October.

Birmingham Museum of Art, Alabama. *Three Generations of Twentieth Century American Art: Betty Parsons, Helen Frankenthaler, Lynda Benglis*, 23 November-12 December.

Marilyn Pearl Gallery, New York. *All That*

Glistens, 2-31 December.

Hansen Fuller Goldeen Gallery, San Francisco. *The Peaceable Kingdom*, 3-31 December.

Fox Graphics, Boston. *Selected Prints Published by Landfall Press*.

Galerie Daniela Ferraria, Rome. *New York City*.

1981

The Sculpture Center, New York. *Decorative Sculpture*, 11 January-20 February.

Whitney Museum of American Art, New York. *1981 Biennial Exhibition*, 20 January-19 April. Catalogue, foreword by Tom Armstrong, preface by John G. Hanhardt, Barbara Haskell, Richard Marshall, and Patterson Sims.

Hamilton Gallery, New York. *Bronze*, 30 January-28 February.

Susanne Hilberry Gallery, Birmingham, Michigan. *Group Exhibition*, January.

Security Pacific National Bank, Los Angeles. *Art in the Public Eye: Recent Acquisitions of the Security Pacific Collection*, 23 February-4 April. Brochure.

Okun-Thomas Gallery, St. Louis. *Coast to Coast*, 10-31 March.

Provincia di Genova, Genoa, Italy. *Donne in Arte-Viaggo a New York*, March.

Institute of Contemporary Art, University of Pennsylvania, Philadelphia. *ICA Street Sights 2*, 15 April-10 May. Organized by Independent Curators, Inc., New York. Traveled to New Gallery of Contemporary Art, Cleveland; Long Beach Museum of Art, California; and Contemporary Arts Center, New Orleans. Catalogue, texts by Janet Kardon and Paula Marincola.

The Aldrich Museum of Contemporary Art, Ridgefield, Connecticut. *New Dimensions in Drawing: 1950-1980*, 2 May-6 September. Catalogue, introduction by Richard E. Anderson.

Lerner Heller Gallery, New York, and Reynolds/Minor Gallery, Richmond. *The Great American Fan Show*, 2 May-3 June (New York); 8 May-12 June (Richmond). Catalogue, preface by Richard Lerner, text by Virginia Fabbri Butera.

John Weber Gallery, New York. *Media Relief*, 6-27 June.

Okun-Thomas Gallery, St. Louis. *In The Summer Space*, 13 June-31 July.

Whitney Museum of American Art, New York. *Developments in Recent Sculpture*, 22 July-27 September. Catalogue, foreword by Tom Armstrong, introduction by Richard Marshall.

Margo Leavin Gallery, Los Angeles. *Cast, Carved and Constructed*, 1 August-19 September.

Susanne Hilberry Gallery, Birmingham, Michigan. *Group Exhibition*, Summer.

Paula Cooper Gallery, New York. *Benefit Exhibition for The Kitchen*, 19-26 September.

Sewall Art Gallery, Rice University, Houston. *Variants: Drawings by Contemporary Sculptors*, 2 November-12 December. Traveled to Art Museum of South Texas, Corpus Christi; Newcomb Art Gallery, Tulane University, New Orleans; and High Museum of Art, Atlanta. Catalogue, text by Esther de Vécsey.

Landfall Gallery, Chicago. *Possibly Overlooked Publications: A Re-examination of Contemporary Prints and Multiples*, 20 November-16 January 1982.

Hansen Fuller Goldeen Gallery, San Francisco. *Polychrome*, 2 December-2 January 1982.

Jacksonville Art Museum, Florida. *Currents: A New Mannerism*, 11 December-24 January 1982. Traveled to University of South Florida Art Galleries, University of South Florida, Tampa. Catalogue, text by Margaret A. Miller.

New Gallery for Contemporary Art, Cleveland. *Art Materialized: Selections from the Fabric Workshop*, 11 December-16 January 1982. Organized by Independent Curators, Inc., New York. Traveled to The Gibbes Art Gallery, Charleston, South Carolina; The Hudson River Museum of Westchester, Yonkers, New York; University of South Florida Galleries, University of South Florida, Tampa; The Art Museum and Galleries, California State University at Long Beach; Alberta College of Art Gallery, Alberta College of Art, Calgary, Canada; and Pensacola Museum of Art, Florida. Catalogue, texts by Sarah McFadden and Carter Ratcliff.

Paula Cooper Gallery, New York. *Group Exhibition*, December-January 1982.

Fox Graphics, Boston. *Selected Prints Published by Landfall Press*.

Mattingly Baker Gallery, Dallas. *New Options in Sculpture*.

Max Hutchinson Gallery, New York. *Sculptor's Drawings and Maquettes*.

121 Gallery, Antwerp, Belgium. *American Reliefs*.

Paula Cooper Gallery, New York.

Zabriskie Gallery, New York. *Art for E.R.A.*

1982

Zabriskie Gallery, New York. *Flat and Figurative: 20th Century Wall Sculpture*, 6 January-6 February.

E.L.A.C. (Espace Lyonnais d'Art Contemporain) Centre d'Echanges, Lyon, France. *Energie New York*, 15 January-15 March. Catalogue, text by Florence Pierre.

P.S. 1, The Institute for Art and Urban Resources, Long Island City, New York. *Critical Perspectives: Curators and Artists*, 17 January-14 March.

105 Greene Street, New York. *Nature as Image and Metaphor: Works by Contemporary Women Artists*, 23 February-13 March. Catalogue, text by Ruth Ann Appelhof, included in *Views by Women Artists*. New York: Women's Caucus for Art, 1982.

The Contemporary Arts Center, Cincinnati. *Dynamix*, 11 March-17 April. Traveled to Sullivan Hall Gallery, Ohio State University, Columbus; Allen Memorial Art Museum, Oberlin College, Ohio; Butler Institute of American Art, Youngstown, Ohio; University of Kentucky Art Museum, University of Kentucky, Lexington; Joslyn Art Museum, Omaha; and Doane Hall Art Gallery, Allegheney College, Meadville, Pennsylvania. Catalogue, preface and text by Robert Stearns.

The New Museum, New York. *Early Work*, 3 April-3 June. Catalogue, introduction by Marcia Tucker, interview with Benglis by Ned Rifkin, additional interviews by Lynn Gumpert and Marcia Tucker.

Thomas Segal Gallery, Boston. *Made in California: Major New Works from Experimental Printmaking, San Francisco*. 8 May-5 June.

Yale University Art Gallery, Yale University, New Haven, Connecticut. *Prints by Contemporary Sculptors*, 18 May-31 August. Catalogue, text by Richard S. Field and Daniel Rosenfeld.

The Art Institute of Chicago. *74th American Exhibition*, 12 June-1 August. Catalogue, introduction by Anne Rorimer.

Franklin Furnace Archive, Inc., New York. *Sweet Art Sale for Franklin Furnace*, June.

Fuller Goldeen Gallery, San Francisco. *Casting: A Survey of Cast Metal Sculpture in the 80's*, 8 July-28 August.

Contemporary Arts Museum, Houston. *The Americans: The Collage*, 11 July-3 October. Catalogue, text by Linda L. Cathcart.

Rhode Island School of Design Museum of Art, Rhode Island School of Design, Providence. *Metals: Cast-Cut-Coiled*, 13 August-26 September. Brochure, foreword by Judith Hoos Fox.

Brooke Alexander, Inc., New York. *Selected Prints III*, 7 September-2 October. Catalogue.

Paula Cooper Gallery, New York. *Group Show: Sculptor's Drawings*, 14 September-30 October.

Kouros Gallery and Center for Inter-American Relations, New York. *Women of the Americas: Emerging Perspectives*, 15 September-17 October. Catalogue, foreword by Kathleen McGuire and Charlotte Camillos.

The Aldrich Museum of Contemporary Art, Ridgefield, Connecticut.

PostMINIMALism, 19 September-19 December. Catalogue, introduction by Richard E. Anderson.

Brainerd Art Gallery, State University of New York College of Arts and Sciences at Potsdam. *Twentieth Anniversary Exhibition of the Vogel Collection*, 1 October-1 December. Traveled to Gallery of Art, University of Northern Iowa, Cedar Falls. Catalogue, introduction by Dorothy Vogel, text by Georgia Coopersmith.

Heath Gallery, Atlanta. *Out of the South*, 5-9 October. Catalogue, foreword by David C. Heath, introduction by Donald B. Kuspit. Text by Donald B. Kuspit, reprinted in "Out of the South: Eight Southern-Born Artists." *Art Papers* (Atlanta) 6, no. 6 (November-December 1982): 2-5.

Newport Harbor Art Museum, Newport Beach, California. *Shift: LA/NY*, 7 October-27 November. Catalogue, foreword by Cathleen Gallander, preface by Paul Schimmel, texts by Marcia Tucker, Paul Schimmel, Melinda Wortz, and Jane Livingston.

Emily Lowe Gallery, Hofstra University, Hempstead, New York. *Androgyny in Art*, 6 November-19 December. Catalogue, introduction by Gail Gelburd.

Harriet Pratt Bush/Pratt Manhattan Gallery, New York. *The Destroyed Print*, 15 November-11 December.

Kestner-Gesellschaft, Hanover, West Germany. *New York Now*, 26 November-23 January 1983. Catalogue, text by Carl Haenlein.

Paula Cooper Gallery, New York. *Changing Group Exhibition: Sculptor's Drawings*, 1 December-11 January 1983.

Nordiska Kompaniet, Stockholm, Sweden. *U.S. Art Now*.

1983

Municipal Art Gallery, Los Angeles. *1984 Olympic Fine Art Posters: 15 Contemporary Artists Celebrate the Games of the XXIII Olympiad*, 11-20 January. Traveled to University Art Gallery, California State University, Dominguez Hills.

Contemporary Arts Center, New Orleans. *Art Cars: National Juried Exhibition*, January. Brochure, text by Marilyn Brown.

Philadelphia College of Art Gallery, Philadelphia College of Art. *Women Artists Invitational 1983: Selections from the Women Artists Historical Archives*, 11 February-19 March.

Swen Parson Gallery, Northern Illinois University, De Kalb. *Selections from the Collection of Robert Vogele*, 13 February-20 March.

The Port of History Museum at Penn's Landing, Philadelphia. *Printed by Women: A National Exhibition of Photographs and Prints*, 17 February-

8 May. Catalogue, introduction by Muriel Magenta, texts by Judith K. Brodsky and Ofelia Garcia.

Guild Hall Museum, East Hampton, New York. *Arrivals*, 19 March-24 April.

Margo Leavin Gallery, Los Angeles. *Lynda Benglis and John Duff*, 23 March-16 April.

Center for the Arts, Muhlenberg College, Allentown, Pennsylvania. *Paula Cooper, Nancy Hoffman, Phyllis Kind: A Profile of Three Art Directors*, 7-25 April.

Whitney Museum of American Art at Philip Morris, New York. *20th Century Sculpture: Process and Presence*, 8 April-11 May. Catalogue, text by Lisa Phillips.

McIntosh/Drysdale Gallery, Houston. *Small Bronzes*, 12 April-14 May.

Robert Miller Gallery, New York. *Surreal*, 3 May-30 June.

The Renaissance Society at the University of Chicago. *The Sixth Day: A Survey of Recent Developments in Figurative Sculpture*, 8 May-15 June. Catalogue, text by Richard Flood.

Tweed Gallery, Plainfield, New Jersey. *All That Glitters*, 11 May-18 June.

Palais des Beaux-Arts, Brussels. *Vente aux enchères: art contemporain*, 27 May-6 June. Catalogue, text by L. Descamps.

Künstmuseum, Lucerne, Switzerland. *Back to the USA*, 29 May-31 July. Traveled to Rheinisches Landesmuseum, Bonn, West Germany, and Württembergischer Künstverein, Stuttgart, West Germany. Catalogue, text by Klaus Honnef and Gabriele Honnef-Harling.

Whitney Museum of American Art, New York. *Minimalism to Expressionism: Painting and Sculpture Since 1965 from the Permanent Collection*, 2 June-14 December. Catalogue, text by Patterson Sims.

The Berkshire Museum, Pittsfield, Massachusetts. *New Decorative Art*, 4 June-31 July. Traveled to University Art Gallery, State University of New York at Albany. Catalogue, foreword by Gary Burger, text by Debra Bricker Balken.

Fuller Goldeen Gallery, San Francisco. *Selections II*, 8 June-2 July.

Margo Leavin Gallery, Los Angeles. *Black and White*, 25 June-13 August.

Paula Cooper Gallery, New York. *Group Exhibition*, June-July.

Ashawag Hall, East Hampton, New York. *Sixteenth Annual Artists of the Springs Invitational Exhibition*, 6-20 August.

Olsen Gallery, New York. *Group Exhibition*, 1-29 October.

The New Museum of Contemporary Art, New York. *Language, Drama, Source and Vision*, 8 October-27 November. Catalogue, text by Marcia Tucker.

U.S.A. Today, Arlington, Virginia. *Of, On or About Paper–III*, October-April 1984. Catalogue, introduction by Allen H. Neuharth.

Marion Koogler McNay Art Museum, San Antonio. *Collector's Gallery XVII*, 4 November-26 December.

Hillwood Art Gallery, Long Island University, Greenvale, New York. *Floored*, 18 November-7 December. Traveled to Tyler Galleries, Tyler School of Art, Temple University, Elkins Park, Pennsylvania. Catalogue, preface by Dr. Judy K. Collischan Van Wagner, text by John Perreault.

Paula Cooper Gallery, New York. *Changing Group Exhibition*, 8-20 December.

Suellen Haber Gallery, New York. *The Knot and Spiral Show*.

1984

Davis-McClain Galleries, Houston. *International Water Sculpture Competition*, 12 January-11 February.

Tyler Galleries, Tyler School of Art, Temple University, Elkins Park, Pennsylvania. *Cover to Cover*, 12-29 January.

The Aldrich Museum of Contemporary Art, Ridgefield, Connecticut. *Intermedia: Between Painting and Sculpture*, 14 January-6 May. Brochure, introduction by Martin Sosnoff.

Paula Cooper Gallery, New York. *Artists Call Against Intervention in Central America Benefit Exhibition*, 14-28 January.

Sidney Janis Gallery, New York. *A Celebration of American Women Artists, Part II*, 11 February-3 March.

La Jolla Museum of Contemporary Art, California. *American Art Since 1970: Painting, Sculpture and Drawings from the Collection of the Whitney Museum of American Art, New York*, 10 March-22 April. Traveled to Museo Tamayo, Mexico City; North Carolina Museum of Art, Raleigh; Sheldon Memorial Art Gallery, University of Nebraska, Lincoln; and Center for the Fine Arts, Miami, Florida. Catalogue, foreword by Tom Armstrong, text by Richard Marshall.

Weintraub Gallery, New York. *Monotypes*, 15 March-14 April.

Turman Gallery, Indiana State University, Terre Haute. *Paper Transformed: A National Exhibition of Paper Art*, 19 March-15 April. Catalogue.

Pam Adler Gallery, New York. *The Decorative Continues*, 4-28 April.

Fuller Goldeen Gallery, San Francisco. *50 Artists/50 States*, 12 July-25 August.

Toledo Museum of Art and Crosby Gardens. *Citywide Contemporary Sculpture Exhibition*, 15 July-14 October. Catalogue, introduction by David C. Hudson, Roger Mandle, and Susan LeCron.

Margo Leavin Gallery, Los Angeles. *American Sculpture*, 17 July-15 September.

The Parrish Art Museum, Southampton, New York. *Forming*, 29 July-23 September. Catalogue, text by Klaus Kertess.

Paula Cooper Gallery, New York. *A Changing Group Exhibition*, 8-29 September.

Monique Knowlton Gallery, New York. *Ecstasy*, 12 September-10 October. Brochure.

Bette Stoler Gallery, New York. *Arabesque: Grand Gestures in Painting, Sculpture and Decorative Arts*, 14 September-13 October.

Olsen Gallery, New York. *Group Exhibition*, 1-29 October.

Hirshhorn Museum and Sculpture Garden, Smithsonian Institution, Washington, D.C. *Content: A Contemporary Focus, 1974-1984*, 4 October-6 January 1985. Catalogue, texts by Howard N. Fox, Miranda McClintic, and Phyllis Rosenzweig.

Plaza Gallery, Concourse Gallery, and A. P. Gianni Gallery, BankAmerica Corporation, San Francisco. *Highlights: Selections from the BankAmerica Corporation Art Collection*, 4 October-27 November.

The Newark Museum, New Jersey. *American Bronze Sculpture, 1850 to the Present*, 18 October-3 February 1985. Catalogue, text by Gary A. Reynolds.

Seattle Art Museum. *American Sculpture: Three Decades*, 15 November-27 January 1985.

Fuller Goldeen Gallery, San Francisco. *Stars: A Theme Exhibition*, 4 December-5 January 1985.

The Contemporary Art Gallery, Seibu Corporation, Tokyo. *Eight Artists from Paula Cooper Gallery*, 6-31 December.

Oil and Steel Gallery, New York. *Creative Time Benefit*.

1985

The Hudson River Museum of Westchester, Yonkers, New York. *A New Beginning: 1968-1978*, 3 February-5 May. Catalogue, introduction by Ted Greenwald, text by Mary Delahoyd.

University Art Museum, California State University, Long Beach. *Monuments To: An Exhibition of Proposals for Monumental Sculpture*, 12 February-31 March.

Dracos Art Center, Athens, Greece. *Dracos Art Center: 1st Show, New Dialogues*, 4 March-18 April. Catalogue, introduction by Vicky Dracos.

Pensacola Museum of Art, Florida. *Kohlmeyer and Benglis: Teacher and Student in the 80's*, 15 March-30 April. Brochure, text by Mary H. Takach.

Lorence Monk Gallery, New York. *Drawings*, 4-27 April.

Museum of Contemporary Art, Chicago. *Selections from the William J. Hokin Collection*, 20 April-16 June. Catalogue, foreword by I. Michael Danoff.

Harriet Pratt Bush/Pratt Manhattan Gallery, New York. *In Three Dimensions: Recent Sculpture by Women*, 22 April-18 May. Brochure, text by Jessica Cusick.

Littlejohn-Smith Gallery, New York. *Benefit Art Auction for Parallel Films*, 5-7 May.

Charles Cowles Gallery, New York. *Abstract Relationships*, 6 June-12 July.

City Gallery, Department of Cultural Affairs, New York. *Paper: From Surface to Form*, 10 June-6 July.

The Contemporary Arts Center, Cincinnati. *Body and Soul: Aspects of Recent Figurative Sculpture*, 6 September-12 October. Catalogue, foreword by Dennis Barrie, introduction and text by Sarah Rogers-Lafferty.

El Bohio Cultural and Community Center, New York. *El Bohio Benefit Auction and Exhibition*, 12-14 September.

The Museum of Modern Art, New York. *20th Anniversary of the National Endowment for the Arts*, 23 September-29 October.

The Palladium, New York. *Guerrilla Girls at The Palladium*, 17 October-17 November.

Brattleboro Museum and Art Center, Vermont. *Workshop Experiments: Clay, Paper, Fabric, Glass*, 18 October-8 December. Traveled to Museum of Art, Wellesley College, Massachusetts; League of New Hampshire Craftsmen, Concord; Worcester Craft Center, Massachusetts; Museum of Art, Science and Industry, Bridgeport, Connecticut; and Bevrier Gallery, Rochester Institute of Technology, New York. Catalogue, foreword by Allison Devine, texts by Susan Taylor, Rose Slivka, Bernard Toale, Paul Wong, Marion Stroud Swingle, Karen Chambers, and Alice Rooney.

Garden Hall, The Museum of Modern Art, New York. *Made in India*, 8 November-21 January 1986.

Daniel Weinberg Gallery, Los Angeles. *AIDS Benefit Exhibition: A Selection of Works on Paper*, 9-30 November.

New Orleans Museum of Art. *Profile of a Connoisseur: The Collection of Muriel Bultman Francis*, 10 November-12 January 1986. Catalogue, introduction by E. John Bullard, text by Edward P. Caraco.

Main Gallery, University of Rhode Island, Kingston. *Diversity: New York Artists*, 12 November-6 December.

Guild Hall Museum, East Hampton, New York. *The East Hampton Star 100th Anniversary Portfolio*, 16 November-2 February 1986.

The Art Museum of Princeton University, Princeton University, New Jersey. *A Decade of Visual Arts at Princeton:*

Faculty, 1975-1985, 17 November-12 January 1986. Catalogue, foreword by Allen Rosenbaum, preface by James Seawright.

The Puck Building, New York. *Independent Curators' Inc. 10th Anniversary Exhibition and Auction*, 18 November.

Paula Cooper Gallery, New York. *Changing Sculpture Exhibition*, 23 November-4 January 1986.

The Helander Gallery, Palm Beach, Florida. *New York Artists*, 12 December-22 January 1986.

Nina Freudenheim Gallery, Buffalo. *Sculpture*, 14 December-15 January 1986.

Stamford Museum and Nature Center, Connecticut. *American Art: American Women*, 15 December-23 February 1986.

Laforet Museum Harajudku, Tokyo. *Correspondences: New York Now*, 20 December-19 January 1986. Traveled to Tochigi Prefectural Museum of Fine Arts and Tazaki Hall Espace Media, Kobe. Catalogue, preface by Shozo Tsurumoto, text by Alan Jones.

1986

Heller Gallery, New York. *Glass America*, 3-26 January.

Whitney Museum of American Art, Fairfield County, Connecticut. *Connecticut Collects: American Art Since 1960*, 29 January-26 March.

Tilden-Foley Gallery, New Orleans. *Group Exhibition*, 14 February-12 March.

Washington State Capitol Museum, Olympia. *Pilchuck: The Creative Fire*, 7 March-14 May.

The Main Art Gallery, Visual Arts Center, California State University, Fullerton. *Cast Glass Sculpture*, 12 April-11 May. Catalogue, foreword by Dextra Frankel, text by Donald Kuspit.

Harriet Pratt Bush/Pratt Manhattan Gallery, New York. *The Artist and the Quilt*, 5-28 May.

Hayden Gallery, List Visual Arts Center, Massachusetts Institute of Technology, Cambridge, and Bank of Boston. *Natural Forms and Forces: Abstract Images in American Sculpture*, 9 May-29 June (Cambridge); 9 May-11 July (Boston). Catalogue, texts by Kathy Halbreich, Marjory Jacobson, Douglas Dreishspoon, and Katy Kline.

Gemini Graphic Editions Limited and Margo Leavin Gallery, Los Angeles. *1986 Museum of Contemporary Art Benefit Auction*, 10-13 May.

Palacio de Velazquez, Centro Nacional de Exposiciones, Madrid. *Entre la Geometria y el Gesto Escultura Norteamericana, 1965-1975*, 23 May-31 July. Catalogue, texts by Richard Armstrong and Richard Marshall.

Indianapolis Museum of Art. *Painting and Sculpture Today: 1986*, 24 June-24 August. Catalogue, foreword by Dorit Paul, text by Holliday T. Day.

Tilden-Foley Gallery, New Orleans. *Changing Group Exhibition*, 26 June-6 September.

Paula Cooper Gallery, New York. *Changing Sculpture Exhibition*, August.

Paula Cooper Gallery, New York. *Group Exhibition*, 4-27 September.

Whitney Museum of American Art, New York. *Painting and Sculpture Acquisitions: 1973-1986*, 18 September-30 November.

Philadelphia Museum of Art. *Philadelphia Collects: Art Since 1940*, 28 September-30 November. Catalogue, preface by Anne d'Harnoncourt, foreword by Anne Percy and Mark Rosenthal, introduction by Mark Rosenthal.

Janie C. Lee Gallery, Houston. *Twentieth Century Drawings and Sculptures*, 9 October-4 September.

John Berggruen Gallery, San Francisco. *Works from the Paula Cooper Gallery*, 14 October-20 November. Catalogue, text by James Elliott.

First Bank Skyway Gallery, Minneapolis. *Works by American Women, 1976-1986*, 15 October-15 January 1987.

The Museum of Modern Art, New York. *Contemporary Works from the Collection*, 6 November-31 March 1987.

BlumHelman, New York. *American Eccentric Abstraction: 1965-1972*, 16 November-31 January 1987.

Berger Museum of Art and Science, Paramus, New Jersey. *Paper's Third Dimension*, 5 December-25 January 1987.

Brooke Alexander, New York. *Benefit for The Kitchen*, 9-20 December.

1987

Margo Leavin Gallery, Los Angeles. *Sculpture Installation*, 3 January-7 February.

Gibson-Barham Art Gallery, The Imperial Calcasieu Museum, Lake Charles, Louisiana. *Kohlmeyer and Benglis: Teacher and Student in the 80's*, 30 January-15 March. Revision of 1985 exhibition at Pensacola Museum of Art, Florida.

Tilden-Foley Gallery, New Orleans. *Group Exhibition*, 14 February-12 March.

Wadsworth Atheneum, Hartford. *From the Sol LeWitt Collection*, 12 March-24 May.

Galeria EMI Valentim de Carvalho, Lisbon, Portugal. *Artistas da Paula Cooper*, 20 March-30 April.

The Contemporary Arts Center, Cincinnati. *Standing Ground: Sculpture by American Women*, 27 March-10 May. Catalogue, foreword by Dennis Barrie, text by Sarah Rogers-Lafferty.

American Craft Museum, New York. *Contemporary American and European Glass: The Saxe Collection*, 11 April-18 October.

David Winton Bell Gallery, List Art Center, Brown University, Providence. *Alternative Supports: Contemporary Sculpture on the Wall*, 25 April-25 May. Catalogue, text by Judith E. Tolnick.

Paula Cooper Gallery, New York. *Art Against AIDS*, 4-30 June. Organized by the American Foundation for AIDS Research, New York. Catalogue, preface by Elizabeth Taylor, foreword by Dr. Mathilde Krim, text by Robert Rosenblum.

Albright-Knox Art Gallery, Buffalo. *Structure to Resemblance: Work by Eight American Sculptors*, 13 June-23 August. Catalogue, texts by Michael Auping, Cheryl A. Brutvan, Susan Krane, and Helen Raye.

Fine Arts Gallery, Long Island University, Southampton, New York. *Masters II*, 1 August-21 September.

Susanne Hilberry Gallery, Birmingham, Michigan. *Group Exhibition*, 15 September-31 October.

Dia Art Foundation, New York. *AMFAR (American Foundation for AIDS Research)*, 16 September-4 October.

Edith C. Blum Art Institute, Bard College, Annandale-on-Hudson, New York. *Avery Distinguished Professors*, 27 September-8 November.

La Jolla Museum of Contemporary Art, California. *Faux Arts*, 2 October-15 November. Catalogue, text by Ronald J. Onorato.

Alexandria Museum of Art, Louisiana. *Lynda Benglis, Keith Sonnier: A Ten-Year Retrospective, 1977-1987*, 9 October-25 November. Catalogue, text by Carter Ratcliff.

The American Express Company, New York. *Handmade Paper*, 10 October-20 February. Organized by The Art Advisory Service for Corporate Members of The Museum of Modern Art, New York.

The Nelson-Atkins Museum of Art, Kansas City, Missouri. *A Bountiful Decade: Selected Acquisitions 1977-1987*, 14 October-6 December. Catalogue, text by Deborah Emont Scott.

Dart Gallery, Chicago. *Sculpture*, 16 October-15 November.

St. Louis Gallery of Contemporary Art. *Contemporary Masters: Selections from the Collection of Southwestern Bell Corporation*, 18 October-29 November.

Herter Art Gallery, University of Massachusetts, Amherst. *Contemporary American Collage, 1960-1986*, 9 November-11 December. Traveled to William Benton Museum of Art, University of Connecticut, Storrs; Lehigh University Galleries, Lehigh University, Bethlehem, Pennsylvania; Butler Institute of American Art, Youngstown, Ohio; Kansas City Art Institute, Missouri; University Art Gallery, Uni-

versity at Albany, State University of New York; and Nevada Institute for Contemporary Art, Las Vegas. Catalogue, foreword by Michael E. Coblyn and Trevor Richardson, text by Trevor Richardson.

Dorothy Goldeen Gallery, Santa Monica, California. *American Artists in Jewelry*, 11 November-5 December. Traveled to Fuller Gross Gallery, San Francisco; Nancy Hoffman Gallery, New York; and Harcus Gallery, Boston.

The Helander Gallery, Palm Beach, Florida. *New Space, New Work, New York*, 13 November-8 December.

Solomon R. Guggenheim Museum, New York. *Fifty Years of Collecting: An Anniversary Selection, Sculpture of the Modern Era*, 13 November-3 March 1988. Catalogue, preface and text by Thomas M. Messer.

Maloney Gallery, Santa Monica, California. *The Gold Show*, 10 December-10 January 1988.

1988

Laguna Gloria Art Museum, Austin, Texas. *Collecting on the Cutting Edge: Frito-Lay, Inc.*, 9 January-28 February. Brochure, text by Monica F. Kindraka.

Susanne Hilberry Gallery, Birmingham, Michigan. *Anniversary Exhibition*, 16 January-20 February.

R.C. Erph Gallery, New York. *Private Works for Public Spaces*, 19 February-19 March.

Res Nova, New Orleans. *Group Exhibition*, 24 February-30 March.

Magasin 3, Stockholm, Sweden. *Lynda Benglis, John Chamberlain, Joel Fisher, Mel Kendrick, Robert Therrien*, February-March. Catalogue, text by Carter Ratcliff.

John C. Stoller and Company, Minneapolis. *Painting in Relief/Sculpture on the Wall*, 11 March-23 April.

Freedman Gallery, Albright College, Reading, Pennsylvania. *Life Forms: Contemporary Organic Sculpture*, 15 March-17 April. Brochure, introduction by David S. Rubin.

Nina Freudenheim Gallery, Buffalo. *Four Sculptors*, 19 March-20 April.

Mayor Rowan Gallery, London. *Eleven Artists from Paula Cooper*, 20 May-22 June.

Rena Bransten Gallery, San Francisco. *American Artists in Jewelry*, 1 June-31 August.

Linda Farris Gallery, Seattle. *Artists in Residence: Pilchuck Glass School, 1980-1988*, 3 June-31 July.

Minos Beach Hotel, Minos Beach, Crete, Greece. *Minos Beach Art Symposium*, 11 June-30 September.

The Herbert F. Johnson Museum of Art, Cornell University, Ithaca, New York. *Knots and Nets*, 15 July-25 September. Traveled to New York State Museum

Cultural Education Center, Albany, and The Parrish Art Museum, Southampton, New York.

Tilden-Foley Gallery, New Orleans. *Group Exhibition: Gallery Artists*, 13 August-24 September.

Elizabeth McDonald Gallery, New York. *The Material Image: Pure and Simple*, 11 June-30 July.

Genovese Gallery, Boston. *The Gold Show 1988*, 13 September-10 October.

Walter Gallery, Santa Monica, California. *Pilchuck: An Exhibition of Contemporary Glass Sculpture*, 15 September-29 October.

Dorothy Goldeen Gallery, Santa Monica, California. *Private Reserve: Important Works from Artists Represented by the Gallery*, 1-31 December.

Paula Cooper Gallery, New York. *Changing Group Exhibition*, 6 December-21 January 1989.

1989

University of Maine Museum of Art, University of Maine, Orono. *Monoprints/Monotypes*, 20 February-28 March.

Cincinnati Art Museum. *Making Their Mark: Women Artists Move into the Mainstream, 1970-1985*, 22 February-2 April. Traveled to New Orleans Museum of Art; Denver Art Museum; and Pennsylvania Academy of the Fine Arts, Philadelphia. Catalogue, introduction by Randy Rosen, texts by Ellen G. Landau, Calvin Tomkins, Judith E. Stein, Ann-Sargent Wooster, Thomas McEvilley, and Marcia Tucker. Excerpt of text by Randy Rosen reprinted in Randy Rosen. "Making Their Mark: Women Artists Move into the Mainstream, 1970-1985." *Arts Quarterly* (New Orleans: New Orleans Museum of Art) 11, no. 2 (April-May-June 1989): 3-7.

Kamakura Gallery, Tokyo. *American Sculptors: New York and Los Angeles, Part I—Lynda Benglis and Mark Lere*, 3-21 April. Catalogue, text by Nakamura Hideki.

Leo Castelli Gallery, New York. *Golden Opportunity: Benefit Exhibit for the Resettlement of Salvadorian Refugees*, 29 April-6 May.

Tony Shafrazi Gallery, New York. *Don't Bungle the Jungle*, 3-20 June.

Walker Art Center, Minneapolis. *First Impressions*, 4 June-10 September. Traveled to Laguna Gloria Art Museum, Austin, Texas; The Baltimore Museum of Art; and Neuberger Museum, State University College at Purchase, New York. Catalogue, introduction by Elizabeth Armstrong, texts by Elizabeth Armstrong and Sheila McGuire.

Yokohama Museum of Art, Japan. *Contemporary Art from New York: The Collection of the Chase Manhattan Bank*, 18

June-1 October. Catalogue, introductions by Willard C. Butcher and David Rockefeller, preface by Brooks Adams, texts by Yoshiaki Tohno and Shigeo Anzai.

International Sculpture Center, Washington, D.C. *Benefit Auction of Contemporary Sculpture*, 16-19 September. Brochure.

Security Pacific Gallery, South Coast Metro Center, Costa Mesa, California. *Sculptural Intimacies: Recent Small-Scale Works*, 12 November-6 January 1990. Catalogue, text by Robert H. Byer.

Ruth Siegel Gallery, New York. *Small and Stellar*, 29 November-22 December.

Brooke Alexander Editions, New York. *Benefit for the Wooster Group*, 30 November-16 December.

1990

Penine Hart Gallery, New York. *The Radiant Principle*, 3-27 January.

Solo Press/Solo Gallery, New York. *Writ in Water*, 11 January-17 February.

Susanne Hilberry Gallery, Birmingham, Michigan. *Group Show*, 19 January-24 February.

Genovese Gallery, Boston. *Group Exhibition*, 17 February-8 March.

Whitney Museum of American Art, New York. *The New Sculpture 1965-1975: Between Geometry and Gesture*, 20 February-20 May (Second Floor); 1 March-3 June (Fourth Floor). Catalogue, preface by Tom Armstrong, introduction by Richard Marshall, texts by Richard Armstrong, John G. Hanhardt, and Robert Pincus-Witten.

Beth Urdang Fine Arts, Boston. *Sculpture from New England Collections*, 17 March-21 April.

Ben Shahn Galleries, William Paterson College, Wayne, New Jersey. *Hand, Body, House: Approaches to Sculpture*, 26 March-27 April. Catalogue, introduction and text by Nancy Einreinhofer.

Joan Kesner Gallery, Los Angeles. *Pharmacy*, 7 April-12 May.

City Gallery, Department of Cultural Affairs, New York. *Hellenikon*, 1 May-1 June. Catalogue, introduction by Christina Eliopoulos, texts by Klaus Ottmann and Catharine Cafopoulos.

Wexner Center for the Visual Arts, Ohio State University, Columbus. *Art in Europe and America: The 1960s and 1970s*, 19 May-5 August.

The Fabric Workshop, Philadelphia. *Let's Play House*, 25 May-7 September. Brochure.

Paula Cooper Gallery, New York. *Group Exhibition*, 7-15 June.

Guild Hall Museum, East Hampton, New York. *Prints of the Eighties*, 16 June-29 July.

Pace Prints, New York. *Tandem Press Benefit*, 11-13 October.

VIDEO EXHIBITION HISTORY

Note: Only verifiable screenings and exhibitions are cited below. Benglis's videotapes have been (and continue to be) distributed widely; records of these showings, however, are incomplete.

1972

De Saisset Museum, Santa Clara University, California. *12th Annual St. Jude Invitational*, 3-29 October. Traveled to Everson Museum of Art, Syracuse, New York.

1973

De Saisset Museum, Santa Clara University, California. *The Four*, 9 January-25 February.

Paula Cooper Gallery, New York. *Lynda Benglis: Video Tapes*, 17 February-10 March. Traveled to Everson Museum of Art, Syracuse, New York.

Hansen Fuller Gallery, San Francisco. *Lynda Benglis: Paintings and Video Tapes*, 2-26 May.

Contemporary Arts Museum, Houston. *Re: Vision: Series of Performance, Concerts and Film*, 24 September-4 October.

Texas Gallery, Houston. *Three Weekends of Video: Lynda Benglis, John Baldessari, William Wegman*, 24 September-4 October.

1974

De Saisset Museum, Santa Clara University, California. *Six from Castelli*, 12 March-28 April.

The Museum of Modern Art, New York. *Project: Video I*, 26 August-31 October.

Smith College Museum of Art, Northampton, Massachusetts. *Video as an Art Form: An Anthology of Videotapes 1969-1974*, 3-8 December.

McLaughlin Library, University of Guelph, Canada. *Video Circuit I*, 5 December-2 January 1975.

1975

Institute of Contemporary Art, University of Pennsylvania, Philadelphia. *Video Art*, 17 January-28 February. Traveled to The Contemporary Arts Center, Cincinnati; Museum of Contemporary Art, Chicago; Wadsworth Atheneum, Hartford.

Lowe Art Museum, University of Miami, Coral Gables, Florida. *Time and Transformation*, 18 January-23 February.

Fine Arts Center Gallery, State University of New York College at Oneonta. *Physical and Psychological Moments in Time: A First Retrospective of the Video Work of Lynda Benglis*, 29 January-26 February. Traveled to the Stedelijk van Abbemuseum, Eindhoven, The Netherlands. Catalogue, text by Robert Pincus-Witten.

Serpentine Gallery, London. *The Video Show*, 1-26 May.

Blair County Arts Festival, Altoona Campus of Pennsylvania State University. *Media Arts Exhibition*, May.

Portland Center for the Visual Arts, Oregon. *Video Weekend*, May.

Whitney Museum of American Art, New York. *Projected Video*, 5-18 June.

Long Beach Museum of Art, California. *Southland Video Anthology*, 8 June-7 September. Traveled to the San Francisco Museum of Modern Art, California. Catalogue, introduction by Jan E. Adelmenn, text by David A. Ross.

State University of New York at Buffalo. *Women's Video Festival*, 21-22 July.

The Kitchen, New York. *Lynda Benglis: Moving Polaroids*, 8-16 November.

Student Art Gallery, University of Guelph, Canada. *Video Circuit II*, 4-13 December.

Whitney Museum of American Art, New York. *Autogeography*, 11 December-7 January 1976.

1976

Johnson Art Gallery, Middlebury College, Vermont. *Exhibition of Recent Work by Nineteen New York Artists*, 9-30 January.

Smith College Museum of Art, Northampton, Massachusetts. *Video II*, 24-29 February.

The Museum of Modern Art, New York. *Video Projects: IX*, 1 July-30 September.

Agnes Etherington Art Center, Queens University, Kingston, Canada. *Celebration of the Body*, August.

Long Beach Museum of Art, California. *Southland Video Anthology, Part 2*, 23 October-9 January 1977. Catalogue, introduction by Karen Pederson and David A. Ross. Traveled to State University of New York at Buffalo.

AND/OR, Seattle, Washington. *Lynda Benglis: Videotapes*, 4-8 December.

1977

ABC Entertainment Center, Century City, California. *Filmex Video and Film Project*, 25-27 March.

Stedman Art Gallery, Rutgers, the State University of New Jersey, Camden. *Video and Performance Art*, 11-21 October.

The Kitchen, New York. *Lynda Benglis Presents the Amazing Bow-Wow*, 18-20 October.

1978

Winnipeg Art Gallery, Canada. *In Video*, 7 March-12 April.

Long Beach Museum of Art, California. *Summer Video Archives*, 25 June-17 September.

The Kitchen, New York. *Video Art: Made for TV?* 30 September-21 October.

Traveled to Long Beach Museum of Art, California.

Leo Castelli Gallery, New York. *Film/Video 1976-1978*, 2-20 December.

1984

Whitney Museum of American Art, New York. *New American Video Art: A Historical Survey, 1967-1980*, 13 June-1 July.

1985

Stockholm, Sweden. *Video Arts Festival*, 1-10 November.

1987

University Gallery, Ohio State University, Columbus. *What Does She Want?: A Video Debate*, April.

Gray Art Gallery, East Carolina University, Greenville, North Carolina. *Video Art Series: Early Experimental Work and Recent Explorations*, 7 November-2 December.

Ritter Art Gallery, Florida Atlantic University, Boca Raton. *Feminism in High Art: A Contradiction in Terms?*, 10 November-11 December.

1988

The Kitchen, New York. *New Erotic Video*, February.

The Kitchen, New York. *Extant Work: Tapes from The Kitchen Archives*, March.

HALLWALLS Contemporary Arts Center, Buffalo. *Floating Values*, 28 March-25 April. Traveled to Artists Space, New York.

1990

Whitney Museum of American Art, New York. *Beyond Illusion: American Film and Video Art, 1965-1975*, 3 May-3 June.

Ausstellungsraum Künstlerhaus Stuttgart, Germany. *Amerikanische Videos aus den Jahren 1965-75, The Castelli/Sonnabend Tapes and Films*, 22 September-13 October.

Compiled by Shella De Shong

1969

Davis, Douglas M. "This Is the Loose-Paint Generation." *The National Observer* (Washington, D.C.), 4 August, sec. 1:20.

Dienst, R. G. "Ausstellungen: Prospect 69." *Das Kunstwerk* (Baden-Baden, West Germany) 23, nos. 1-2 (October-November): 59-60.

Kline, Katherine G. "Reviews and Previews." *ARTnews* (New York) 68, no. 7 (November): 12.

Kurtz, Stephan A. "Reviews and Previews." *ARTnews* (New York) 68, no. 4 (Summer): 12-13.

Monte, James, and Tucker, Marcia. *Anti-Illusion: Procedures and Materials.* New York: Whitney Museum of American Art. 6-7, 9-10, 27, 52. Exhibition catalogue; Benglis's works were not included in the exhibition.

Nemser, Cindy. "Reviews: In the Galleries. David Paul, Richard Van Buren, Lynda Benglis and Chuck Close." *Arts Magazine* (New York) 43, no. 8 (Summer): 58.

Pincus-Witten, Robert. "Reviews: New York." *Artforum* (New York) 8, no. 4 (December): 68-69.

Schjeldahl, Peter. "Chronicles: New York." *Art International* (Lugano, Switzerland) 13, no. 9 (November): 71.

_____. "Chronicles: New York Letter." *Art International* (Lugano, Switzerland) 13, no. 7 (September): 72.

Wasserman, Emily. "Reviews: New York." *Artforum* (New York) 8, no. 1 (September): 56-62.

1970

"Benglis, Sanderson, Van Buren. Ithaca College Museum: Art Review." *The Ithaca Journal* (Ithaca, New York), 20 October, 12.

[Bourdon, David.] "Fling, Dribble and Dip." *Life* (New York) 68, no. 7 (27 February): 62-66.

Bourgeois, Jean-Louis. "Reviews: New York." *Artforum* (New York) 8, no. 8 (April): 82.

Butterfield, Jan. "Poured Art Sculptor Reveals Technique." *Fort Worth Star-Telegram* (Texas), 14 June, sec. 1:6.

"Campus Notes." *Intra College* (Ithaca, New York: Ithaca College) 2, no. 6 (5 October): 2.

"Campus Notes." *Intra College* (Ithaca, New York: Ithaca College) 2, no. 7 (12 October): 3.

Constable, Rosalind. "New Sites for New Sights." *New York Magazine* (New York) 3, no. 2 (2 January): 42-45.

Domingo, Willis. "Reviews: In the Galleries." *Arts Magazine* (New York) 44, no. 5 (March): 58.

Leider, Philip. "Reviews: New York." *Artforum* (New York) 8, no. 6 (February): 68-70.

Pfeiffer, Günter. "Lynda Benglis." *Das Kunstwerk* (Baden-Baden, West Germany) 23, nos. 11-12 (October-November): 67.

Pincus-Witten, Robert. "Reviews: New York." *Artforum* (New York) 8, no. 6 (January): 65-70.

Ratcliff, Carter. "Reviews and Previews." *ARTnews* (New York) 69, no. 2 (April): 12.

Vinklers, Bitite. "Chronicles." *Art International* (Lugano, Switzerland) 14, no. 4 (20 April): 65.

1971

Benglis, Lynda. "Social Conditions Can Change." In "Eight Artists Reply: Why Have There Been No Great Women Artists?" *ARTnews* (New York) 69, no. 9 (January): 43.

"Closed Circuit TV to Cover Hayden Sculpture Creation." *Tech Talk* (Cambridge, Massachusetts: Massachusetts Institute of Technology), 10 November, sec. 1:6.

Davis, Douglas. "The Invisible Woman Is Visible." *Newsweek* (New York) 78, no. 20 (15 November): 130-31.

Domingo, Willis. "In the Galleries." *Arts Magazine* (New York) 46, no. 2 (November): 60.

Dubrowin, S. R. "Latex: One Artist's Raw Material." *Rubber Developments* (London) 24, no. 1: cover, 10-12. Reprinted in S. R. Dubrowin. "Latex in der Hand einer Kunstlerin." *Semperit-Informationen* (Munich, West Germany) 15, no. 66/67 (February-March 1972): 4.

Edwards, Karen. "The Interview/9: Lynda Benglis." *The Herald* (city unknown), 13 June, sec. 2:11.

"Foam, Paint, Wire Go into Hayden Sculpture." *Tech Talk* (Cambridge,

Massachusetts: Massachusetts Institute of Technology), 17 November, sec. 1:6.

Gerrit, Henry. "New York: The Whole Picture." *Art International* (Lugano, Switzerland) 15, no. 10 (20 December): 90.

Glueck, Grace. "New York: Trendless but Varied, the Season Starts." *Art in America* (New York) 59, no. 5 (September-October): 121-23.

Gollin, Jane. "Reviews and Previews." *ARTnews* (New York) 70, no. 6 (October): 8.

"Hayden to Feature Growing Sculpture." *Tech Talk* (Cambridge, Massachusetts: Massachusetts Institute of Technology), 3 November, sec. 1:4.

Kramer, Hilton. "Grace, Flexibility, Esthetic Tact." *The New York Times*, 30 May, sec. 2:19.

———. "Minneapolis Museum Opens Today." *The New York Times*, 18 May, sec. 2:44.

"Minneapolis: The New Museum." *Art International* (Lugano, Switzerland) 15, no. 9 (20 November): 17-21.

Muller, Gregoire. "Materiality and Painterliness." *ArtsMagazine* (New York) 46, no. 1 (September-October): 34-37.

Perreault, John. "Ferrer: Puzzling, Ominous, Moving." *The Village Voice* (New York) 16, no. 41 (14 October): 37.

Pincus-Witten, Robert. "New York: Lynda Benglis." *Artforum* (New York) 10, no. 4 (December): 78-79.

Schjeldahl, Peter. "Sculptors Make It Big Down in Soho." *The New York Times*, 30 October, sec. 2:23.

Schwartz, Bruce. "Adhesive Product." *The Tech* (Cambridge, Massachusetts: Massachusetts Institute of Technology), 16 November, sec. 1:11.

Teres, Rosemary. "UR Studio Arts Faculty Exhibit Intriguing." *The Times-Union* (Rochester, New York), 18 December, sec. C:11.

Wolmer, Bruce. "Reviews and Previews." *ARTnews* (New York) 69, no. 10 (February): 17.

1972

Frankenstein, Alfred. "From Foam to Wax." *San Francisco Chronicle*, 12 February, sec. 1:35.

Kertess, Klaus. "Foam Structures." *Art and Artists* (London) 7, no. 2 (May): 32-37.

McCann, Cecile. "Benglis' Record of a Flowing." *Artweek* (Oakland) 3, no. 8 (19 February): 2.

Matthias, Rosemary. "Galleries." *Arts Magazine* (New York) 47, no. 1 (September-October): 57-58.

Nunemaker, David. "New York." *Art and Artists* (London) 6, no. 10 (January): 50-51.

Welish, Marjorie. "Exhibitions." *Craft Horizons* (New York) 32, no. 1 (February): 48.

1973

Albright, Thomas. "Three Major U.S. Artists." *San Francisco Chronicle*, 22 May, sec. 1:45.

Anderson, Laurie. "Reviews and Previews." *ARTnews* (New York) 72, no. 3 (March): 82.

Boice, Bruce. "Exhibition Reviews." *Artforum* (New York) 11, no. 9 (May): 83.

Crimp, Douglas. "Chronicles: New York." *Art International* (Lugano, Switzerland) 17, no. 3 (March): 40-41.

"Exploring the Medium." *Art + Cinema* (New York) 1, no. 2 (Fall): 22-23.

Fagan, Beth. "Benglis Show in Center for Visual Arts Reflects Her Painting-Sculpture Concerns." *The Sunday Oregonian* (Portland), 24 June, 18.

Kurtz, Bruce. "Video Is Being Invented." *Arts Magazine* (New York) 47, no. 3 (December-January): 37-44.

McCann, Cecile N. "Linda [*sic*] Benglis Dimensional Paintings." *Artweek* (Oakland) 4, no. 20 (19 May): 3.

Markell, Jon. "At the Galleries." *The Daily Californian Arts Magazine* (San Francisco) 4, no. 137 (25 May): 3.

Meisel, Alan. "Exhibitions." *Craft Horizons* (New York) 33, no. 4 (August): 26.

Minton, James. "Linda [*sic*] Benglis: Videotapes." *Artweek* (Oakland) 4, no. 20 (19 May): 2.

Montgomery, Cara. "West Coast Report." *Arts Magazine* (New York) 48, no. 1 (September-October): 55-56.

Morris, Robert. "Exchange '73: From a Videotape." *Avalanche* (New York), no. 8 (Summer/Fall): 22-25.

"Part VI: Videotape and the New Imagery." *Art + Cinema* (New York) 1, no. 1 (January): 34.

"Part III: The Video Artist." *Art + Cinema* (New York) 1, no. 3 (n.d.): 28.

Perreault, John. "At the Table, On the Stoop." *The Village Voice* (New York) 18, no. 50 (20 December): 37, 39.

Pincus-Witten, Robert. "Thought Itself Is the Subject of This Art." *The New York Times*, 13 May, sec. 2:23.

Sutinen, Paul. "A Tough-Minded Approach to Glitter." *Portland Scribe* (Oregon) 2, no. 19 (30 June-6 July): 21.

1974

Alloway, Lawrence; Kozloff, Max; Krauss, Rosalind; Masheck, Joseph; and Michelson, Annette. "Letters." *Artforum* (New York) 13, no. 4 (December): 9.

André, Michael. "Reviews and Previews." *ARTnews* (New York) 73, no. 2 (February): 90.

Benglis, Lynda. Advertisement. *Artforum* (New York) 12, no. 8 (April): 85.

———. Advertisement. *Artforum* (New York) 13, no. 3 (November): 4-5.

———. Cover Photo. *Extra* (Cologne, West Germany), July.

———. Illustration and Artist's Statement. *Art-Rite* (New York), no. 7 (Autumn): 12.

"Collage." *ARTnews* (New York) 73, no. 7 (September): 44-45.

Corry, John. "About New York: A Serious Dirty Picture?" *The New York Times*, 22 November, sec. 1:78.

Freed, Hermine. "Video and Abstract Expressionism." *Arts Magazine* (New York) 49, no. 4 (December): 67-69.

Gilbert-Rolfe, Jeremy. "Reviews: Lynda Benglis." *Artforum* (New York) 12, no. 6 (March): 69-70. Reprinted in Richard Armstrong, John G. Hanhardt, and Robert Pincus-Witten. *The New Sculpture 1965-75: Between Geometry and Gesture*. New York: Whitney Museum of American Art, 1990. 314-15.

Herrera, Hayden. "Reviews." *ARTnews* (New York) 73, no. 7 (September): 100.

Johnson, Ray. "Abandoned Chickens." *Art in America* (New York) 62, no. 6 (November/December): 107-12.

Kuhn, Annette. "Culture Shock." *The Village Voice* (New York) 19, no. 48 (2 December): 96.

Lubell, Ellen. "Museum and Gallery Reviews." *Arts Magazine* (New York) 48, no. 5 (February): 68.

———. "Museum and Gallery Reviews." *Arts Magazine* (New York) 49, no. 1 (September): 59-60.

Nemser, Cindy. "Lynda Benglis: A Case of Sexual Nostalgia." *The Feminist Art Journal* (New York) 3, no. 4 (Winter): 7, 23.

Perreault, John. "Celebrations Knotted and Dotted." *The Village Voice* (New York) 19, no. 20 (16 May): 44.

Pincus-Witten, Robert. "Lynda Benglis: The Frozen Gesture." *Artforum* (New York) 13, no. 3 (November): 54-59. Reprinted in Robert Pincus-Witten. *Postminimalism into Maximalism: American Art, 1966-86*. Ann Arbor, Michigan: UMI Research Press, 1987. 167-76; and in Richard Armstrong, John G. Hanhardt, and Robert Pincus-Witten. *The New Sculpture 1965-75: Between Geometry and Gesture*. New York: Whitney Museum of American Art, 1990. 310-13.

Plagens, Peter. "Letters." *Artforum* (New York) 13, no. 4 (December): 9.

Raynor, Vivien. "The Art of Survival (and Vice Versa)." *The New York Times Magazine*, 17 February, sec. 4: cover, 8-9, 50, 52-55.

Schjeldahl, Peter. "Updated Data on the

Adventure of Being Human." *The New York Times*, 26 May, sec. D:17.

Schwartz, Barbara. "Exhibitions." *Craft Horizons* (New York) 34, no. 4 (August): 38-39.

Teres, Rosemary. "Modern Artists Have Varied Ways of Representing Space." *The Times Union* (Rochester, New York), 2 February, sec. D:5, 8.

"Un-Skirting the Issue." *Art-Rite* (New York), no. 5 (Spring): 6-7.

Wooster, Ann-Sargent. "Reviews of Exhibitions: Lynda Benglis at Paula Cooper." *Art in America* (New York) 67, no. 5 (September-October): 106.

1975

Antin, David. "Television: Video's Frightful Parent." *Artforum* (New York) 14, no. 4 (December): 36-45.

Asbjornsen, Allison, and Burg, Dick. "Letters." *Artforum* (New York) 13, no. 4 (March): 9.

Bourdon, David. "The Grand Acquisitor Shows Off." *The Village Voice* (New York) 20, no. 50 (15 December): 123.

Chalupecky, J. "U.S.A.: Retour du puritanisme." *Chroniques de l'art vivant* (Paris), no. 55 (February-March): 37.

"Conventional Wisdom." *Art-Rite* (New York), no. 8 (Winter): 17-18.

Davis, Douglas. "Art: What's in the Galleries." *Newsweek* (New York) 86, no. 23 (8 December): 106-7.

Glueck, Grace. "Nude Art in Halls of Justice Stirs a Storm in Bronx." *The New York Times*, 20 February, sec. 2:40.

Hess, Thomas. "Review." *New York Magazine* (New York) 8, no. 49 (8 December): 114. Reprinted in Richard Armstrong, John G. Hanhardt, and Robert Pincus-Witten. *The New Sculpture 1965-75: Between Geometry and Gesture*. New York: Whitney Museum of American Art, 1990. 326-27.

Kramer, Hilton. "What Happens When Art Is Confused with Publicity?" *The New York Times*, 23 November, sec. D:25.

Kutner, Janet. "Nude Photo Shocks Artistic Community." *Dallas Morning News*, 16 February, sec. C:6.

Lippard, Lucy R. "Transformation Art." *Ms.* (New York) 4, no. 4 (October): 33-39. Reprinted in Lucy R. Lippard. *From the Center: Feminist Essays of Women's Art*. New York: E. P. Dutton, 1976.

Maritime, Mickey. "Letters." *Artforum* (New York) 13, no. 7 (March): 8.

Miller, John Pindyck. "Letters." *New York Magazine* (New York) 8, no. 10 (10 March): 5.

Nemser, Cindy. "Four Artists of Sensuality." *Arts Magazine* (New York) 49, no. 7 (March): 73-75.

Robinson, Walter. "The Chorus Line: Role Style, Media." *Art-Rite* (New York), no. 10 (Fall): n.p.

Rosenblum, Robert. "Letters." *Artforum* (New York) 13, no. 7 (March): 8-9.

Seiberling, Dorothy. "The New Sexual Frankness: Goodbye to Hearts and Flowers." *New York Magazine* (New York) 8, no. 7 (17 February): 37-44.

Steward, Daniel H. "Letters." *Artforum* (New York) 13, no. 7 (March): 9.

1976

Ballatore, Sandy. "Lynda Benglis' Humanism." *Artweek* (Oakland) 7, no. 21 (22 May): 5-6.

Baracks, Barbara. "Artpark: The New Esthetic Playground." *Artforum* (New York) 15, no. 3 (November): 28-33.

Beller, Miles. "Albuquerque, Arnoldi, Benglis, Castoro, Steir." *Artweek* (Oakland) 7, no. 31 (18 September): 3.

Buchloh, Benjamin; Fuchs, Rudi; Fischer, Konrad; Matheson, John; and Strelow, Hans. *ProspectRetrospect: Europa 1946-1976*. Cologne, West Germany: Buchhandlung Walther König. Exhibition catalogue; Benglis's work was not included in the exhibition.

Davis, Douglas. "Douglas Davis on Artpolitics: Thoughts Against the Prevailing Fantasies." *New York Arts Journal* (New York) 1, no. 1 (May): 8-9. Reprinted in Douglas Davis. *Artculture Essays on the Post Modern*. New York: Icon Editions, Harper and Row, 1977.

"Etcetera: News and Views of the World of Art." *The Art Gallery* (Ivyton, Connecticut) 19, no. 6 (August-September): 10.

Kramer, Hilton. "Artview: A Successful Counterexhibition Inspired by the Whitney's Failure." *The New York Times*, 18 July, sec. D:22.

Langway, Lynn, and Rourke, Mary. "Corporations: The New Medicis." *Newsweek* (New York) 88, no. 20 (15 November): 95.

Lippard, Lucy R. *From the Center: Feminist Essays on Women's Art*. New York: E. P. Dutton.

———. "The Pains and Pleasures of Rebirth: Women's Body Art." *Art in America* (New York) 64, no. 3 (May-June): 73-81. Reprinted in Lucy R. Lippard. *From the Center: Feminist Essays on Women's Art*. New York: E. P. Dutton, 1976.

Lubell, Ellen. "Arts Reviews." *Arts Magazine* (New York) 50, no. 5 (January): 17.

Moser, Charlotte. "El mundo interior y exterior del movimiento artistico femenino." *Artes Visuales* (Mexico City: Museo de Arte Moderno), no. 9 (Spring): 37-42.

Perlmutter, Elizabeth. "Master Drawings, Voluptuous Boxes." *ARTnews* (New York) 75, no. 7 (September): 76.

Pincus-Witten, Robert. "Scott Burton: Conceptual Performance as Sculpture." *Arts Magazine* (New York) 51,

no. 1 (September): 112-17. Reprinted in Robert Pincus-Witten. *Postminimalism into Maximalism: American Art, 1966-1986*. Ann Arbor, Michigan: UMI Research Press, 1987. 211-18.

Pozzi, Lucio. "Questa nuova tendenza e di grande rilievo." *Bolaffiarte* (Turin, Italy) 7, no. 60 (May-June): 47-53.

Ratcliff, Carter. "Reviews." *Artforum* (New York) 15, no. 2 (October): 62-63.

Schwartz, Barbara, "Exhibitions." *Craft Horizons* (New York) 36, no. 1 (February): 58.

Seldis, Henry J., and Wilson, William. "Art Walk: A Critical Guide to the Galleries." *Los Angeles Times*, 7 May, sec. 4:12.

Soper, Susan. "Spring-Flowering Sculpture." *New York Newsday*, 30 April, sec. A:4-5.

Stubbs, A. "Rosalind Krauss." *Women Artists Newsletter* (Los Angeles) 2, no. 5 (November): 1, 6.

Tarlton, John. "The Biennale." *Quarterly* (Auckland City, New Zealand: Auckland City Art Gallery), nos. 62-63 (December): 11.

Weissman, Julian. "New York Reviews." *ARTnews* (New York) 75, no. 1 (January): 120.

Wilson, William. "Downbeat Exhibit at Otis Galleries." *Los Angeles Times*, 6 September, sec. 4:2.

Wooster, Ann-Sargent. "Reviews." *Artforum* (New York) 14, no. 6 (February): 60-64.

1977

Amateau, Michele. "Interview: Paula Cooper." *Ocular* (Denver) 2, no. 2 (Summer): 28-37.

Askey, Ruth. "L.A., Women, Art and the Future." *Women Artists Newsletter* (Los Angeles) 3, no. 1 (May): 2, 7.

Lippard, Lucy R. "Centers and Fragments: Women's Spaces." In *Women in American Architecture: A Historic and Contemporary Perspective*, ed. Susana Torre. New York: Whitney Library of Design, Watson-Guptill Publications. 186-97.

———. "You Can Go Home Again: Five From Louisiana." *Art in America* (New York) 65, no. 4 (July-August): 22-23, 25.

Lubell, Ellen. "Reviews: Group Show—Paula Cooper." *Arts Magazine* (New York) 52, no. 4 (December): 32.

———. "Reviews: Paintings." *Arts Magazine* (New York) 51, no. 7 (March): 39.

Meisel, Alan. "Exhibitions." *Craft Horizons* (New York) 37, no. 6 (December): 68.

Morin, France. "Lynda Benglis in Conversation with France Morin." *Parachute* (Montreal, Canada), no. 6 (Spring): 9-11.

_____. "Quelques réflexions sur le régionalisme." *Parachute* (Montreal, Canada), no. 6 (Spring): 33-34.

Muchnic, Suzanne. "Lynda Benglis: Sculptural Knots." *Artweek* (Oakland) 8, no. 22 (4 June): 1, 20.

Parun, Phyllis. "Four from Louisiana Talk about Making and Marketing Art." *Contemporary Art/Southeast* (Atlanta) 1, no. 1 (April-May): 32-34.

Perreault, John. "Women Artists." *The Soho Weekly News* (New York), 13 October, 40-41, 44.

Pincus-Witten, Robert. *Postminimalism.* New York: Out of London Press. Essay on pp. 157-64 reprinted from Robert Pincus-Witten. "Benglis' Video: Medium to Media." In *Physical and Psychological Moments in Time: A First Retrospective of the Video Work of Lynda Benglis.* Oneonta, New York: Fine Arts Center Gallery, State University of New York College at Oneonta, 1975. N.p.

Price, Jonathan. "Video Art: A Medium Discovering Itself." *ARTnews* (New York) 76, no. 1 (January): 41-47.

_____. *Video Visions: A Medium Discovers Itself.* New York: New American Library. 92, 96, 184-88, 190-91.

Seldis, Henry J. "Art Walk, A Critical Guide to the Galleries." *Los Angeles Times,* 27 May, sec. 4:18.

Trini, Tommaso. "La Biennale di Sydney." *DATA* (Milan), no. 26 (April-June): 38-44.

"U of H to Show Plastics." *The Hartford Courant* (Connecticut), 30 January, sec. F:2.

Watkins, Ellen. "Creativity Is Alive and Well." *The Sunday Star-Ledger* (Newark, New Jersey), 22 May, sec. 4:11.

Williams, Tennessee. "Lynda Benglis." *Parachute* (Montreal, Canada), no. 6 (Spring): 92-93. Reprinted from Tennessee Williams, Liza Béar, Philip Glass, Calvin Tomkins, and Calvin Harlan. *Five From Louisiana.* New Orleans: New Orleans Museum of Art, 1977. 3-5. Exhibition catalogue published as supplement to *The Times-Picayune* (New Orleans), 30 January 1977.

Wortz, Melinda. "Majority Rule." *ARTnews* (New York) 76, no. 3 (March): 92-93.

1978

Cole, Darrah. "Lynda Benglis: Visiting Lecturer at Skowhegan." *Vision, A Journal of the Visual Arts in Maine* (Alna, Maine) 1, no. 3 (September-October-November): 10-11.

Robinson, Walter. "Storytelling, Infantilism and Zoöphily." *Art-Rite* (New York), no. 19 (June-July): 29-30.

Russell, John. "Art People." *The New York Times,* 17 February, sec. C:20.

_____. "Review." *The New York Times,* 17 November, sec. C:19.

1979

Bonesteel, Michael. "Art and the New Androgyny." *The New Art Examiner* (Chicago) 6, no. 10 (Summer): 9-11.

Boots, Alice. "Waartegen Richt Zich de Agressie Van de Feministische Kunst?" *Museumjournaal* (Amsterdam) 24, no. 2 (April): 66-69.

Brown, Stephanie M. "Sculpting the Sensuous Line: Lynda Benglis Knows How to Throw a Curve." *Hartford Advocate* (Connecticut), 10 October, sec. 1:19.

Burnett, W. C. "Women Add Textures to Art World Mosaic." *The Atlanta Journal/Constitution,* 21 October, sec. E:1.

Crossley, Mimi. "Reviews: Johnson, Goodnough, Benglis and the Museum School Faculty." *The Houston Post,* 26 January, sec. E:3.

Falling, Patricia. "New York Reviews." *ARTnews* (New York) 78, no. 3 (March): 183-84.

Gardner, Paul. "Look! It's the Vogels." *ARTnews* (New York) 78, no. 3 (March): 84-88.

Hirsch, Linda Blaker. "Beginnings Which Never End." *Hartford Advocate* (Connecticut), 10 October, sec. 1:19.

"Interview: Linda [sic] Benglis." *Ocular* (Denver) 4, no. 2 (Summer): 30-43.

Kuspit, Donald B. "Cosmetic Transcendentalism: Surface Light in John Torreano, Rodney Ripps and Lynda Benglis." *Artforum* (New York) 18, no. 2 (October): 38-40.

Lawson, Thomas. "Color and Structure, Hamilton Gallery." *Flash Art* (Milan), nos. 90-91 (June-July): 53.

_____. "Painting in New York: An Illustrated Guide." *Flash Art* (Milan), nos. 92-93 (October-November): 4-11.

Lubell, Ellen. "Lynda Benglis." *Arts Magazine* (New York) 53, no. 5 (January): 14.

_____. "Lynda Benglis at Paula Cooper Gallery." *The Soho Weekly News* (New York), 14 June, 28.

Moser, Charlotte. "New Show Reflects Intensification of Benglis' Art." *Houston Chronicle,* 24 January, sec. 6:1.

"Multiples and Objects and Artists' Books." *The Print Collector's Newsletter* (New York) 10, no. 3 (July-August): 94-95.

"News of the Print World: People and Places." *The Print Collector's Newsletter* (New York) 10, no. 5 (November-December): 158.

Raynor, Vivien. "Avant Garde Experiments in an Alternative Space." *The New York Times,* 21 October, sec. 23:20.

Ricard, René. "Review of Exhibitions: New York, Lynda Benglis at Paula Cooper." *Art in America* (New York) 67, no. 1 (January-February): 141-42.

Sandler, Irving. "Art as Auto-Image." *Arts Month* (Amherst, Massachusetts: Hampshire College), March, 1-6.

Shapiro, Lindsay Stamm. "Exhibitions." *Craft Horizons* (New York) 39, no. 1 (February): 50.

Stevens, Mark. "The Dizzy Decade." *Newsweek* (New York) 93, no. 13 (26 March): 88-91, 94.

Tatransky, Valentin. "Arts Reviews." *Arts Magazine* (New York) 53, no. 5 (January): 18.

"Voice Choices—Art: Gold/Silver." *The Village Voice* (New York) 24, no. 2 (8 January): 47.

1980

Artner, Alan G. "After Recent Misses, MCA Hits Target with Three New Shows." *Chicago Tribune,* 10 August, sec. 6:10-11.

Ashbery, John. "Ramshackle Kennels Glimpsed by Moonlight." *New York Magazine* (New York) 13, no. 39 (6 October): 63.

Ballatore, Sandy. "High Points, Low Points, and No Points: Los Angeles, 1980." *Images and Issues* (Santa Monica, California) 1, no. 3 (Winter): 17-21.

Bertolo, Diane. "Paper Exhibit." *The Buffalo Evening News,* 16 September, sec. 2:30.

Bickerton, Jane. "Reviews." *Atlanta Art Papers* 4, no. 6 (November-December): 12-13.

Burnett, W. C. "Art as Afterthought Suffers in Poor Light, Placement; Avant Garde Works Humanize Structure, But Few Are Well Integrated with Architecture." *The Atlanta Journal/Constitution,* 14 September, sec. S:16.

Colby, Joy Hakanson. "The Versatility Clicks in Photography Exhibit." *The Detroit News,* 7 December, sec. E:14.

Crossley, Mimi. "Review: Extensions." *The Houston Post,* 25 January, sec. E:1, 5.

Dougherty, Steve. "Of Future World and Bad Art on Concourse C." *The Atlanta Constitution,* 14 September, sec. S:1, 19.

Edmunds, Emma. "Airport Photos Create Trip Theme." *The Atlanta Constitution,* 15 August, sec. B:1, 6.

Elliot, David. "In 3-D, He's a Diamond that Glitters." *Chicago Sun-Times,* 10 August, Show section: 9.

Glueck, Grace. "How Picasso's Vision Affects American Artists." *The New York Times,* 22 June, sec. 2:1, 25.

Goldberger, Paul. "New Atlanta Terminal Is Orderly, but Will It Fly?" *The New York Times,* 24 September, sec. A:16.

Gruen, John. "Women Artists: 25 Best Investments." *Working Woman* (New York) 5, no. 7 (July): 30-32.

Henson, Judy. "Reviews." *Atlanta Art Papers* 4, no. 6 (November-December): 13-14.

Houck, Catherine. "Women Artists Today." *Cosmopolitan* (New York) 188, no. 1 (January): 198-99, 220-21, 258, 266.

Huntington, Richard. "Throwaway Paper Put on Pedestal." *The Courier Express* (Buffalo), 21 September, 1, 5.

Kalil, Susie. "Issues in Extension." *Artweek* (Oakland) 11, no. 5 (9 February): 1, 16.

Kramer, Hilton. "Art Contrasts in Imagery, Two Views of Louise Bourgeois." *The New York Times*, 3 October, sec. C:29.

Larson, Kay. "Avant To Be in Style." *The Village Voice* (New York) 25, no. 41 (8-14 October): 85.

Nelson, James. "Museum's Three-Artist Show Is a Modest But Fun Exhibition." *Birmingham News* (Alabama), 30 November, sec. E:6.

Rickey, Carrie. "Reviews." *Artforum* (New York) 19, no. 4 (December): 71.

Roth, Karen. "Lynda Benglis' Colorful, Curious Paintings." *Phase Two* (Berkeley: California College of Arts and Crafts), December, 4-5.

Russell, John. "Review." *The New York Times*, 28 June, sec. C:27.

Saunders, Wade. "Hot Metal." *Art in America* (New York) 68, no. 6 (Summer): 86-95.

Taylor, Ron. "Caviar Was Mite Salty, but Folks at Airport Party Had a Real Bash." *The Atlanta Journal*, 19 September, sec. A:1, 4.

Tennant, Donna. "Four Artists in Struggle for Originality." *Houston Chronicle*, 27 January, Zest section: 15-29.

Warren, George. "Lynda Benglis: Recent Work." *The Atlanta Art Workers Coalition Newspaper* 4, no. 1 (January-February): 14-15.

Welch, Douglas. "Arts Reviews." *Arts Magazine* (New York) 55, no. 3 (November): 35.

Wilson, William, and Muchnic, Suzanne. "The Galleries." *Los Angeles Times*, 28 March, sec. 6:6.

1981

Butera, Virginia Fabbri. "The Fan as Form and Image in Contemporary Art." *Arts Magazine* (New York) 55, no. 9 (May): 88-92.

Deschamps, Madeline. *La Peinture Américaine: Les Mythes et la matière*. Paris: Denoël.

Dubois, Philippe. "Peinture et vidéographie, miroir et narcissisme." *Art Press* (Paris), no. 47 (April): 19-21.

Fleming, Lee. "Adventures at Artpark." *Washington Review* (Washington, D.C.) 7, no. 3 (October-November): 6-7.

Horne, David. "Provocateur Breaks New

Ground." *Arizona Daily Star* (Tucson), 10 May, sec. I:7.

Johnstone, Bryan. "Benglis: A Flamboyant Approach to Contemporary Art." *Encore: Arizona Daily Wildcat* (Tucson), 30 April, 1-2.

Knight, Christopher. "Cast, Carved and Constructed." *Los Angeles Herald Examiner*, 16 August, sec. E:9.

Kramer, Hilton. "Art: Post-Minimalists Show Recent Sculpture." *The New York Times*, 24 July, sec. C:22.

Larson, Kay. "Live Five." *New York Magazine* (New York) 14, no. 36 (14 September): 55-58.

Lawson, Thomas. "Schilderkunst in New York: Een geïllustreerde gids." *Museumjournaal* (Amsterdam) 26, no. 3 (n.d.): 127-37.

"Lynda Benglis Aquanots: Review." *The Print Collector's Newsletter* (New York) 12, no. 1 (March-April): 22.

Morgan, Stuart. "Animal House: The Whitney Biennial." *Artscribe* (London), no. 29 (June): 28-31.

Muchnic, Suzanne. "A 'Cast' of 21 at Leavin Gallery." *Los Angeles Times*, 28 August, sec. 6:2.

Niepold, Mary Martin. "A Peak at Paris in Bourse." *Philadelphia Inquirer*, 12 April, sec. K:3.

Perrone, Jeff. "Notes on the Whitney Biennial." *Images and Issues* (Santa Monica, California) 2, no. 1 (Summer): 46-49.

———. "Reviews." *Images and Issues* (Santa Monica, California) 1, no. 4 (Spring): 45-46.

Phillips, Deborah C. "New York Reviews." *ARTnews* (New York) 80, no. 1 (January): 170-71.

———. "Reviews." *ARTnews* (New York) 80, no. 7 (September): 234, 236.

Pincus-Witten, Robert. "Entries: Style Shucks." *Arts Magazine* (New York) 56, no. 2 (October): 94-97.

Raynor, Vivien. "30 Years of American Drawing." *The New York Times*, 21 June, sec. 23:22.

Rickey, Carrie. "Curatorial Conceptions: The Whitney's Latest Sampler." *Artforum* (New York) 19, no. 8 (April): 52-57.

Rock, Maxine A. "A Gigantic Airport Harmonizes Art with Technology." *Smithsonian* (Washington, D.C.) 11, no. 11 (February): 90-94.

Schjeldahl, Peter. "The Hallelujah Trail." *The Village Voice* (New York) 26, no. 2 (18-24 March): 77.

Super, Gary. *Atlanta International Airport Art Collection: A First Anniversary Commemorative Catalogue*. Atlanta: Nexus Press.

Van Izzy, Abrahami. "On Speaking Terms: Lynda Benglis." *Avenue* (Amsterdam), no. 2 (February): 89-90.

Wolff, Theodore F. "Whitney Museum of Art: Dateline New York." *Philadelphia Inquirer*, 23 March, sec. C:5.

Zimmer, William. "Under Developments." *The Soho Weekly News* (New York), 4 August, 46.

1982

Albright, Thomas. "At the Galleries: Baubles and Freeways." *San Francisco Chronicle*, 24 November, sec. 1:32.

Baker, Kenneth. "Heavy Metals: A Tangle of Sculpture." *The Boston Phoenix*, 14 September, sec. 3:10.

Benglis, Lynda. Illustration. *River Styx* (St. Louis), no. 10 (n.d.): inside front cover.

———. Illustrations. *River Styx* (St. Louis), no. 11 (n.d.): 81, inside back cover.

———. Illustrations. *River Styx* (St. Louis), no. 13 (n.d.): 74-75.

"Benglis at Paula Cooper: In Review." *The Art Gallery Scene* (New York), 4 December, 3.

Bishop, Joe. "Pick of the Week." *Los Angeles Weekly*, 5-11 February, Arts section: 84.

Braff, Phyllis. "From the Studio." *The East Hampton Star* (East Hampton, New York), 18 November, sec. 2:6.

Canady, John. "The Artful Body." *Town and Country* (New York) 136, no. 5024 (May): 148-58.

Cohen, Ronny H. "Developments in Recent Sculpture." *Artforum* (New York) 20, no. 5 (January): 79.

"Critic's Tip." *St. Louis Globe-Democrat*, 8 January, sec. B:7.

Curtis, Cathy. "Metallic Gestures." *Artweek* (Oakland) 13, no. 39 (20 November): 7.

Dickinson, Nancy Godwin. "Metals: Cast-Cut-Coiled." *Art New England* (Brighton, Massachusetts) 3, no. 8 (October): 11.

"Editor's Choice." *Portfolio* (New York) 4, no. 6 (November-December): 17.

Findsen, Owen. "Gleefully Exploding Art at CAC." *The Cincinnati Enquirer*, 14 March, sec. D:8.

Foreman, B. J. "CAC's 'Dynamix' Big, Bold and Raucous Show." *The Cincinnati Post*, 24 March, sec. A:12.

Gedo, Mary Mathews. "Art Institute of Chicago Exhibition." *Arts Magazine* (New York) 57, no. 1 (September): 20.

Glueck, Grace. "Art: After 2 Years, Selected Prints III." *The New York Times*, 24 September, sec. C:21.

Handy, Ellen. "Arts Reviews." *Arts Magazine* (New York) 57, no. 4 (December): 32-33.

Henry, Gerrit. "Women of the Americas: Emerging Perspectives." *ARTnews* (New York) 81, no. 10 (December): 155.

King, Mary. "Lynda Benglis' Works: Diverse, Physical." *St. Louis Post-Dispatch*, 26 January, sec. D:6.

Kuspit, Donald B. "Out of the South: Eight Southern-born Artists." *Art Papers* (Atlanta) 6, no. 6 (November-December): 2-5. Reprinted from David Heath and Donald B. Kuspit. *Out of the South*. Atlanta: Heath Gallery, 1982. Exhibition catalogue.

Lawson, Thomas. "The Dark Side of the Bright Light." *Artforum* (New York) 21, no. 3 (November): 62-66.

Lewison, David. "Lynda Benglis." *Art Express* (Providence) 2, no. 3 (May-June): 62-63.

Lipkin, Joan. "Lynda Benglis Is a Provocative Artist." *St. Louis Globe-Democrat*, 4 February, sec. B:4.

"Lyon: Les punks de Manhattan." *L'Express* (Paris), no. 1599 (5 March): 7.

McKay, Gary. "Artful Lodgings: How Four Houstonians Live with Art." *Houston Home and Garden* 9, no. 2 (November): 132-37.

Oresman, Janice. *Lehman Brothers/Kuhn Loeb Incorporated Art Collection*. New York: Lehman Brothers/Kuhn Loeb, Inc.

Park, Betty. "The Whitney Museum of American Art." *Fiberarts* (Asheville, North Carolina) 9, no. 2 (March-April): 11-14.

Perrone, Jeff. "Golden Peonie of Words." *Arts Magazine* (New York) 56, no. 10 (June): 62-68.

————. "Subject A." *Arts Magazine* (New York) 57, no. 3 (November): 123-31.

"Public Sculpture." *Art in America Guide to Galleries, Museums, Artists*. New York: *Art in America*.

"Punk au mur." *Connaissance des Arts* (Paris), no. 360 (February): 21.

Raynor, Vivien. "Art: Knot-Theme Sculptures by Lynda Benglis." *The New York Times*, 26 November, sec. C:15.

Rozier, Jacqueline. "Energie importée d'outre-Atlantique." *Le Journal* (Paris), 28 February, n.p.

Russell, John. "Finding Pleasure in Early Work." *The New York Times*, 9 May, sec. D:29, 33.

Seiberling, Dorothy. "A New Kind of Quilt." *The New York Times Magazine*, 3 October, sec. 6:42-50.

Sozanski, Edward J. "RISD Exhibit Redefines Traditional Sculpture." *Providence Journal*, 27 August, sec. W:3.

Warmus, William. *New Glass Review: 3*. Corning, New York: The Corning Museum of Glass.

Wilson, William. "Galleries: La Cienega Area." *Los Angeles Times*, 22 January, sec. 6:10.

1983

Anderson, Alexandra. "Editor's Choice: Selected Gallery Previews." *Portfolio* (New York) 5, no. 2 (March-April): 26.

"Art Notes." *The Washington Times* (Washington, D.C.), 26 May, sec. B:3.

Artner, Alan G. "Art Galleries: Joan Thorne, Lynda Benglis." *Chicago Tribune*, 25 November, sec. 5:18.

————. "The Return of the Human Touch: Figurative Sculpture Is Really Back in Vogue." *Chicago Tribune*, 15 May, sec. 6:20-21.

Bienn, David, and Tews, Mary Kate. "Results: 1984 Louisiana World Exposition's First International Water Sculpture Competition." *Arts Quarterly* (New Orleans: New Orleans Museum of Art) 5, no. III (July-August-September): 36-40.

Braff, Phyllis. "From The Studio." *The East Hampton Star* (East Hampton, New York), 21 April, sec. 2:6.

Cohen, Ronny. "Paper Routes." *ARTnews* (New York) 82, no. 8 (October): 78-85.

Eisenman, Stephan F. "Arts Reviews." *Arts Magazine* (New York) 57, no. 5 (January): 40.

"A Fortune Portfolio: Keepers of Corporate Art." *Fortune* (New York) 107, no. 6 (21 March): 114-20.

Halley, Peter. "A Note on the 'New Expressionism' Phenomenon." *Arts Magazine* (New York) 57, no. 7 (March): 88-89.

Larson, Kay. "The New Ugliness." *New York Magazine* (New York) 16, no. 22 (30 May): 64-65.

"Lynda Benglis." *The Detroit News*, 3 July, sec. E:5.

Miro, Marsha. "Feminism Takes a Delicate Stance in Relief Sculptures." *Detroit Free Press*, 26 June, sec. C:7.

Muchnic, Suzanne. "The Galleries." *Los Angeles Times*, 1 April, sec. 6:12.

————. "16 Artists Chart an Independent Course for '84." *Los Angeles Times*, 12 January, sec. 6:1, 4.

"Multiples and Objects and Books." *The Print Collector's Newsletter* (New York) 13, no. 6 (January-February): 220.

Official 1984 Olympic Fine Art Posters Catalog. Los Angeles: Olympic Organizing Committee.

"Olympic Poster Artists Flex Their Muscles." *The Daily News of Los Angeles* (Van Nuys, California), 14 January, Friday section: 22-25.

Raynor, Vivien. "All That Glitters Isn't Always Gold." *The New York Times*, 29 May, sec. 11:28.

Ryan, David. "Lynda Benglis: For Carl Andre." In *A Guide to the Painting and Sculpture Collection, The Fort Worth Art Museum*. Fort Worth, Texas: The Fort Worth Art Museum.

Tully, Judd. "Paper Chase." *Portfolio* (New York) 5, no. 3 (May-June): 78-85.

"Visions of the Olympics." *Newsweek* (New York) 101, no. 4 (24 January): 74.

Watkins, Eileen. "TWEED Mines 'All That Glitters.'" *The Sunday Star-Ledger* (Newark, New Jersey), 5 June, sec. 4:16.

Zimmer, William. "'Before' and 'After' Look from the Coast." *The New York Times*, 30 October, sec. C:20.

1984

Bachmann, Donna G. "Works by Women: Central Exchange." *Forum* (Kansas City, Missouri: Kansas City Artists Coalition), September, 10-12.

Bell, Tiffany. "Lynda Benglis." *Arts Magazine* (New York) 58, no. 10 (Summer): 2.

Braff, Phyllis. "From the Studio." *The East Hampton Star* (East Hampton, New York), 2 August, sec. 2:6.

Brenson, Michael. "Art: Open Juried Show at Academy of Design." *The New York Times*, 30 March, sec. C:24.

Calas, Terrington. "Cannon, Benglis, Dale." *The New Orleans Art Review* 3, no. 4 (October-November): 24-26.

"Calendar." *Dialogue* (Akron: Ohio Foundation of the Arts) 7, no. 4 (July-August): 40.

Freeman, Phyllis; Himmel, Eric; Pavese, Edith; and Yarowsky, Anne. *New Art*. New York: Harry N. Abrams, Inc.

Green, Roger. "Diaphanous Designs as Heavy Metal." *The Times-Picayune* (New Orleans), 26 October, Lagniappe section: 14.

Handy, Ellen. "Lynda Benglis at Paula Cooper Gallery." *Arts Magazine* (New York) 58, no. 10 (Summer): 36-37.

Henry, Gerrit. "Ecstasy." *Arts Magazine* (New York) 59, no. 3 (November): 13.

Johnson, Patricia C. "Sculpture Exhibits Visions of Beauty." *Houston Chronicle*, 20 October, sec. 4:1.

King, Marcia. "Go Sculp-Touring." *Toledo Alive Magazine* 1, no. 2 (July-August): 20-22.

Kohen, Helen L. "Water, Water, Everywhere at New Orleans Fair." *The Miami Herald* (Florida), 15 April, sec. L:9.

Lubell, Ellen. "Review of Exhibitions." *Art in America* (New York) 72, no. 8 (September): 219.

McDarrah, Timothy. "East Hampton Sculptress, Lynda Benglis." *Hamptons Newspaper/Magazine* (Southampton, New York), 10 July, sec. 1:7-8.

Mayer, Charles. "Paper Transformed." *Arts Insight* (Indianapolis) 6, no. 4 (May): 22-23.

Murray, Mary. "Toledo Alive." *Dialogue* (Akron: Ohio Foundation of the Arts) 7, no. 5 (September-October): 22.

Robins, Corinne. *The Pluralist Era: American Art 1968-1981*. New York: Harper and Row.

Russell, John. "Art: Just the Show for Summer in Hamptons." *The New York Times*, 3 August, sec. C:1, 20.

Sozanski, Edward J. "Finding Right Space for Sculpture in World of Art."

Philadelphia Inquirer, 22 January, sec. H:14.

Winkel, Gabrielle. "Art of the Ankas." *House & Garden* (New York) 56, no. 9 (September): 166-73.

Zimmer, William. "Three Shows, Three Styles." *The New York Times*, 29 April, sec. 23:28.

1985

Blue, Macdowell. "Film, Exhibit to Show at Museum." *Voyager* (Pensacola, Florida), 18 March, sec. 1:3.

Brenson, Michael. "Art: 8 Artists in 'Between Drawing and Sculpture.'" *The New York Times*, 20 December, sec. C:29.

Colby, Joy Hakanson. "Glass Gets a Boost from Ms. Benglis and Friends." *The Detroit News*, 13 October, sec. J:4.

Dupont, Diana C.; Holland, Katherine Church; Muller, Garna Garren; and Sueoka, Laura L. *Painting and Sculpture Collection, San Francisco Museum of Modern Art*. New York: Hudson Hills Press.

Gilbert-Rolfe, Jeremy. *Immanence and Contradiction*. New York: Out of London Press.

Green, Roger. "Visiting Atlanta's 'Magazine Street.'" *The Times-Picayune* (New Orleans), 6 December, Lagniappe section: 14.

Larson, Kay. "Keep Your Eye on Art . . . Women in the Vanguard." *Harper's Bazaar* (New York), no. 3280 (March): 276-77, 318, 320.

Lloyd, Pat. "Museum Opening." *The Pensacola Journal* (Florida), 13 March, sec. D:2.

Lucie-Smith, Edward. *American Art Now*. Oxford, England: Phaidon Press Limited.

McKenna, Kristine. "The Art Galleries." *Los Angeles Times*, 6 September, sec. 6:10.

Miro, Marsha. "Fearless Sculptor Sets Her Eyes on Glass." *Detroit Free Press*, 29 October, sec. C:1.

"Museum Features Sculpture, Abstracts." *The Pensacola Journal* (Florida), 5 April, sec. E:14.

Parker, Douglas M. "Anniversary Portfolio: Artists View the South Fork." *The East Hampton Star* (East Hampton, New York), 5 September, sec. 2:4.

Raynor, Vivien. "Abstract Relationships." *The New York Times*, 5 July, sec. C:21.

Rose, Barbara. "Portrait of Paula." *Vogue* (New York), April, 362-67, 410.

Saunders, Wade. "Talking Objects: Interviews with Ten Younger Sculptors." *Art in America* (New York) 73, no. 11 (November): 110-36.

Staniszewski, Mary Anne. "Corporate Culture." *Manhattan, Inc.* (New York) 2, no. 12 (December): 145-49.

Tuchman, Phyllis. "Bryan Hunt's Balanc-ing Act." *ARTnews* (New York) 84, no. 8 (October): 64-73.

Watson, Bret. "Vision Helps a Young Couple Focus on Art Coming into View." *Avenue Magazine* (New York) 9, no. 5 (February): 126-30.

Wilson, William. "The Galleries: La Cienega Area." *Los Angeles Times*, 22 February, sec. 6:13.

Wortz, Melinda. "The Nation: Los Angeles." *ARTnews* (New York) 84, no. 6 (Summer): 101.

1986

Arnason, H. H. *History of Modern Art*. 3rd ed. New York: Harry N. Abrams, Inc.

Art in the Environment. Boca Raton, Florida: Boca Raton Museum of Art.

Baker, Kenneth. "Benglis: Sculptures Whose Form Is Their Substance." *San Francisco Chronicle*, 17 April, Daily Date Book section: 65.

Benglis, Lynda. Illustration. *Parnassus: Poetry in Review* (New York) 13, no. 2 (Spring-Summer): 56.

Bonetti, David. "Back to Natural, Sculpture Takes on the World." *The Boston Phoenix*, 3 June, sec. 3:4-5.

Bos, Michael. "Abstract Sculpture Show Is Very Impressive." *The Tech* (Cambridge, Massachusetts: Massachusetts Institute of Technology), 13 May, sec. 1:7.

Brenson, Michael. "Art: The Guide." *The New York Times*, 3 August, sec. A:2.

———. "Sculpture Breaks the Mold of Minimalism." *The New York Times*, 23 November, sec. 2:1, 33.

Cohen, Stan. "Lynda Benglis." *Art Papers* (Atlanta) 10, no. 1 (January-February): 63.

Costello, Daniel W.; Earls-Solari, Bonnie; and Stankus, Michelene. *BankAmerica Corporation Art Program 1985*. San Francisco: BankAmerica Corporation.

"Evolución comparativa de ARCO." *El Punto* (Madrid), 14 April, 6.

"Fans and Bows Sculpture Unveiled." *Sutter Post* (San Francisco: Crocker West Tower, Inc.), February, 3.

Malcolm, Janet. "Profiles, A Girl of the Zeitgeist." *The New Yorker* (New York) 62, no. 35 (20 October): 49-66.

Morch, Al. "Creations of Steel and Glass." *San Francisco Examiner*, 7 April, sec. E:1, 6.

Morse, Margaret. "The Big Sleek." *House & Garden* (New York) 158, no. 4 (April): 205-8.

Muchnic, Suzanne. "Glass Society Shows Its Mettle." *Los Angeles Times*, 17 April, sec. 6:1, 10.

Taylor, Robert. "Sculpture Show a Pioneering Effort." *The Boston Globe*, 18 May, sec. A:17.

Wohlfert-Wihlborg, Lee. "A New Place in the Sun." *Town and Country* (New York) 140, no. 5070 (May): 203-28.

1987

"Album: Lynda Benglis." *Arts Magazine* (New York) 61, no. 8 (April): 100-101.

Barnett, Kay. "Teacher/Student Exhibition." *Arts, Humanities, Culture Clippings* (Lake Charles, Louisiana: Calcasieu Arts and Humanities Council) 6, no. 3 (February-March): 5.

"Benglis and Kohlmeyer Exhibit at The Lake Charles Museum." *Lagniappe* (Lake Charles, Louisiana) 5, no. 5 (1 March): 13.

Berman, Anne E. "Sculptors in Progress." *Town and Country* (New York) 141, no. 5088 (September): 269-72.

Bernikow, Louise. "An Oasis in Bangkok." *Architectural Digest* (Los Angeles) 44, no. 1 (January): 60-63.

Braff, Phyllis. "Faculty Show: Range of Ideas." *The New York Times*, 6 September, Long Island section: 25.

Cotter, Holland. "Reviews." *Art in America* (New York) 75, no. 7 (July): 124.

Donohue, Marlena. "Lynda Benglis." *Sculpture* (Washington, D.C.) 6, no. 5 (September-October): 39-40.

Fassburg, Terry A., and Neff, Terry A. *Selections from the Frito-Lay Collection*. Dallas: Frito-Lay, Inc.

Field, Richard S., and Fine, Ruth E. *A Graphic Muse: Prints by Contemporary American Women*. New York: Hudson Hills Press with the Mount Holyoke College Art Museum. Exhibition catalogue; Benglis's works were not included in the exhibition.

Huntington, Richard. "Albright-Knox Turns Good Idea into Fine Show." *The Buffalo Evening News*, 2 August, sec. G:1.

Long, Robert. "Faculty Art Is Shown." *Southampton Press* (Southampton, New York), 3 September, sec. B:9.

Morgan, Robert C. "American Sculpture and the Search for a Referent." *Arts Magazine* (New York) 62, no. 3 (November): 20-23.

Muchnic, Suzanne. "Review of Exhibition." *Los Angeles Times*, 22 May, sec. 6:14.

Nilson, Lisbet. "Chicago's Art Explosion." *ARTnews* (New York) 86, no. 5 (May): 110-19.

Pincus-Witten, Robert. *Postminimalism into Maximalism: American Art, 1966-1986*. Ann Arbor, Michigan: UMI Research Press. Essay on pp. 177-83 reprinted from Robert Pincus-Witten. "Benglis' Video: Medium to Media." In *Physical and Psychological Moments in Time: A First Retrospective of the Video Work of Lynda Benglis*. Oneonta, New York: Fine Arts Center Gallery, State University of New York College at Oneonta, 1975.

"R.S.V.P.: Reception for Guest Artists." *Lake Charles American Press* (Louisiana), 8 February, sec. 1:48.

Thomas, Alice B. "Museum Celebrates 10th Year, Shows Works by 2 L.A. Natives." *Alexandria Daily Town Talk* (Louisiana), 9 October, sec. C:1.

Wallach, Amei. "Moving Beyond Provincialism." *New York Newsday*, 21 August, Weekend section: 20.

1988

Avgikos, Jan. "The Southern Artist, Lynda Benglis." *Southern Accents* (Birmingham, Alabama) 11, no. 6 (November-December): 168-71.

Baker, Kenneth. "Show of Benglis, Henderson at Fuller Gross." *San Francisco Chronicle*, 30 December, sec. E:4.

Coad, Robert James. *Between Painting and Sculpture: A Study of the Work and Working Process of Lynda Benglis, Elizabeth Murray, Judy Pfaff and Gary Stephan.* Ann Arbor, Michigan: UMI Dissertation Information Service (copyright 1983).

Heartney, Eleanor. "A Necessary Transgression." *New Art Examiner* (Chicago) 16, no. 3 (November): 20-23.

Hieronymus, Clara. "Two Women Artists with Style." *The Tennessean* (Nashville), 3 April, sec. F:1, 8.

Schwalb, Claudia. "Review." *Cover* (New York) 2, no. 8 (September): 12.

Van Proyen, Mark. "Layered Improvisations." *Artweek* (Oakland) 19, no. 43 (24 December): 6.

1989

Blagdan, Donna. "At the ACA: Former ACA Master Artist Exhibits." *The Observer* (New Smyrna Beach, Florida), 14-20 July, Volusia Magazine section: cover, 7.

Bookhardt, D. Eric. "Lynda Benglis: Tilden-Foley Gallery." *Art Papers* (Atlanta) 13, no. 4 (July/August): 58.

Booth, I. MacAllister; Armstrong, Tom; Heiferman, Marvin; Phillips, Lisa; and Hanhardt, John G. *Image World.* New York: Whitney Museum of American Art. Exhibition catalogue; Benglis's work was not included in the exhibition.

Cullinan, Helen. "Center's Exhibit Displays All the Art That's Fit for Print." *The Plain Dealer* (Cleveland), 16 July, sec. H:4.

Donohue, Marlena. "Expressing Herself." *Los Angeles Times*, 29 June, sec. 5:2.

———. "The Galleries: La Cienega Area." *Los Angeles Times*, 21 July, sec. 6:17.

Gardner, Paul. "Mesmerized by Minimalism." *Contemporanea* (New York) 2, no. 9 (December): 56-61.

Gerak, Sally. "Artists 'Show and Tell' Their Works at Benefit." *Observer and Eccentric* (Birmingham, Michigan), 30 October, sec. B:4.

Gilbert, Jan. "Portraits of Success: Women Artists." *The Times-Picayune* (New Orleans), 14 May, sec. E:8.

Green, Roger. "Material Evidence of Success." *The Times-Picayune* (New Orleans), 7 April, Lagniappe section: 16.

"Growing Recognition of Regional Differences Reflected in Exhibition by Two West Coast Artists." *The Japan Times* (Tokyo), 16 April, Arts section: 11.

Howell, John. "Paula Cooper: Quite Contrary." *ARTnews* (New York) 88, no. 3 (March): 152-57.

Koplos, Janet. "Foreign Invasion." *Asahi Evening News* (Tokyo), 14 April, Arts section, n.p.

Milani, Joanne. "Artist's Prints Leave a Lasting Impression." *The Tampa Tribune*, 19 April, sec. F:4.

Rosen, Randy. "Making Their Mark: Women Artists Move into the Mainstream, 1970-1985." *Arts Quarterly* (New Orleans: New Orleans Museum of Art) 11, no. 2 (April-May-June): 1-7. Essay on pp. 3-7 excerpted from Randy Rosen, Ellen G. Landau, Calvin Tomkins, Judith E. Stein, Ann-Sargent Wooster, Thomas McEvilley, and Marcia Tucker. *Making Their Mark: Women Artists Move into the Mainstream, 1970-1985.* New York: Abbeville Press, 1989. Exhibition catalogue.

Silberman, Rob. "Prints Charming." *City Pages* (Minneapolis), 21 June, sec. 1:20.

Solomon, Deborah. "A Downtown Aesthetic." *Architectural Digest* (Los Angeles) 46, no. 11 (November): 316.

Straayer, Chris. "Sexuality and Video Narrative." *AfterImage* (Rochester, New York) 16, no. 10 (May): 8-11.

Waddington, Chris. "Critic's Choice/Exhibition." *The Minneapolis Star Tribune*, 2 June, sec. E:2.

Whitington, G. Luther. "Expositions." *Art and Auction* (New York) 12, no. 5 (December): 84.

Zevon, Susan. "Modern Goes Mellow." *House Beautiful* (New York) 131, no. 1 (January): 80-83.

1990

Chadwick, Whitney. *Women, Art and Society.* New York: Thames and Hudson.

Colby, Joy Hakanson. "The Hilberry's Show Brings Gallery Regulars Together to Show Off Their Outstanding Work." *The Detroit News*, 1 February, sec. C:5.

Danto, Arthur C. "Art: Postminimalist Sculpture." *The Nation* (New York) 250, no. 19 (14 May): 680-84.

"A Dozen for the Decade." *Southpoint* (Birmingham, Alabama) 2, no. 1 (January): 48-49.

Hackett, Regina. "Artist's Eye for Tawdry is Exhibited." *Seattle Post-Intelligencer*, 10 August, What's Happening section: 12.

Hanson, Henry. "Living with Art." *ARTnews* (New York) 89, no. 2 (February): 93-96.

Hixson, Kathryn. "Chicago in Review." *Arts Magazine* (New York) 64, no. 10 (Summer): 104.

Honda, Margaret. "Interview: Jack Brogan." *Visions Art Quarterly* (Los Angeles) 4, no. 3 (Summer): 28-31.

Larson, Kay. "Foreign Exchange." *New York Magazine* (New York) 23, no. 37 (24 September): 106-7.

McCracken, David. "Gallery Scene: Litzenberger Finds Beauty in Found Objects." *Chicago Tribune*, 6 April, sec. 7:84.

Princenthal, Nancy. "The New Sculpture 1965-75: Between Geometry and Gesture." *Sculpture* (Washington, D.C.) 9, no. 4 (July-August): 40-45.

Rafferty, Carole. "Arts Alive at Ben Shahn: Modern Sculpture Now on Display." *The Beacon* (Wayne, New Jersey: William Paterson College), 23 April, sec. 1:20.

Rayner, William P. "Art with a View." *House & Garden* (New York) 162, no. 5 (May): 202-9.

Schmerler, Sarah. "Lynda Benglis." *Cover* (New York) 4, no. 7 (September): 21.

Smith, Roberta. "Sculpture at the Whitney: The Radical Years." *The New York Times*, 9 March, sec. B:1, 9.

Watkins, Eileen. "Art: William Paterson Exhibits Deal with Ancient and Modern Styles." *Newark Star-Ledger* (New Jersey), 15 April, sec. 4:15.

Yood, James. "Reviews: Lynda Benglis." *New Art Examiner* (Chicago) 17, no. 10 (June): 49.

Zimmer, William. "2 Themes: Domesticity and Grid." *The New York Times*, 5 April, sec. 12:11.

VIDEOGRAPHY

McIntosh, Ann, and Don Schaefer. *Lynda Benglis Paints with Foam (Totem)*, 1971. Black and white, 27 minutes (Cambridge, Massachusetts: Video/One Production). Distributed by Video Data Bank, Chicago.

Tschinkel, Paul. *New Art*, 1981. Color, 28 minutes (New York: ART/new york). Includes interview with Lynda Benglis by Paul Tschinkel. Distributed by ART/new york.

Compiled by Shella De Shong

CHECKLIST OF THE EXHIBITION

1. **UNTITLED**, 1966
 Pigmented beeswax and gesso on
 masonite; wood
 65 x 5 x 1½ inches
 Collection of Helen Herrick and
 Milton Brutten, Philadelphia

2. **UNTITLED**, ca. 1966
 Pigmented beeswax and gesso
 on masonite; wood
 23¾ x 7¾ x 1¹/₁₆ inches
 Collection of Richard Tuttle

3. **UNTITLED**, 1966-67
 Pigmented beeswax and gesso
 on masonite; wood
 65½ x 5⅝ x 1¼ inches
 Private Collection

4. **FALLEN PAINTING**, 1968
 Pigmented latex rubber
 ¼ x 69¼ x 355 inches
 Private Collection

5. **FOR CARL ANDRE**, 1970
 Pigmented polyurethane foam
 56¼ x 53½ x 46½ inches
 Collection of The Modern Art
 Museum of Fort Worth, Museum
 Purchase, The Benjamin J. Tillar
 Memorial Trust

6. **EXCESS**, 1971
 Pigmented beeswax, damar resin
 and gesso on masonite; wood
 36 x 5 x 3½ inches
 Collection of the Walker Art Center,
 Minneapolis, Art Center Acquisition
 Fund, 1972

7. **UNTITLED** (from the "Pinto"
 series), 1971 +
 Pigmented beeswax, damar resin
 and gesso on masonite; wood
 36 x 4½ x 1⅓ inches
 Collection of the New Orleans
 Museum of Art, gift of Mr. and Mrs.
 Leonard Glade

8. **UNTITLED**, 1971
 Pigmented beeswax, damar resin
 and gesso on masonite; wood
 36¼ x 5½ x 2⅝ inches
 Collection of Camille and Paul
 Oliver-Hoffmann

9. **HOOFERS I**, 1971-72
 Glitter, acrylic, pigments and gesso
 on plaster; cotton bunting; alumi-
 num screen
 102 x 5½ x 4 inches
 Courtesy Paula Cooper Gallery,
 New York

10. **HOOFERS II**, 1971-72
 Glitter, acrylic, pigments and gesso
 on plaster; cotton bunting; alumi-
 num screen
 102 x 4½ x 3 inches
 Courtesy Paula Cooper Gallery,
 New York

11. **EPSILON**, 1972
 Acrylic, enamel, glitter and gesso on
 plaster; cotton bunting; aluminum
 screen
 37 x 30 x 12 inches
 Collection of the Philadelphia
 Museum of Art, gift of Donald Droll

12. **VALENCIA I**, 1973
 Acrylic, enamel, glitter and gesso on
 plaster; cotton bunting; aluminum
 screen
 27 x 16 x 12 inches
 Collection of Mr. and Mrs. Donnelley
 Erdman, Aspen, Colorado

13. **KLAUS**, 1974*
 Enamel, glitter, acrylic resin and hot
 glue on aluminum foil; aluminum
 screen
 53 x 18 x 12 inches
 Collection of Sondra and Charles
 Gilman, Jr.

14. **PETER**, 1974
 Enamel, acrylic resin and hot
 glue on aluminum foil; aluminum
 screen
 65 x 15 x 13 inches
 Collection of A. J. Aronow,
 New York

15. **VICTOR**, 1974*
 Zinc, tin, liquid metal in plastic
 medium and gesso on plaster;
 cotton bunting; aluminum screen
 69 x 26 x 16 inches
 Collection of The Museum of
 Modern Art, New York, purchased
 with the aid of funds from the
 National Endowment for the Arts
 and an anonymous donor, 1975

16. **Foxtrot**, 1974-75
Zinc, tin, liquid metal in plastic
medium and gesso on plaster;
cotton bunting; aluminum screen
ca. 52 x 23 x 15 inches
Collection of Mr. and Mrs. M. A.
Benglis, Lake Charles, Louisiana

17. **Alpha II**, 1975
Zinc, tin, liquid metal in plastic
medium and gesso on plaster;
cotton bunting; aluminum screen
73 x 29 x 24 inches
Courtesy Margo Leavin Gallery,
Los Angeles

18. **Eat Meat**, 1975
Cast aluminum
24 x 80 x 54 inches
Collection of Anne and
William J. Hokin

19. **Eat Meat**, 1975
Cast bronze
24 x 80 x 54 inches
Private Collection

20. **Wing**, 1975
Cast aluminum
67 x 59¼ x 60 inches
Courtesy Paula Cooper Gallery, New
York, and Margo Leavin Gallery,
Los Angeles

21. **North, South, East,
West**, 1976
Zinc, tin, liquid metal in plastic
medium and gesso on plaster;
cotton bunting; aluminum screen
Four parts, left to right:
40 x 23 x 15½, 51 x 27 x 14,
37 x 29 x 19, 60 x 24 x 17 inches
Collection of Anne and
William J. Hokin

22. **Lagniappe: Bayou Babe**,
1977
Acrylic, glitter and gesso on plaster;
cotton bunting; aluminum screen;
polypropylene
32 x 8 x 9 inches
Collection of Phillip G. Schrager

23. **Megiste**, 1978
Gold leaf, oil-based sizing and
gesso on plaster; cotton bunting;
chicken wire
45 x 26 x 11½ inches
Private Collection

24. **Rhodos**, 1978
Gold leaf, oil-based sizing and
gesso on plaster; cotton bunting;
chicken wire
55½ x 26 x 11 inches
Courtesy Paula Cooper Gallery,
New York

25. **Vessel**, 1978
Cast bronze
35 x 4½ x 12 inches
Courtesy Paula Cooper Gallery,
New York

26. **Fanfarinade**, 1979
Gold leaf, oil-based sizing and
gesso on plaster; bronze screen
36 x 21 x 3¼ inches
Collection of Gerd Metzdorff,
Vancouver, Canada

27. **Gilgit**, 1980
Gold leaf, oil-based sizing and gesso
on plaster; bronze screen
36 x 36 x 3¼ inches
Collection of Sally Sirkin Lewis
and Bernard Lewis, Beverly Hills,
California

28. **Nar**, 1980+
Gold leaf, oil-based sizing and gesso
on plaster; bronze screen
32½ x 25 x 10¾ inches
Collection of Barbara and George
Erb, Birmingham, Michigan

29. **Nari**, 1980+
Gold leaf, oil-based sizing and gesso
on plaster; bronze screen
24 x 22 x 9 inches
Collection of Barbara and George
Erb, Birmingham, Michigan

30. **One Dime Blues**, 1980
Gold leaf, oil-based sizing and gesso
on plaster; bronze screen
35½ x 31 x 3 inches
Collection of Iris and Allen Mink,
Los Angeles

31. **Cassiopeia**, 1982*
Zinc and copper on bronze
mesh; patina
48 x 27 x 14 inches
Collection of Jeanne Randall
Malkin, Chicago

32. **Hydra**, 1982
Zinc and aluminum on
bronze mesh
48½ x 48 x 12 inches
Collection of Sue and Steven Antebi

33. **Patel II**, 1982
Gold leaf, oil-based sizing and gesso
on plaster; bronze mesh
64 x 24 x 20 inches
Private Collection

34. **Mirtak**, 1983
Zinc and aluminum on
bronze mesh
22 x 55½ x 12½ inches
Private Collection

35. **Perseus**, 1984
Zinc and aluminum on
bronze mesh
81 x 56 x 24 inches
Courtesy Margo Leavin Gallery,
Los Angeles

36. **La Gonda L. G. 6**, 1986
Bronze and chrome on
bronze mesh
43 x 48 x 13 inches
Courtesy Paula Cooper Gallery,
New York

37. **Twin Coach**, 1988
Copper on wire mesh
55 x 65 x 15 inches
Courtesy Paula Cooper Gallery,
New York

38. **Red and Blue Jungle
Gym**, 1988
Enamel on wrought iron; neon
86 x 84 x 60 inches
Courtesy Tilden-Foley Gallery,
New Orleans

39. **Super Two**, 1989
Aluminum on stainless
steel mesh
67 x 32 x 18 inches
Collection of Frederick Weisman
Company

40. **Eclat**, 1990
Aluminum on stainless
steel mesh
65 x 105 x 31 inches
Courtesy Paula Cooper Gallery,
New York

41. **Isabella Borgward**, 1990
Aluminum on stainless
steel mesh
88 x 54 x 22 inches
Collection of Mr. and Mrs. Graham
Gund

* indicates work shown at the High
Museum of Art only

+ indicates work shown at the High
Museum of Art and the Contempo-
rary Arts Center, New Orleans, only

PHOTO CREDITS

BLACK AND WHITE

Fig. 1: George Holmes
Fig. 2: Michael McKelvey
Fig. 3: Courtesy The Art Institute of Chicago
Fig. 4: Courtesy Gagosian Gallery, New York
Fig. 5: Charles Rogers/Lumens, Atlanta
Fig. 6: Philip Steinmetz; courtesy Ronald Feldman Fine Arts, New York
Fig. 7: Greenberg, Razen & May, Buffalo, New York
Fig. 8: Peter Muscato
Fig. 9: Elliot Schwartz; courtesy Lynda Benglis
Fig. 10: Lynton Gardiner; courtesy Timken Publishers
Fig. 11: Phototech, Buffalo, New York
Figs. 12-14: Robert Fiore; courtesy Whitney Museum of American Art Archives
Figs. 15: Geoffrey Clements; courtesy Lynda Benglis
Fig. 16: Courtesy Lynda Benglis
Figs. 17-19: Eric Sutherland; courtesy Walker Art Center, Minneapolis
Fig. 20: Margaret Foote; courtesy The MIT Museum
Figs. 21-25: Eric Sutherland; courtesy Walker Art Center, Minneapolis
Fig. 26: Courtesy Paula Cooper Gallery, New York
Figs. 27-28: Richard Eells; courtesy Lynda Benglis
Fig. 29: Courtesy Lynda Benglis
Fig. 30: Eric Sutherland; courtesy Walker Art Center, Minneapolis
Fig. 31: Geoffrey Clements; courtesy Paula Cooper Gallery, New York
Fig. 32: Courtesy Lynda Benglis
Fig. 33: Lynda Benglis
Fig. 34: Nathan Rabin; courtesy Paula Cooper Gallery, New York
Fig. 35: Courtesy The Chrysler Museum, Norfolk, Virginia
Figs. 36-37: Fernando La Rosa
Fig. 38: Charles Rogers/Lumens, Atlanta
Fig. 39: Courtesy San Francisco Museum of Modern Art
Fig. 40: Frank J. Thomas; courtesy Margo Leavin Gallery, Los Angeles
Fig. 41: Courtesy Leo Castelli Gallery, New York
Figs. 42-43: Charles Rogers/Lumens, Atlanta

Fig. 44: Courtesy Leo Castelli Gallery, New York
Figs. 45-46: Charles Rogers/Lumens, Atlanta
Fig. 47: Allan Finkelman; courtesy Robert Miller Gallery, New York
Fig. 48: Peter Moore
Fig. 49: Roy Trahan; courtesy New Orleans Museum of Art
Fig. 50: Fernando La Rosa
Fig. 51: Susan Krane
Figs. 52-53: Charles Rogers/Lumens, Atlanta
Fig. 54: Geoffrey Clements; courtesy Paula Cooper Gallery, New York
Figs. 55-56: Jack Brogan; courtesy Margaret Honda
Fig. 57: Michael McKelvey
Fig. 58: eeva-inkeri; courtesy Margo Leavin Gallery, Los Angeles
Fig. 59: Lynda Benglis
Fig. 60: Anand Sarabhai
Fig. 61: Courtesy Paula Cooper Gallery, New York
Fig. 62: Courtesy Lynda Benglis
Fig. 63: SlideMakers, Atlanta
Fig. 64: Courtesy State University College of New York at Oneonta
Fig. 65: Courtesy Lynda Benglis
Fig. 66: Courtesy Paula Cooper Gallery, New York
Figs. 67-69: SlideMakers, Atlanta
Fig. 70: Gwen Thomas
Fig. 71: Courtesy Paula Cooper Gallery, New York
Figs. 72-74: SlideMakers, Atlanta
Fig. 75: Laurie Lambrecht
Fig. 76: Geoffrey Clements; courtesy Paula Cooper Gallery, New York
Fig. 77: Peter Bellamy; courtesy Paula Cooper Gallery, New York

COLOR

Cat. 1: Gregory Benson
Cat. 2: Frank Hunter, Atlanta
Cats. 3-4: D. James Dee, New York
Cat. 5: John van Beekum
Cat. 6: Glenn Halvorson; courtesy Walker Art Center, Minneapolis
Cat. 7: Owen F. Murphy, New Orleans
Cat. 8: Joe Ziolkowski, New York
Cats. 9-10: D. James Dee, New York; courtesy Paula Cooper Gallery, New York
Cat. 11: Courtesy Philadelphia Museum of Art

Cat. 12: Jeffrey Riggenbach, Aspen
Cat. 13: Michael McKelvey, Atlanta
Cat. 14: Peter Muscato, New York
Cat. 15: Courtesy the Museum of Modern Art, New York
Cat. 16: Scott Bowron
Cat. 17: Douglas M. Parker, Los Angeles
Cats. 18-20: Frank Hunter, Atlanta
Cat. 21: Courtesy William J. Hokin
Cat. 22: Larry Ferguson, Omaha
Cats. 23-25: D. James Dee, New York; courtesy Paula Cooper Gallery, New York
Cat. 26: Courtesy Lynda Benglis
Cat. 27: Courtesy Sotheby's, New York
Cats. 28-29: Tim Thayer, Detroit
Cat. 30: Courtesy Paula Cooper Gallery, New York
Cat. 31: Courtesy Lynda Benglis
Cat. 32: Douglas M. Parker, Los Angeles
Cat. 33: Owen F. Murphy; courtesy Tilden-Foley Gallery, New Orleans
Cat. 34: Geoffrey Clements; courtesy Paula Cooper Gallery, New York
Cat. 35: Courtesy Paula Cooper Gallery, New York
Cat. 36: D. James Dee, New York; courtesy Paula Cooper Gallery, New York
Cat. 37: Douglas M. Parker, Los Angeles; courtesy Margo Leavin Gallery
Cat. 38: Owen Murphy; courtesy Tilden-Foley Gallery, New Orleans
Cat. 39: Douglas M. Parker, Los Angeles; courtesy Margo Leavin Gallery
Cat. 40: Geoffrey Clements; courtesy Paula Cooper Gallery, New York
Cat. 41: Douglas M. Parker, Los Angeles; courtesy Paula Cooper Gallery, New York

Designer: Jim Zambounis, Atlanta
Copy editor: Georgette Morphis
 Hasiotis
Managing editors: Margaret Miller,
 Kelly Morris
Typesetter: Katherine Gunn
Printer: Garamond/Pridemark Press,
 Inc., Baltimore

Library of Congress No. 90-84883
ISBN 0-939802-63-5

Cover: Detail of *Super Two*, 1989,
aluminum on stainless steel mesh,
67 x 32 x 18 inches, Collection of
Frederick Weisman Company.